Interlink Books

UKRAINE AT WAR

STREET ART POSTERS +POETRY

A PHOTO-REPORTAGE OF ART AND WAR BY
DAOUD SARHANDI-WILLIAMS
UNLESS OTHERWISE CREDITED ALL PHOTOGRAPHS IN THIS BOOK
WERE TAKEN BY THE AUTHOR IN AND AROUND KYIV IN AUGUST 2022

DEDICATED TO THE BRAVE PEOPLE OF UKRAINE
THE LIVING AND THE DEAD

First published in 2023 by Interlink Books
An imprint of Interlink Publishing Group, Inc.
46 Crosby Street, Northampton, MA 01060
www.interlinkbooks.com

Text copyright © Daoud Sarhandi, 2023
Photography copyright © Daoud Sarhandi, 2023 (unless otherwise credited)
English translation of poems © Daoud Sarhandi & Katarzyna Szczepańska-Kowalczuk, 2023 (except *The Keys to Happiness*)
Introduction copyright © Emma Mateo, 2023
Foreword copyright © Andrey Kurkov, 2023

All rights reserved.

Each mural, graffiti, poster, illustration, photograph or other artistic image reproduced and credited by name in this book or on the cover of this book—regardless of whether it was recorded in a public space (museum, gallery, street, metro, etc.) or passed to the author as an electronic or digital file—remains the sole intellectual property of its creator.

Poems were selected from www.warpoetry.mkip.gov.ua. Each poem remains the sole property of its author. Poets who did not reply to Mr Sarhandi-Williams or his assistant after being contacted by the State Arts Agency of Ukraine—and whose permission to publish was therefore not formally received—are invited to contact Olha Rossoshanska or Olha Martyniuk at the State Arts Agency, Kyiv.

Unless otherwise indicated, photographic and other images credited "public domain" or "Creative Commons" were sourced from Wikimedia Commons (www.commons.wikimedia.org) between September–December 2022.

Library of Congress Cataloging-in-Publication Data available
ISBN: 978-1-62371-726-1

Publisher: Michel Moushabeck
Book editorial and design: Daoud Sarhandi-Williams
Assistant editor: Kateryna Honcharova
Copyeditor (first draft): Rupert Wolfe Murray
Cover illustration: Harrison Williams
Back cover image: detail from a mural by Vitaliy Gideone
End-papers: detail from a mural of Lesya Ukrainka by Guido van Helten

Typeset in Helvetica and Baskerville
Printed and bound in Korea

THE AUTHOR ALSO WROTE AND DESIGNED
BOSNIAN WAR POSTERS
PUBLISHED BY INTERLINK BOOKS

AUTHOR'S ACKNOWLEDGEMENTS

SPECIAL THANKS
- KATERYNA HONCHAROVA—WHOSE PARTICIPATION IN UKRAINE MADE THIS BOOK POSSIBLE
- RUPERT WOLFE MURRAY—FOR EARLY ENCOURAGEMENT AND SUPPORT
- VLADYSLAVA OSMAK (NATIONAL UNIVERSITY KYIV–MOHYLA ACADEMY)—FOR SO MUCH HELP
- OLEG BOZHKO—FOR UNCONDITIONAL GENEROSITY WITH HIS PORTFOLIO OF STREET PHOTOS
- KATARZYNA SZCZEPAŃSKA-KOWALCZUK & OKSANA SZMYGOL—FOR TRANSLATING THE WAR POEMS
- MICHEL MOUSHABECK & HARRISON WILLIAMS—FOR GUIDING THIS BOOK THROUGH TO PUBLICATION
- CAROLINA RIVAS—FOR HER PATIENCE AND SUPPORT

CONTRIBUTORS IN UKRAINE
- ALL ILLUSTRATORS AND STREET ARTISTS—CREDITED WHERE THEIR ARTWORKS APPEAR
- ALL POETS—CREDITED WHERE THEIR POEMS APPEAR
- IHOR KUCHER—FOR HIS FRIENDSHIP AND GUIDANCE AROUND KYIV
- OLEG GRYSHCHENKO & OLENA STARANCHUK (PICTORIC ILLUSTRATORS' CLUB)
- OLHA ROSSOSHANSKA & OLHA MARTYNIUK (STATE ARTS AGENCY OF UKRAINE)
- SERHII MOSKALYUK & NIKITA ISHCHENKO (WWW.4MYUKRAINE.UA)
- ANDRII KOVTUN (WWW.MYFORESTBRIDGE.COM)
- ANTON KONDRASHOV & GRISHA SHOKOLE
- MISHEL & NICOL FELDMAN (WWW.SESTRYFELDMAN.COM)
- MYKOLA HONCHAROV & MICHAEL KARLOVSKI (INSTAGRAM: MYKOLAHONCHAROV)
- VARVARA LOGVYN, VIKTORIYA ZHURAVLOVA, MYKOLA KULYKOV

OTHER CONTRIBUTORS
- ALL INTERNATIONAL AND ANONYMOUS ARTISTS WHOSE WORK APPEARS IN THIS BOOK
- ZAFIRAH SARHANDI RIVAS
- ROXANA DENEB
- ANA BELÉN VELA SANTIAGO

THANKS
- HANNAH SARHANDI RIVAS
- MICHAŁ KOWALCZUK
- ALLA SIRENKO (THE UKRAINIAN CULTURAL ASSOCIATION IN THE UK)
- MARY RUTH WILLIAMS—FOR SHARING *MAGPIES IN PICARDY* (PAGE 318)
- KYIVMURAL.COM—FOR A REALLY HELPFUL WEBSITE

 FOR ASSISTANCE IN PROMOTING THIS PROJECT AND BOOK

PUBLISHING PARTNER DONORS
- BILL JOHNSON
- ENES CERIC
- MOLLY GRIFFIN MCKENNA
- RUSS WIGGIN
- SARA TREVELYAN
- SÖNKE MARTIN
- XANDER BERKELEY

DONORS
- ALINA WOLFE MURRAY
- AMILA HANDŽIĆ FEROVIĆ
- DAVID CASALS-ROMA
- JEAN FINDLAY
- GIEDRĖ PUTELYTĖ
- KIM WOLFE MURRAY
- LILIJAN SULEJMANOVIĆ
- MAGDALENA HILL
- MARTA RODRÍGUEZ
- MIRIAM MINGUET PANÈ
- ÒSCAR CERESUELA ALONSO
- PETER FLYNN
- ROWENA DIGGLE
- VESNA MANOJLOVIĆ

Those named above donated modest sums of money to cover the cost of my trip to Ukraine in August 2022. Publishing Partner Donors gave a little more, but the help of all was invaluable.

Right: *Hope,* by Katya Lisova. More of this artist's collages appear on pages 170–173.

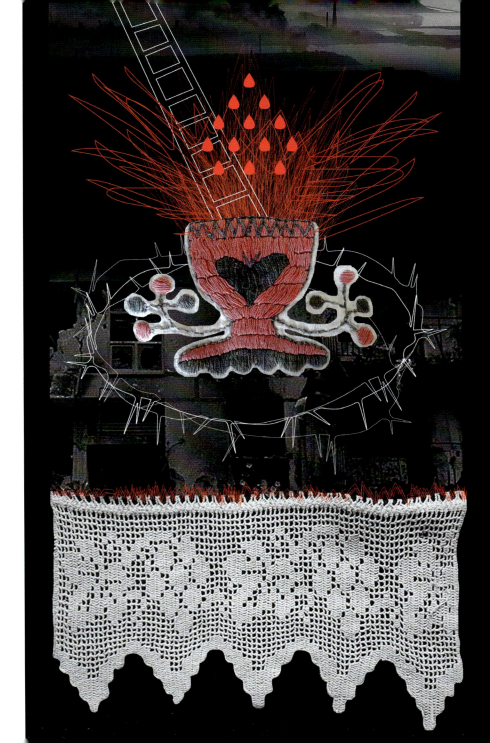

CONTENTS

AUTHOR'S ACKNOWLEDGEMENTS	8
NOTE TO THE POEMS	19
FOREWORD by Andrey Kurkov	20
PREFACE by Daoud Sarhandi-Williams	24
INTRODUCTION by Emma Mateo	28
ALPHABET BATTLES	35
WELCOME TO HELL: IRPIN, BUCHA, HOSTOMEL	41
PUTIN'S PARADE & OTHER WAR DEBRIS	65
SANDBAGGING HISTORY	89
BEAUTIFUL HEDGEHOGS	97
UNITED COLORS OF UKRAINE	107
MADE IN UKRAINE	115
FLORAL TRIBUTES	125
ANTI-WAR GRAPHICS	135
ILLUSTRATING RESISTANCE AT UKRAINE HOUSE	153
OSOKORKY METRO STATION	177
NAÏVE ART: AN INTERLUDE	187
MURALS MURALS EVERYWHERE	193
GHOST OF KYIV	229
GRAFFITI ARTISTS PAINT CARS	259
MAKING GRAFFITI GREAT AGAIN	277
THE "FRIENDSHIP" ARCH	313
TO END A BOOK: IN CONCLUSION	318

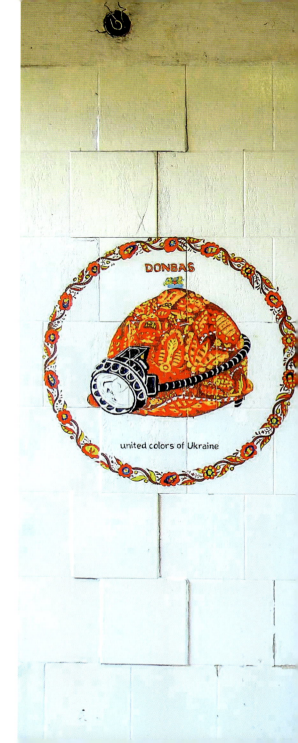

INDEX TO WAR POEMS

SLEEP	15
WITH UKRAINE IN MY HEART	34
WILD ORCS	40
THAT VERY DAY	64
I HAD A DREAM	88
FOR YOU	96
I LOVED YOU EVEN BEFORE THE WAR	106
THE BRASS BAND	114
SPRING SYMPHONY	124
ON THAT BLACK MORNING …	134
RETRIBUTION	152
LULLABY	176
KHARKIV	186
SON	192
DO YOU HEAR ME, MUMMY?	228
EXILE	258
THE KEYS TO HAPPINESS	276
WHEN?	312

Above: See page 19 for information about this poetry.

Left and right: graffiti in an underpass. The third part of this triptych is on page 67. Photograph by Oleg Bozhko, Kyiv, 2017.

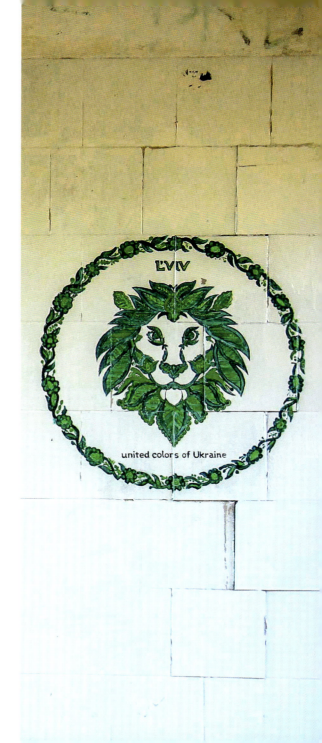

Right: photograph from the official Kremlin website (www.en.kremlin.ru). It is dated 14 February 2022—ten days before Russia invaded Ukraine (Creative Commons). The quote from *Alarabiya News* is from the day after the invasion.

C. S. Lewis (1898–1963) was a British writer *(The Chronicles of Narnia)* and an Anglican lay theologian.

Russian Foreign Minister Sergei Lavrov said Friday, Moscow was ready for talks if Ukraine's military surrendered, as he insisted that invading forces were looking to free the country from "oppression".

Alarabiya News
25 February 2022

Of all tyrannies, a tyranny sincerely exercised for the good of its victims may be the most oppressive.

C. S. Lewis

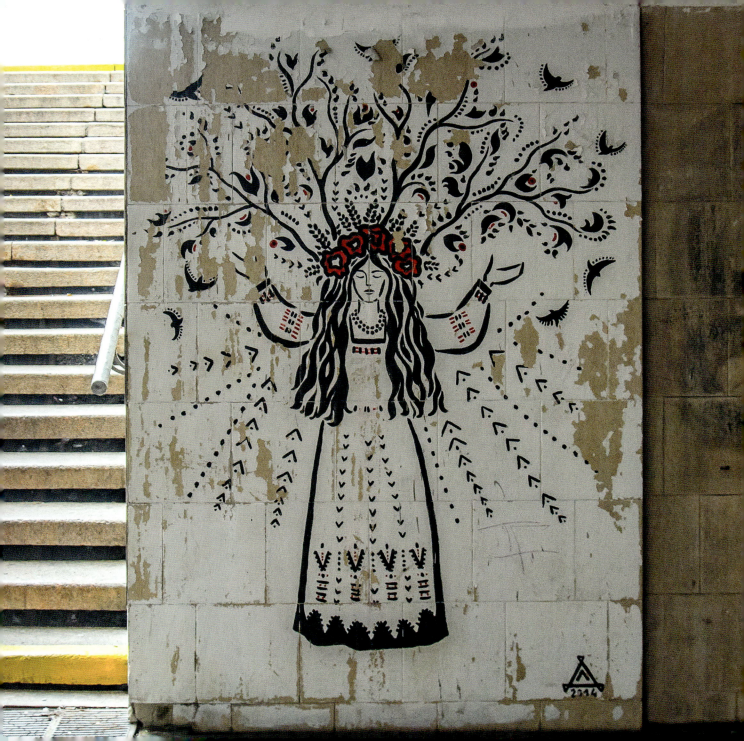

SLEEP
Vasylyna

I dreamed of war
And planes overhead.
But I ran, I was alive—
I believed that I would meet you
I saw destroyed cities—
I looked for loved-ones among the ruins
I bit my cracked lips
And was full of hope!
But I don't know if I found anyone.
Waking up at home
I felt the joy of your warm embrace
And forgot the dream with the ruins.
We lived as we always had
We were planning to travel …

But then I got a call—
"Are you sleeping? Get up! War!"

See page 19 for information about the source of this poem, which is written in rhyming verse in Ukrainian language.

Left: Berehynia (see overleaf) on an underpass wall. Photograph by Oleg Bozhko, Kyiv, 2017.

СОН
Василина

Мені снилася війна,
І літаки над головою.
Але я бігла, я була жива —
Я вірила, що зустрінуся з тобою!
Я бачила зруйновані міста —
Шукала рідних між руїнами,
Кусала потріскані вуста,
І була сповнена надіями!
Та я не знаю, чи когось знайшла.
Проснулась вдома і з обіймами,
Відчула радість від твого тепла,
І забула сон з руїнами.
Ми жили як завжди,
Планували подорож країнами…

Але прийшла пора дзвінка —
"Ти спиш?! Вставай. Війна".

Berehynia (illustrated on the previous spread) is a pre-Christian Ukrainian female deity that has made a comeback in contemporary culture. Indeed, when the nation gained its independence from the Soviet Union in 1991, interest was rekindled in all aspects of previously suppressed Ukrainian culture.

Berehynia is a defender. She is a female spirit whose magical powers protect her nation and people. She is usually depicted as seen here: with her eyes closed and arms raised to the sky. At times of intense national struggle—such as in 2014 when she was painted on this underpass wall in Kyiv—Berehynia has been evoked to protect Ukraine's warriors (Cossacks in bygone years) from harm. Berehynia unites various ideas: neopaganism, feminism and Ukrainian nationalism. Connected to birds, trees, animals and flowers, she can also be seen as an eco-warrior ahead of her time.

Nature and natural beauty play a large role in Ukrainian culture. Feminism also has deep roots in the country. In 1920 the Ukrainian Women's Union (UWU) was founded in Lviv; it was one of the largest organisations of its kind in Europe at the time. Active until the late 1930s, it was finally suppressed by the Kremlin as "anti-revolutionary" and crushed.

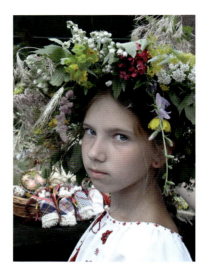

Above: a Ukrainian girl in a floral headdress, called a *vinok*. Originally a 10th-century, pre-Christian, Pagan tradition, the vinok symbolises purity and fertility, and is still beloved in Ukrainian culture. Photograph by Pavlo Boyko, Kyiv, 2006 (Creative Commons).

Flowers are cherished in Ukraine—and none more so than sunflowers.

These graffiti images, in an otherwise dingy pedestrian underpass near Independence Square in Kyiv, appeared quite magical when I passed them.

A mural painted in Kyiv by the Ukrainian artist, Olexander Hrebenyu.

NOTE TO THE POEMS

Most of the poems published in this book were selected from a website where Ukrainian citizens can freely upload their work. The site, called Poetry of the Free, is hosted by the State Arts Agency of Ukraine, which states that: "Every poem, every line, and every word are already a part of Ukrainian history."

Some of the poems are credited to pen-names, and we have left these as originally given. Poets are from cities, towns and villages all over Ukraine.

When I came across the website in late August 2022, it contained a staggering twenty-three thousand poems. Needless to say, I was unable to translate them all. My selection methodology, therefore, was a little crude but finally effective: with the initial help only of Google Translate, I chose the first poems that resonated with me and which fitted this book's structure. I also tried to include poems that reflected the range of emotions on display: from sadness and lament, to unbridled rage at Russia's entirely unprovoked war against Ukraine—which started in 2014 and intensified in 2022.

Anyone who has ever tried to translate poetry knows that the task has some big literary challenges, especially as concerns rhyming. We decided not to try to make words rhyme in English where they did in Ukrainian, but to translate only for meaning and tone. This issue affected all the poems except *On That Black Morning,* which is written in syllabic, rather than rhyming, verse.

Original punctuation has been simplified where possible—as can be seen by comparing original Ukrainian language versions with their translations.

I would like to thank my translator, Katarzyna Szczepańska-Kowalczuk; alongside Oksana Szmygol, she worked on the English versions of nearly all the war poems in the book.

For more about the poetry project, please visit https://warpoetry.mkip.gov.ua.

FOREWORD
ANDREY KURKOV

Andrey Kurkov was born on 23 April 1961 in Leningrad, Russia, and moved to Kyiv as a young child. He is a Ukrainian novelist who writes in Russian. The author of more than 20 novels and 10 books for children, his work is currently translated into 42 languages, including English, Japanese, French, Chinese, Swedish, and Hebrew. He also writes articles for the international press, including *The New York Times, The Guardian, The New Statesman, La Liberation, Le Monde, Die Welt,* and *Die Zeit.*

He was President of PEN Ukraine from 2018 until 2022.

His novel *Jimi Hendrix Live in Lviv* was longlisted for the International Booker Prize 2023, and he has won numerous awards for his novels and literary and human rights activities, including the Halldor Laxness Prize (Iceland, 2022), the Hans and Sophie Scholl Prize (Germany, 2022), Medici Prize for Best Foreign Novel (France 2022), Freedom of Expression Award (Index on Censorship, London 2022), Legion d'Honeur (France 2015), and Readers' Award (France, 2012).

THREE MINUTES BEFORE the start of 2023, I poured champagne into glasses. My family had decided to greet the New Year in the usual way, at home in the centre of Kyiv, but there was no sense of celebration. The only toast was to the "ZSU"—the Armed Forces of Ukraine. There were no fireworks, but our neighbours stood on their balconies shouting, "Glory to Ukraine!"

Five minutes into the New Year, artillery rumbled in the sky above our home. Russia had decided to congratulate the Ukrainians with Iranian drones and missiles. The air raid alarm sounded across Kyiv simultaneously with the blasts of anti-aircraft defence systems. With glasses in hand, we moved into the corridor—our apartment's "bomb shelter". The corridor is fairly wide and protected by two thick, load-bearing walls. The building is one hundred and twenty years old and seems safer than those constructed in the Soviet and post-Soviet eras.

Thus began a year that we felt was empty of anything new. Since February 2022, every Ukrainian has been forced to play Russian roulette. Every day, Russian missiles, guided bombs, and drones explode somewhere in Ukraine. Before February 24, 2022, they most often exploded in the Donbas, but now the entire country is targeted. Our windows are still intact. The doors of our balcony have not yet been blown out by any blasts. But our friend Irina Khazina, who lives less than a kilometre from us, has not been so fortunate. On October 10 last year, a rocket exploded in Shevchenko Park, across the street from her house. Irina and her neighbours were left without windows and with damaged roofs.

Still, Irina would admit that Kyiv is in a privileged position compared to towns and cities closer to the frontline. The Russian army has damaged or destroyed one-third of the buildings in Kharkiv. Nonetheless, even there life goes on, and each new shelling is a brick in the wall between its inhabitants and the country that lies only 30 kilometres to the east—Putin's Russia. After each atrocity, the people of Kharkiv pick themselves up and go to a café or a restaurant, the theatre, or the cinema. They go out to show that they are not afraid—that they are stronger than this cruel enemy, which seeks to wipe Ukrainian cities and villages off the face of the earth.

In Kharkiv, the air regularly smells of burning and gunpowder. Kyivites smell the war less often, but they see it and hear it everywhere. It is present in the signs giving directions to the nearest bomb shelter, in the names

of the cocktails served at The Bald Mountain bar on Lviv Square—when you get a "General Zaluzhny" (Blue Curacao and advocaat), all the money goes to the 71st Brigade, fighting near Bakhmut. The war is even present in the supermarket, where you can buy a new type of sausage named in honour of the Ukrainian armed forces.

The war is visible in the murals on some apartment blocks and in buildings that are now missing walls. It is present in songs and poems, films, and theatre productions. It is in our dreams, in conversations on the bus, in our every waking thought. This war is here for the long haul and will not leave Ukraine even when it ends. It will become history only for those born after it. For every survivor of this atrocity, it will never fade into the past.

Ukraine at War: Street Art, Posters + Poetry, will guide you through today's Ukraine more honestly than any future history might. These days, the war on my country must also battle with the artists—the ones most resourceful at combating the lived horrors of the Russian invasion. Ukrainians are a creative people, and they react instantly to changes in the country, especially during disastrous times. What this book shows is the restorative power of art in a time of war. Art during wartime cannot dispel the pain inflicted on human bodies. But it can cast in a different perspective the suffering caused by that pain, allowing us to perceive it on another scale. Art lets us look at today's pain from the viewpoint of the future, so there can be a future. And it helps us to imagine a future we will wish to remember.

Kyiv, March 2023

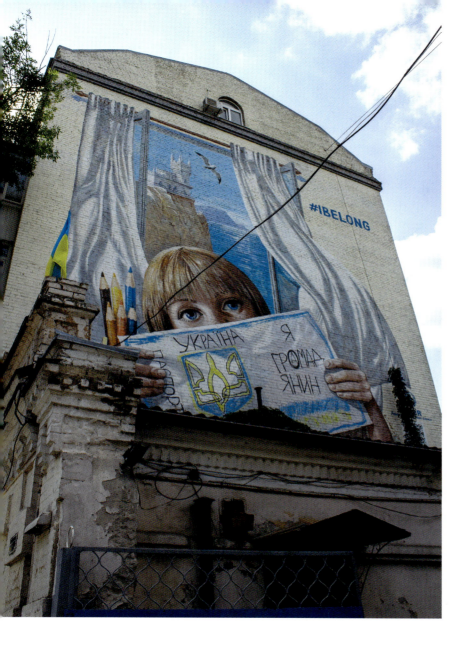

Left and above: photographed in Kyiv in August 2022, this mural (by Kateryna Rudakova) reminds us that the war in Ukraine actually started in 2014, when Russia annexed Crimea.

The most famous landmark on the Crimean peninsula—Swallow's Nest Castle: a neo-Gothic, fairytale-like edifice overlooking the Black Sea, near Yalta—can be seen through the Ukrainian refugee girl's open window. The text reads: PASSPORT. UKRAINE. I AM A CITIZEN.

The #IBelong campaign against statelessness was launched in November 2014 by the United Nations High Commissioner for Refugees.

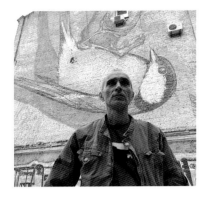

PREFACE
DAOUD SARHANDI-WILLIAMS

Daoud Sarhandi-Williams (London, 1962) is a British writer and filmmaker. He is the author of *Bosnian War Posters* (Interlink Books, 2022), and is a regular contributor to *Eye Magazine,* London. He is currently working on an anthology of poetry commissioned from Iranian women poets. He rigorously designs his own books, a creative activity he considers part of the writing process.

He has made many films in the UK, Mexico, Spain and elsewhere. In Palestine he produced, shot and edited the award-winning feature documentary, *The Colour of Olives* (2006, dir. Carolina Rivas), and in Mexico made *Lessons for Zafirah* (2011), a feature documentary co-directed with Ms Rivas. Together, Sarhandi and Rivas have produced a series of 50 short films in Spain and Germany, generically titled Video Values, that poetically deals with universal human values.

He grew up in Bristol, England, before moving to London to study film and photography. Since the late 1980s, he has lived in many countries, including Mexico for a decade and before that in many parts of Eastern Europe. He now lives with his family in Catalonia, Spain.

Above: photograph of the author (in front of a mural by Alex Maksiov) by Oleg Bozhko, Kyiv, 2022.

RUSSIA INVADED UKRAINE in the early hours of 24 February 2022. This was not unexpected given its steady and massive troop build-up on Ukraine's borders throughout the winter. The Russian Federation's illegal war of choice actually began in 2014, with the annexation of Crimea and the attempted take-over of parts of eastern Ukraine; so the full-scale invasion happened *not* without precedent or surprise.

In February 2022, I had just finished my previous book, *Bosnian War Posters*. I didn't feel I could get involved so soon in another political-art book about another European conflict; I just didn't think I had the mental energy. But like many people I was deeply affected by the war in Ukraine—and I was consuming a lot of news about it. One day I read a fascinating article about how Ukrainian artists were responding to the war, and I quickly became committed to the idea of finding out more. Ukraine is a much larger country than Bosnia, however, and with many more artists. Plus much of the territory was under attack and mortally dangerous to visit.

So I decided to restrict my research to the relatively secure (at that time) capital city, Kyiv, in north-central Ukraine. I had no contacts there, however, until I had a stroke of exceptional good luck: Alla Sirenko, a Ukrainian pianist living in London, put me in touch with Kateryna Honcharova, a journalist in Kyiv. She knew her hometown like the back of her hand, spoke great English, and was really keen to help me. I can humbly say that without Kateryna, this book wouldn't exist.

Another leading person in the story of its creation is Vladyslava Osmak from the National University Kyiv–Mohyla Academy. She not only kindly invited me to present *Bosnian War Posters* to her students, but worked tirelessly researching exhibitions and interesting places for me to visit and people to meet once I got to Kyiv: that really helped.

I finally arrived there (by overnight bus from Poland) on 13 August 2022 (day #171 of the war), with the aim of focussing on street art and public exhibitions. The reason for this decision was that I didn't have the time or the resources to knock on artists' doors all over Kyiv—that would have been logistically impossible in the relatively short space of time I had available. Moreover, many artists had left Kyiv as refugees and nobody was quite sure where they were. I also just liked the idea of art in public spaces: free, open art.

Most of the images in this book were photographed by me between 14 August and 1 September. Later, several posters and illus-

tration images were sent to me once I got home to Spain. Over the next few months, Kateryna and I collaborated by email and WhatsApp. Together—during the incessant power cuts and communication blackouts that began to plague Ukraine—long-distance we tidied up numerous visual and factual odds-and-ends.

Just before I left Kyiv in September, I had the good fortune to discover the website from where the war poems included in the book were selected. I have written about the process of poem selection and translation on page 19; here I only want to add that this poignant literary element is for me the most fitting accompaniment to the images I could have imagined. Finding the poems was a heart-stopping experience; reading them (with the initial help of Google Translate) was a deeply moving one; and supervising the English translations was immensely satisfying.

Ukraine at War took shape quite quickly once I got home. I simultaneously structured, wrote and designed the book, and while doing so I also selected the poems. Four months after sitting down at my desk, it was finished.

I cannot claim *Ukraine at War* is the definitive study of the country's street art, posters or poetry; far from it—and neither is it meant to be. Rather, it is an eclectic portrait of what I managed to see and record in a short period of time—and immediately before, as would soon become apparent, Ukraine's much-anticipated counter-offensive began.

As this book goes to press, the war is still raging and nobody knows when or how it will end. I trust Ukraine will win it; Ukrainians have no doubt they will. And when this finally happens the Russian Federation might implode or stay much the same. Either of these possible outcomes mean we shall all be affected in one way or another. Indeed, the war is already impacting much of the world in a myriad of political, economic and humanitarian ways. For these reasons, we all have an interest in the outcome of this war. We also owe Ukrainians (and the many soldiers of other nationalities fighting for Ukraine) a huge debt of gratitude: I really believe they are fighting for the kind of world we wish to live in.

This book is a tribute to bravery and to creativity in the face of it. Good journalism is invaluable—but so too is art, design and literature. Sometimes with greater clarity than News, the Arts allow us to see beyond the shifting daily headlines and ticker-tape live feeds, to core human values and deeper spiritual concerns.

Vallfogona de Riucorb, June 2023

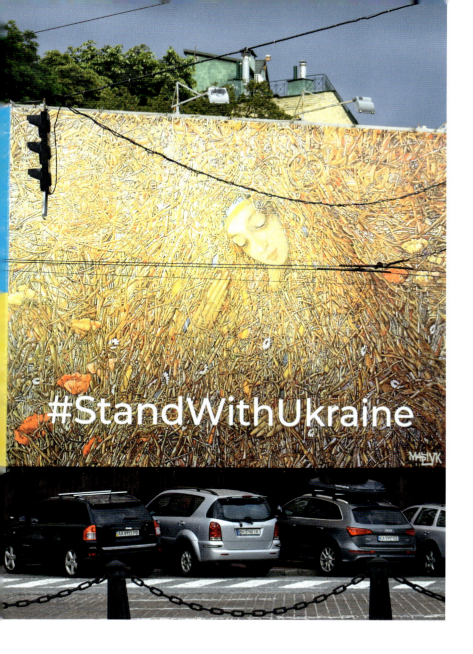

Left: in the summer of 2022, this #StandWithUkraine banner took up the corner of an entire block on Volodymyrska Street, opposite St Sophia church in Old Kyiv. The Stand With Ukraine movement is a decentralised international support group that emerged to help Ukraine after Russia invaded in February 2022.

INTRODUCTION
EMMA MATEO

Emma Mateo is a sociologist who studies protest and civil society in Ukraine and Eastern Europe. Her research focuses on local mobilization during mass protests and significant political events. She is currently researching how ordinary Ukrainians have mobilized in response to Russia's full-scale invasion of their country. Her other projects explore the role of networks during nationwide protests in Ukraine and Belarus, and the slogans and symbols of Ukraine's Euromaidan protests.

She is currently a Postdoctoral Research Scholar in Ukrainian Studies at Columbia University in New York City, where she also teaches on Ukrainian protest and activism. She holds a DPhil (PhD) in Sociology and a Master's in Russian and East European Studies, both from the University of Oxford.

RUSSIA'S WAR AGAINST UKRAINE is one of immense destruction. The havoc wrought by the Russian Federation is so great that on the first anniversary of the February 2022 invasion, it is impossible to know how many civilians have been killed. The true number is much higher than the 8,000 deaths and 13,000 injuries confirmed so far. Over 8 million Ukrainians have fled to Europe, with just as many displaced within Ukraine. Many thousands of Ukrainian children have been abducted by Russia under the guise of "evacuation". Eighteen million people are in dire need of humanitarian assistance. Almost one fifth of Ukrainian territory is currently under occupation. Towns that used to be home to tens of thousands of people have been razed to the ground. And yet, in the face of this unfathomable devastation, Ukrainians continue to resist, and create art and poetry. This book by Daoud Sarhandi-Williams bears witness to the continuing resilience and creativity of the Ukrainian people in a time of war.

Of course, the Russian invasion did not begin in 2022, but in 2014. Similarly, Ukrainians' artistic response to the current conflict can be traced back to events of 2013–14. Art was a crucial element of the Euromaidan protests which started on 21 November 2013. The initial trigger was the then-president Viktor Yanukovych's refusal to sign planned association agreements with the EU, which triggered protests in many cities that November. Yanukovych democratically came to power in 2010. He had been engaging with both Russia and the EU, but bowed to Russian pressure and reneged on his EU plans. Outraged protesters took to the streets with the blue and yellow flags of both Ukraine and the European Union. However, the mood and the focus of demonstrators rapidly shifted when peaceful protesters in Kyiv were beaten by security forces on the night of 29 November. From this point onwards, protesters mobilised not only to call for closer ties with the EU, but to defend democracy, freedom, and the independence of Ukraine. Demonstrations spread to dozens more cities, and protests became larger, and at times violent, in response to increasingly harsh attacks by security forces and hired thugs. This escalation of the protests was accompanied by an outpouring of artistic creativity. The protests, particularly the largest, permanent camp on Kyiv's Independence Square, were awash with colourful banners, flags, street art and posters. Activists read poetry on stages and played the piano on the barricades. They hosted art and photography exhibitions, and

staged films in occupied government buildings and city squares. They organised flashmobs and staged performances to highlight the corruption and brutality of the government. In Kyiv, some protesters even decorated the helmets and improvised shields they used to defend themselves from the *Berkut* riot police sent to attack them. Poems, paintings, street art and folk songs were dedicated to the hundred or so protesters who were killed in the final, most violent weeks of the protests—a period which many Ukrainians now refer to as the 'Revolution of Dignity'.

Amidst this widespread unrest, Yanukovych fled Ukraine on 22 February 2014. In the subsequent days and weeks, Russia stirred up separatist conflict in Ukraine's eastern Donbas region, and annexed the peninsula of Crimea, all under the pretence of protecting Russian speakers from Ukraine's new government, which it (falsely) claimed was a Nazi regime out to persecute anyone who was not an ultra-nationalist. And so, since the spring of 2014, Russia has occupied Crimea, and been at war with Ukraine, providing weapons, support, and manpower to defend the self-declared separatist republics in the east of Ukraine.

Upon the outbreak of war, Ukrainian civil society re-oriented itself from protesting to supporting those resisting Russian aggression, as well as Ukrainians displaced by the war and annexation. Some activists volunteered to join Ukrainian troops fighting in the east. Others worked to provide equipment and support for the under-resourced troops and volunteer fighters. The artistic scene began to shift too, in response to Ukrainian society finding itself at war. Poets such as Lyuba Yakimchuk, displaced from her hometown, and Serhii Zhadan, who played a leading role in Kharkiv's Euromaidan protests, began to write about conflict and resistance and loss. Playwright Natalya Vorozhbit, who was present on the Kyiv Euromaidan, wrote plays and screenplays about the war and its impact on Ukrainians. Artist Sergei Zakharkov created street art in his home of occupied Donetsk critiquing separatism. These are just a few examples amongst many.

This book provides a snapshot of artistic responses to the latest iteration of Russia's violence against Ukraine: full-scale invasion. Daoud isn't aiming to provide a definitive account of cultural responses to the escalation of the conflict. But still, he manages to capture a number of key features of the current artistic resistance, which like the war, emerged prior to 2022. Historical and cultural figures are note-

worthy, such as the poet Taras Shevchenko, and writers Lesya Ukrainka and Ivan Franko. They have become major symbols because they represent how Ukrainian culture has been challenging Russian imperialism for centuries. Ukrainian folk culture is also significant: traditional crafts and symbols such as *rushnyk* embroidery, the *Petrykivka* style of folk painting, the *vinok* floral headdress, and images of Ukrainian Cossack fighters are repurposed to give the art of protest and war a distinctly Ukrainian flavour. Even the use of more modern forms of expression pre-dates the full-scale invasion. Ukrainian graphic design, now producing anti-war posters, thrived during the Euromaidan protests. Designers created iconic posters and social media images such as the famous blue and yellow 'I am a drop in the ocean' campaign. The huge public murals depicting icons of the current war can also be viewed as continuing the post-Euromaidan trend of public art in Kyiv, intended to mark the city as a vibrant, European capital.

The fact that Daoud is focusing his lens on ordinary Ukrainians and their wartime creations is crucially important. Instead of capturing Ukrainian victimhood, he is chronicling Ukrainian agency. The diversity and richness of cultural responses to the war are a testament to the fact that Ukrainians are actively resisting Russian attempts at annexation and occupation. And this is happening not only with art, but all across Ukrainian society. An August 2022 survey suggests that in response to the war, 81% of Ukrainians have donated to their armed forces, 63% have donated clothes or money to those displaced, 54% have hosted or assisted displaced people, 37% have volunteered in some capacity, and 21% have joined the armed forces, territorial defence, or national guard. The images in this book bring these statistics to life, from young girls selling home-made jewellery to raise money for the army, to graffiti artists spraying vehicles in camouflage before they are sent to the frontlines. So much reporting on and analysis of this war has focused on geopolitics, the military, and political leaders. We must remember that ordinary Ukrainians are not only the victims of this war, but the ones fighting it on thousands of fronts, in a myriad of different ways—whether that be with a weapon, a laptop, a paintbrush, or a pen.

Even so, Ukrainian art does not need to be directly dealing with themes of war and loss for it to be a form of resistance. Russia's war is based upon the denial of and attempts to eradicate a sense of Ukrainian identity. Putin

has stated that there is "no historical basis" for the "idea of Ukrainian people as a nation separate from the Russians". Sergey Aksyonov, the head of Russia's occupying forces in Crimea, wrote in September 2022 that "the future of Ukraine, or rather what remains of it, is possible only with the complete elimination of Ukrainian statehood." In this context, expressions of Ukrainian culture and symbolism become an act of defiance. When displaying the Ukrainian flag can get you arrested and tortured, painting a garage door or park bench yellow and blue is activism. When speaking your national language can make you a target for beatings, sexual violence, and murder, even the alphabet becomes politicized. In occupied territories, the Ukrainian letter ï—which does not exist in Russian—is graffitied in public spaces as a statement of protest.

Even simply creating or enjoying art for art's sake can be considered a form of defiance during wartime. Selling pastoral paintings or spray-painting psychedelic canvases becomes a statement of the fact that life goes on for Ukrainians in Kyiv and many other cities, after Russia failed to occupy them. As Russia continues to launch rockets and drones, Ukrainians are not only fighting back. They are also painting, and writing, and going to the ballet, and attending concerts. Away from the frontlines, life continues in free and independent Ukrainian towns and cities. Towns and cities that over a year ago, Russia thought it would take control of in just a few days.

Naturally, many of the images and poems in this volume do confront the war head on, with minimal symbolism or metaphor. These are unlikely to be the first images you have seen relating to the war. But there is something about intentionally taking the time to sit with words and images on pages held in your hands, which brings home the human impact of the war. As a researcher working on Ukraine, I read, view and listen to information about events in the country almost every day. And yet, the collection shared here by Daoud still moves me deeply. There is a familiar cliché: 'a picture is worth a thousand words.' The image on page 46 of a cheerful playground bus, painted in Ukrainian colours, now peppered with bullet holes, seems to capture the brutality of this war in one image. But many of the other photographs, and poems, reflect the defiance of people that the invading forces seek to subdue. This book is a visceral reminder not just of Russian cruelty, but, above all, of Ukrainian resilience. As *Ukraine at War* goes to press, this resilience seems stronger than ever.

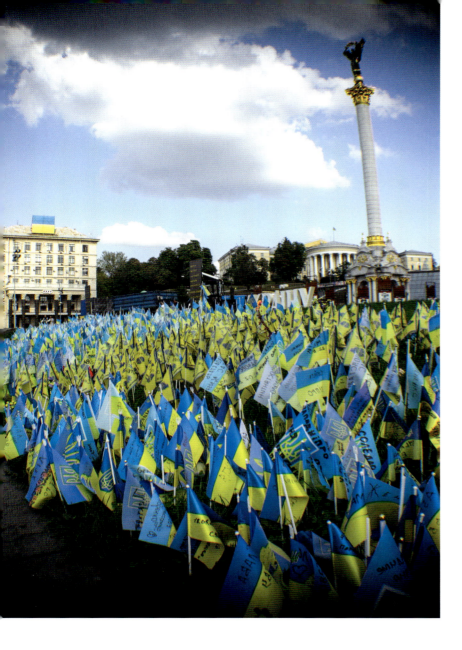

Left: Independence Square, Kyiv, in August 2022. This was ground zero during the Euromaidan Revolution, which took place between 2013–14, when Ukrainian youth and violent riot police *(Berkut* and *Titushky)* fought running battles. After much bloodshed, the protesters effectively won; Putin's puppet president (Viktor Yanukovych) was ousted; and Ukraine embarked on a new path—one that was immediately undermined when Russia invaded and annexed Ukraine's Crimea peninsula.

For any reader who wants a fast primer on this Ukrainian history, I recommend Evgeny Afineevsky's excellent documentary, *Winter on Fire* (Netflix, 2015).

WITH UKRAINE IN MY HEART
Julia Bezerko

Thousands of kilometres stand between us
We are a thousand roads apart.
But my heart beats only for you
There, over the threshold of my parents' home.
For you, beloved Ukraine
I pray to God each day—
To save you from harm
Sorrow, grief and regret.
And let the damned aggressors
Worse than wild beasts
Burn in the fire of the war they started!
I'm with You in thoughts and faith.

See page 19 for information about the source of this poem, which is written in rhyming verse in Ukrainian language.

Right: the Ukrainian Cyrillic alphabet. Although it is very similar to the Russian Cyrillic alphabet—and they both have 33 letters—not all letters are shared.

ALPHABET
BATTLES

А	Б	В	Г	Ґ	Д
Е	Є	Ж	З	И	І
Ї	Й	К	Л	М	Н
О	П	Р	С	Т	У
Ф	Х	Ц	Ч	Ш	Щ
Ь	Ю	Я			

З УКРАЇНОЮ В СЕРЦІ
Юлія Безерко

Між нами тисячі кілометрів,
Між нами тисячі доріг.
Та серце б'ється лиш Тобою,
Воно – де батьківський поріг.
За Тебе, Рідна Україно,
Я Бога кожен день молю:
Щоби зберіг Тебе від лиха,
Печалі, горя та жалю.
І хай агресори прокляті,
Що гірші, аніж дикі звірі,
Горять вогнем в війні початій!
З Тобою я в думках та вірі.

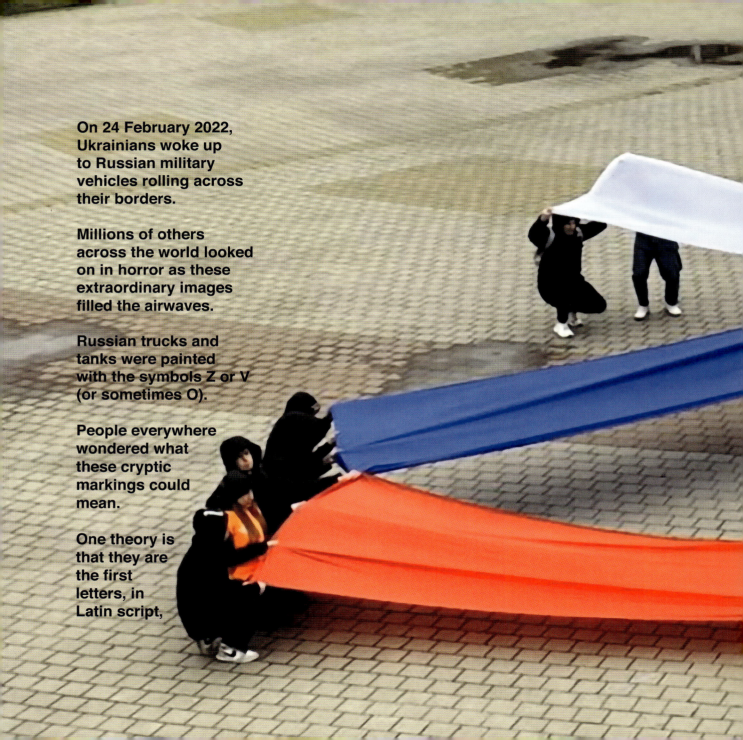

On 24 February 2022, Ukrainians woke up to Russian military vehicles rolling across their borders.

Millions of others across the world looked on in horror as these extraordinary images filled the airwaves.

Russian trucks and tanks were painted with the symbols Z or V (or sometimes O).

People everywhere wondered what these cryptic markings could mean.

One theory is that they are the first letters, in Latin script,

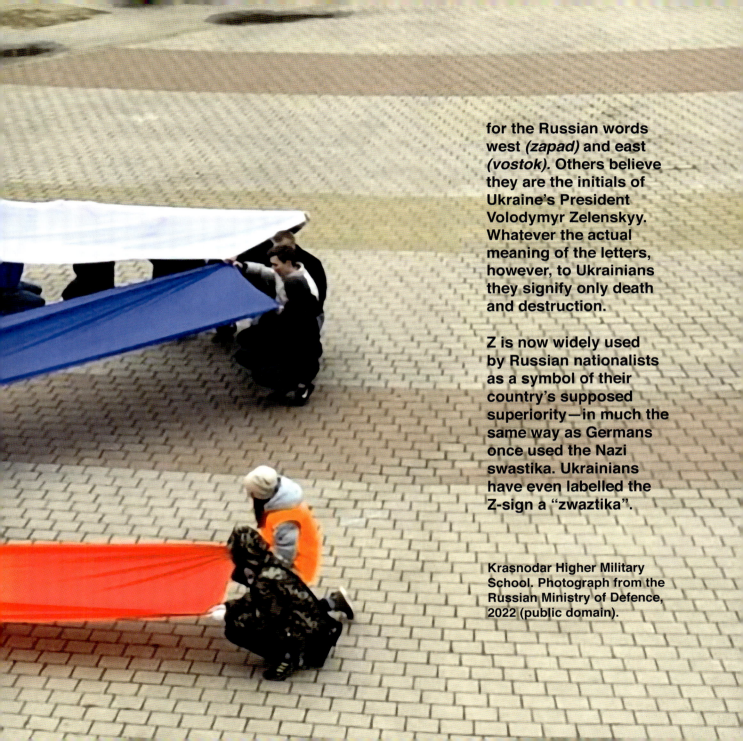

for the Russian words west *(zapad)* and east *(vostok)*. Others believe they are the initials of Ukraine's President Volodymyr Zelenskyy. Whatever the actual meaning of the letters, however, to Ukrainians they signify only death and destruction.

Z is now widely used by Russian nationalists as a symbol of their country's supposed superiority—in much the same way as Germans once used the Nazi swastika. Ukrainians have even labelled the Z-sign a "zwaztika".

Krasnodar Higher Military School. Photograph from the Russian Ministry of Defence, 2022 (public domain).

Ukrainians resisting in occupied parts of their country devised a riposte to the hated Russian symbols Z and V: they started graffitiing the letter Ï wherever they could. Others have even tattooed it close to their heart. The letter Ï, pronounced "yee", appears in the Ukrainian alphabet, but not the Russian one—hence the symbolic significance of Ï.

This page: the letter Ï on a monument and road. Anonymous, 2022.
 Opposite, top: Ï tattoo appears courtesy of Daryna Dmyrtiievska; she asked me to publish this selfie, and to name her.
 Bottom left: a captured Russian armoured personnel carrier. State Border Guard Service of Ukraine, 2022 (Creative Commons).
 Bottom right: the slogan reads: GO TO WORK, BROTHERS! This photograph of a Russian car, registered in the Tyumen region of Siberia, was taken in April 2022 by a person credited as RG72 (Creative Commons—the licence plate has been obscured in this publication.)

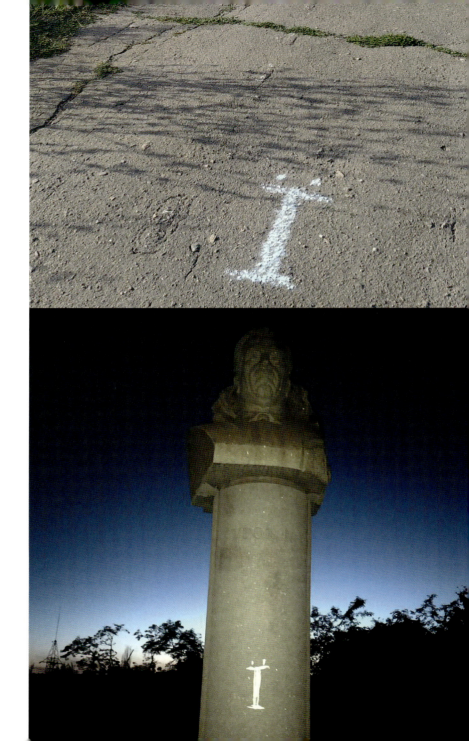

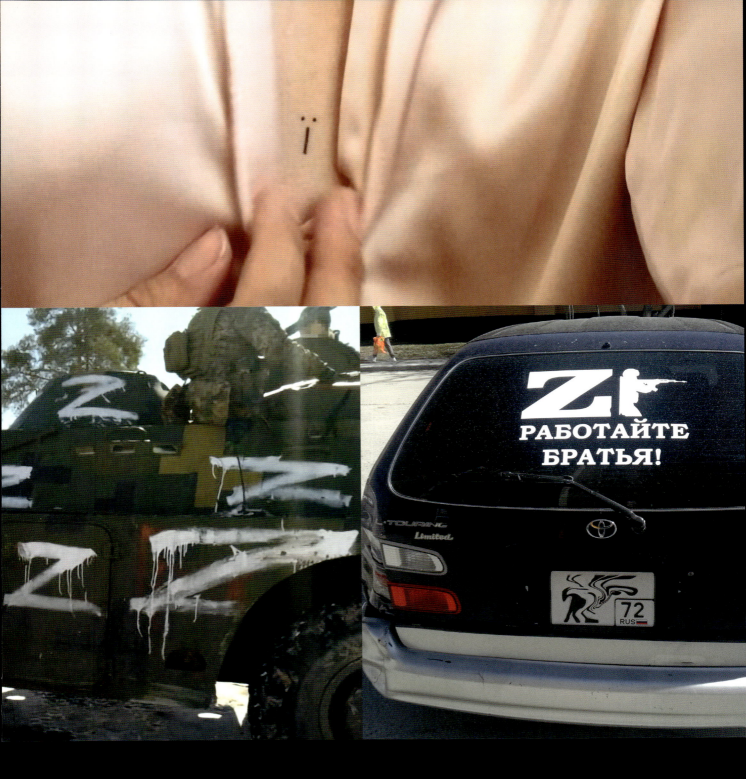

WILD ORCS
Anna Schmidt

Wild orcs, mindless horde!
Who messed with your heads?
You go home in coffins.
We bury innocent children.

No, we shan't forget you!
We shall erase you from our memory.
While you rot
We'll rise from these ghastly ruins!

From the black ashes you leave behind
Ukrainian land will be reborn.
United, we grow strong!
The Mother of God protects our skies.

So return to your Mordor.
Where your mothers shower you with curses.
Because in the world where the sun rises
You are no longer human.

The derogatory name "orc" is now commonly used in Ukraine to refer to Russian invaders. It is borrowed from the fictional world of J. R. R. Tolkien (1892–1973). Orcs are a savage, degenerate race of fighters who serve the evil Sauron—the primary antagonist in *The Lord of the Rings* (1954). Mordor (or Middle-earth) is also a Tolkien creation: it is a dark, volcanic place ruled over by Sauron.

See page 19 for information about the source of this poem, which is written in rhyming verse in Ukrainian language.

Right: shattered house windows with Christmas lights from 2021 still hanging. Photograph by the author, Hostomel, 2022.

WELCOME TO HELL was a graffitied slogan prominent during the siege of Sarajevo in the 1990s. It came to my mind when I walked the streets of the towns featured in this chapter.

WELCOME TO HELL
IRPIN, BUCHA, HOSTOMEL

ДИКІ ОРКИ
Анна Шмідт

Дикі орки, орда знедумлена!
Хто аж так одурив вам голови?
Ви додому вертаєтесь трунами.
Ми невинних дітей хоронимо.

Ні, ніколи цього не забудемо!
Вас на віки тепер перекреслимо.
Поки ви загнивати будете,
Ми з руїн цих страшних воскреснемо!

З чорних згарищ, що ви покинули,
Українська земля відродиться.
Об'єднавшись, ми стали сильними!
Небо нам береже Богородиця.

Повертайтесь до свого Мордору.
Там, де матір вам сипле матами.
Бо на світі, де сходить сонце,
Ви подобу людську вже втратили.

The names Irpin, Bucha and Hostomel live on in infamy. They are satellite towns north-west of, but surprisingly close to, Kyiv. As in numerous other places across Ukraine, before being forced out, Russian soldiers tortured, raped, robbed and indiscriminately murdered Ukrainian citizens in these towns. Russian soldiers' crimes were only fully revealed once they had fled.

Visiting these towns, I saw widespread destruction of course. But I also found an indomitable spirit and green shoots of recovery. Indeed, seated in a very pleasant restaurant in Bucha, life felt strangely normal.

Right: just outside Hostomel we passed a burnt-out Ukrainian tank decorated with flowers and graffiti.

Kateryna Honcharova, my assistant, stands on the far right of the lower photograph. Vladyslava Osmak (from the National University Kyiv–Mohyla Academy) is on Kateryna's left carrying a bag. These two women were of invaluable help to me while preparing this book.

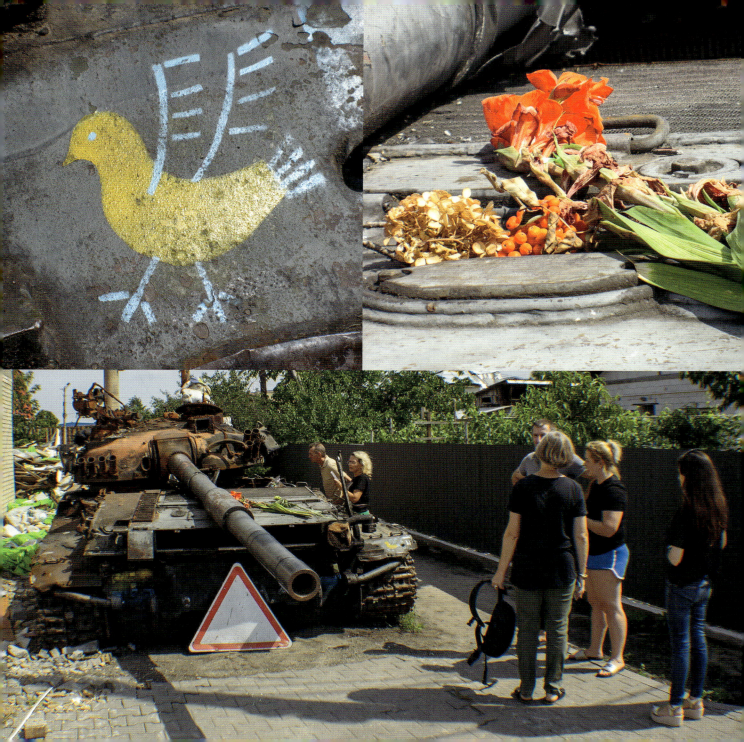

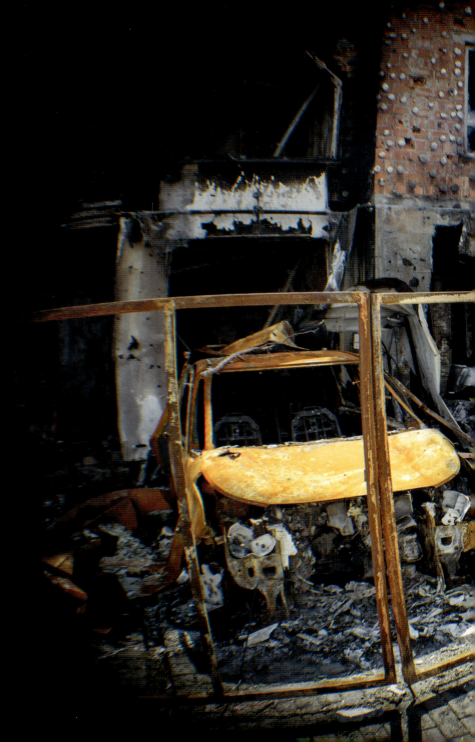

Cars parked in front of these town houses in Hostomel were incinerated where they stood when this street was shelled.

Since before what Russia calls its "special military operation" in Ukraine began, the Kremlin has pushed two main lines of propaganda: that Ukrainians need "saving" from their own democratically elected government; and that Ukraine is an integral part of Russia. Ukrainians, the most extreme Russian nationalists claim, do not really exist at all—they are all actually Russians. Not only is this propaganda absurd in any sense, but it is contradicted by the way Russian forces have treated everyone in their murderous path.

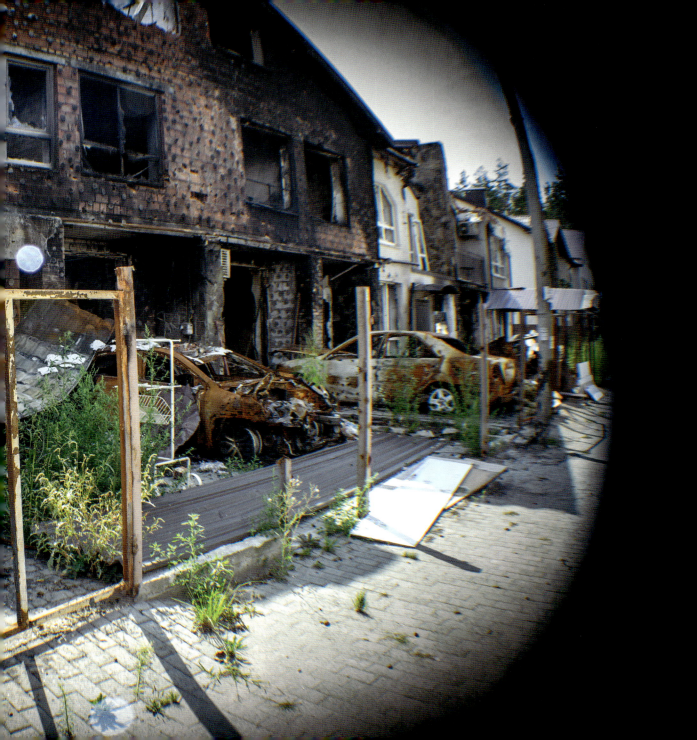

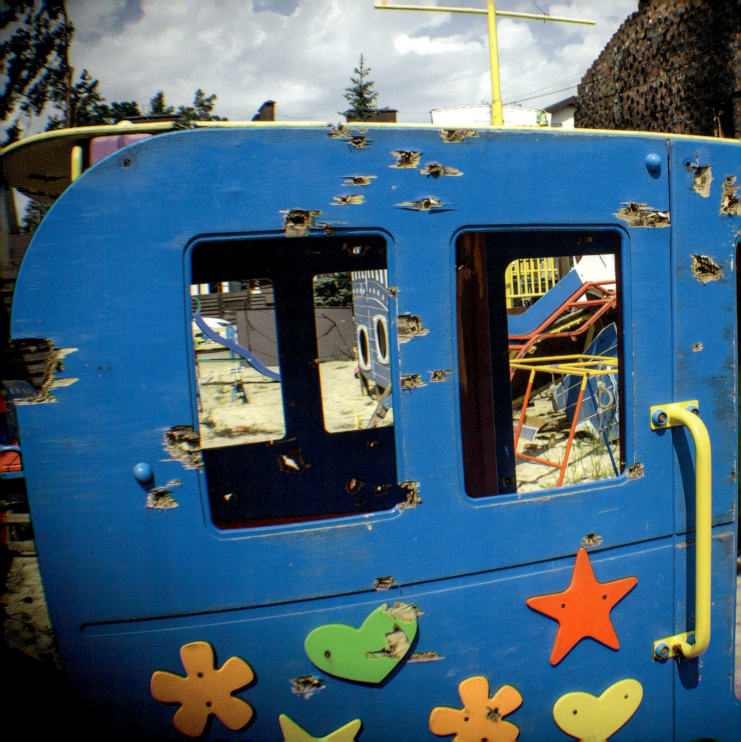

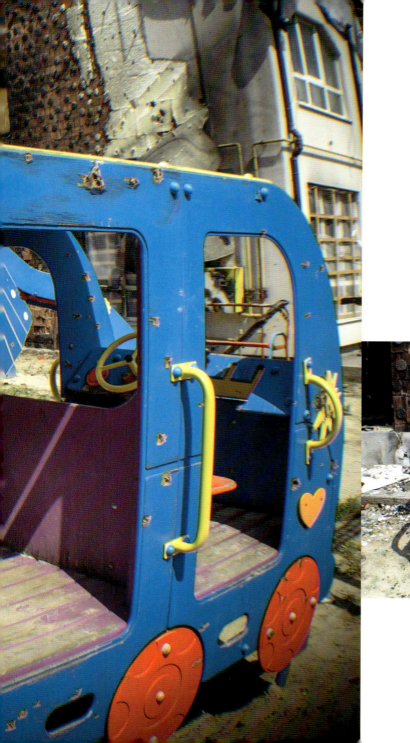

Russian soldiers shot up nearly everything they encountered—including this playground bus in Hostomel.

I wondered how many mothers, seated on what was left of this bench, had watched their children play here.

Most destroyed cars collected by Ukrainians after liberating their towns seem to have been shot multiple times through the windscreen or crushed by tanks. In hastily constructed scrapyards throughout the country, hundreds of civilian cars bear witness to the people who died within them.

If you look inside these cars, the sight of bloodstained seats, lost shoes, and abandoned teddy bears breaks the heart … A string of rosary beads swinging in the breeze.

The unfathomable, mindless cruelty of it all chills the soul.

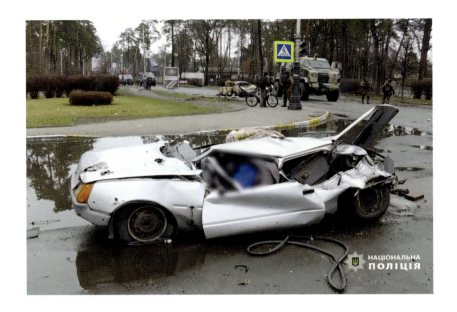

Above: shortly after Bucha was liberated, on 2 April 2022 the National Police of Ukraine took this crime scene photograph showing a flattened car with the dead driver still inside (Creative Commons).

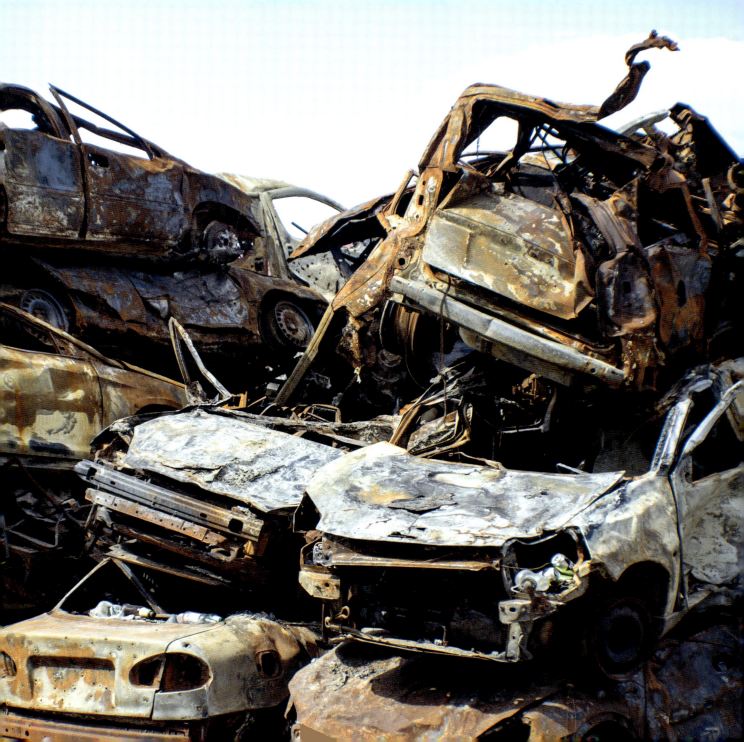

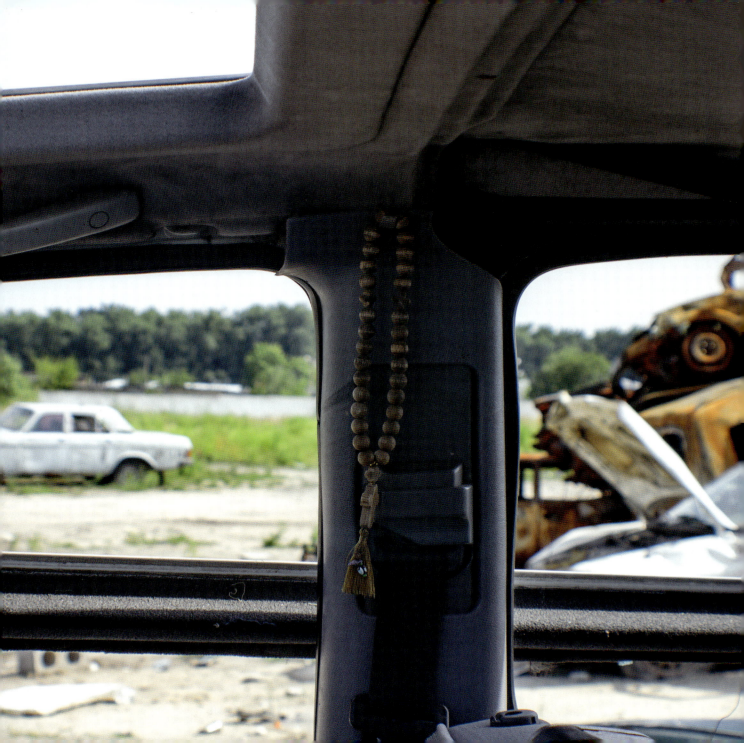

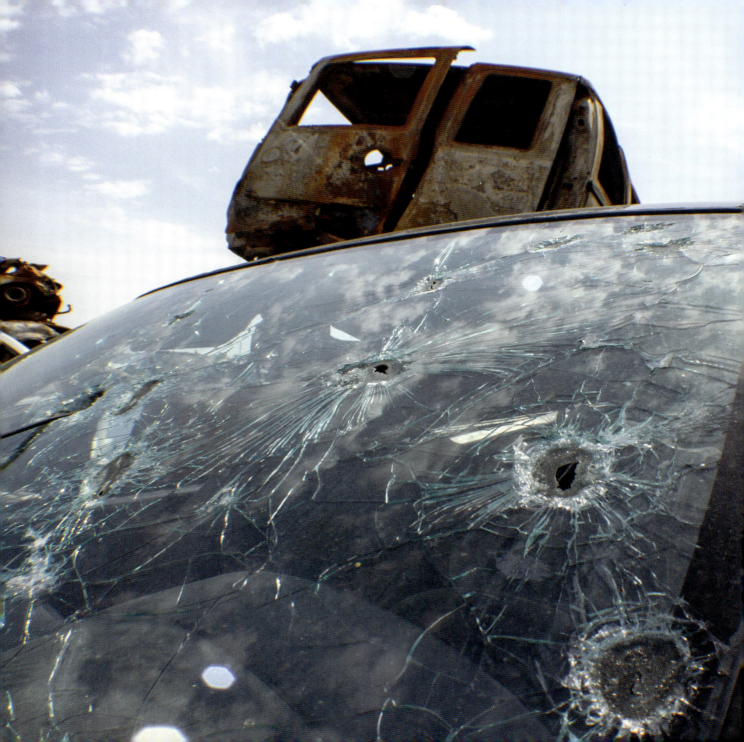

Megastores such as Intersport and the garden centre below—both of which are part of the Epicenter shopping centre in Bucha—seem to have been popular targets for Russian missiles in the first days of the invasion.

Their size, plus the fact that they were frequently full of shoppers, made them attractive and easy targets to hit.

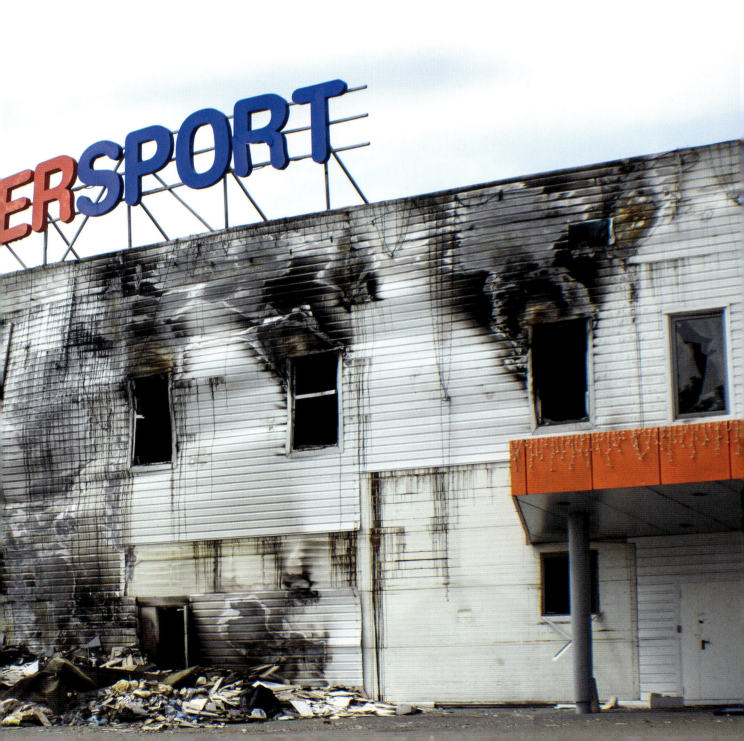

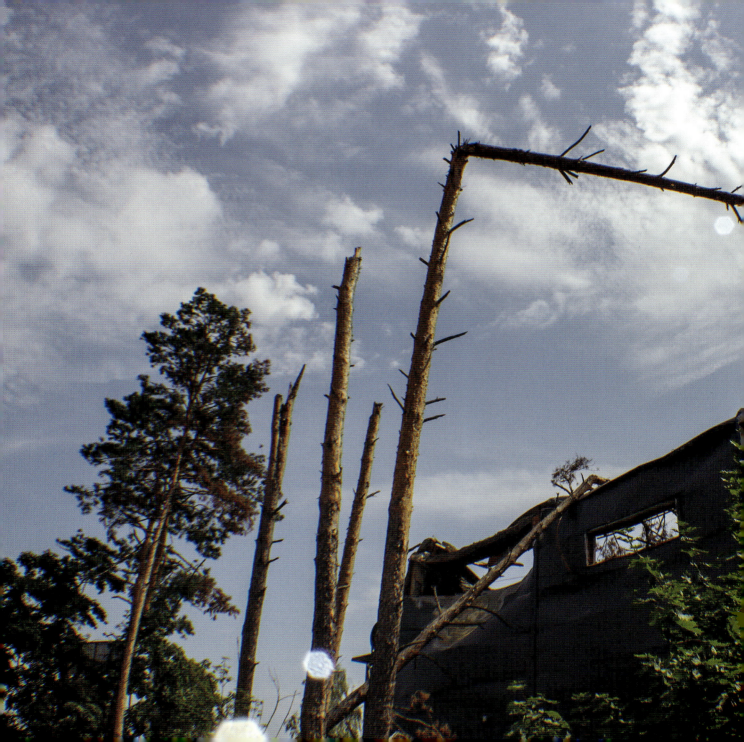

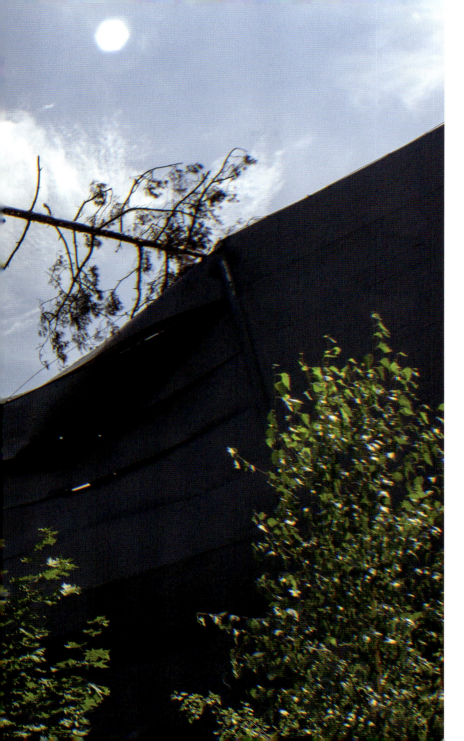

Nature—whether urban, wild or arable—is also one of war's victims. Ukraine is just beginning to count the cost of the mass destruction of vegetation and wildlife.

Water and soil contamination from the use of so much ordnance also represents an ecological time bomb—to say nothing of the risk to nuclear power stations, of which we hear so much. When I was in Ukraine, the Zaporizhzhia power plant was under daily attack and fears of a disaster were high.

This photograph was taken in Irpin.

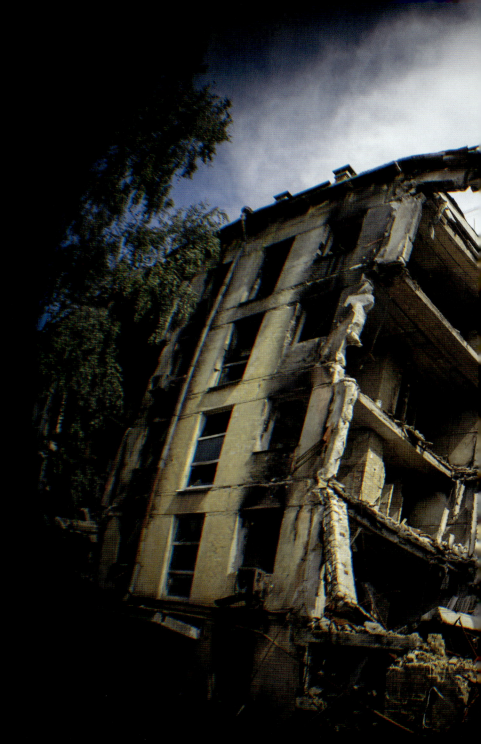

After Russia invaded Ukraine it became common to see residential blocks (such as this one in Hostomel), schools, government buildings and even hospitals with their middle sections blown out. Only guided cruise missiles can cause this level of precise destruction from afar.

Hostomel was important to the Russians since it has an airport they attempted to land Special Forces at, to facilitate the occupation of Kyiv. As the world now knows, their plan ultimately failed.

The ochre hues of this building's burnt concrete suddenly gave way to a small burst of colour: a saucepan still perched on its stove …

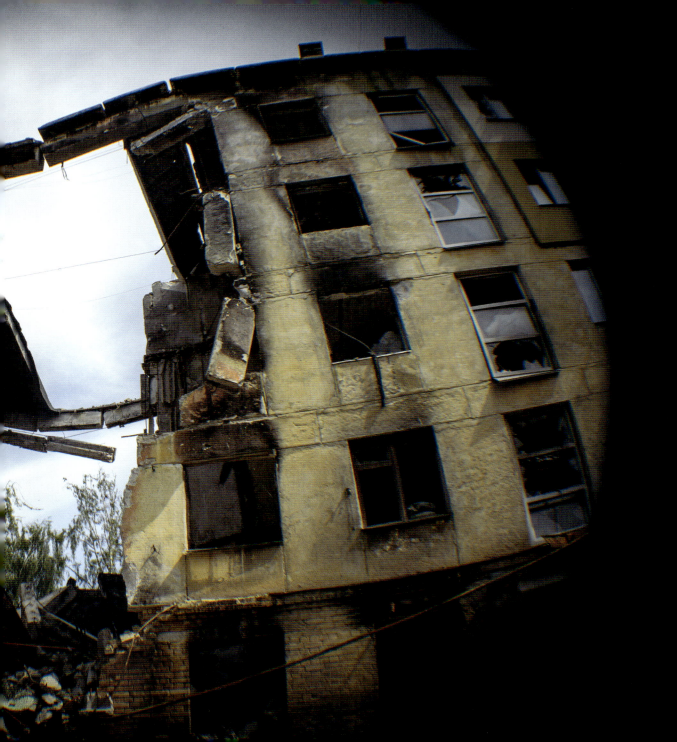

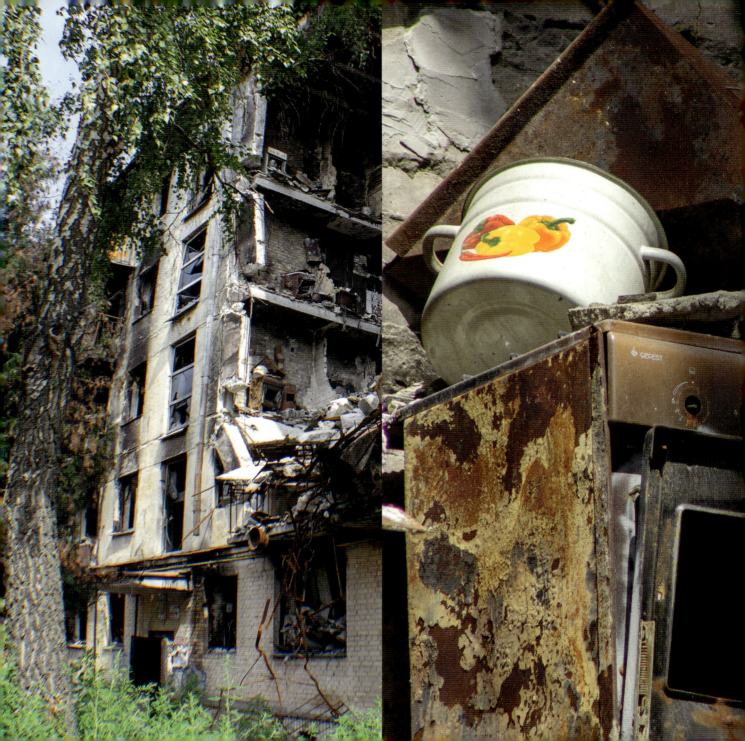

The day I visited Irpin, I was introduced to Viktoriya Zhuravlova. She is an activist fighting to save her block of flats from demolition. Her home is on a former frontline and was heavily damaged. Viktoriya and fellow residents are trying to raise private funds to study the feasibility of renovating their building. The authorities would rather tear the building down and rebuild it, but residents question if that is really necessary.

People worry about being made homeless for years to come. But with sub-zero Ukrainian winters, people without a roof, windows or central heating will be in mortal danger at home too.

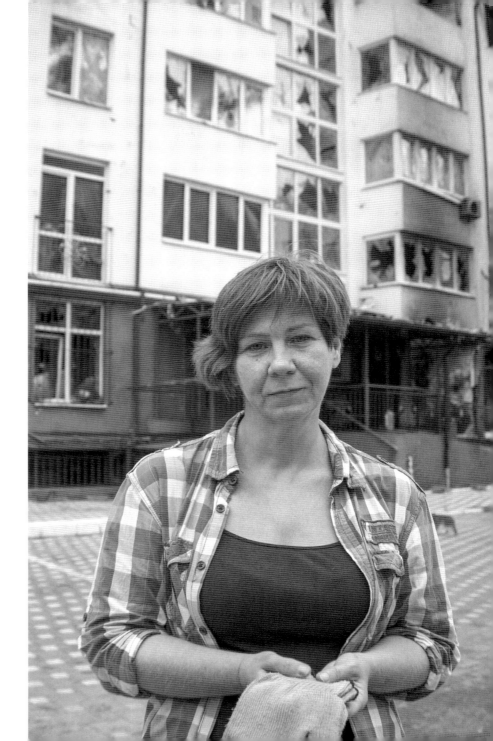

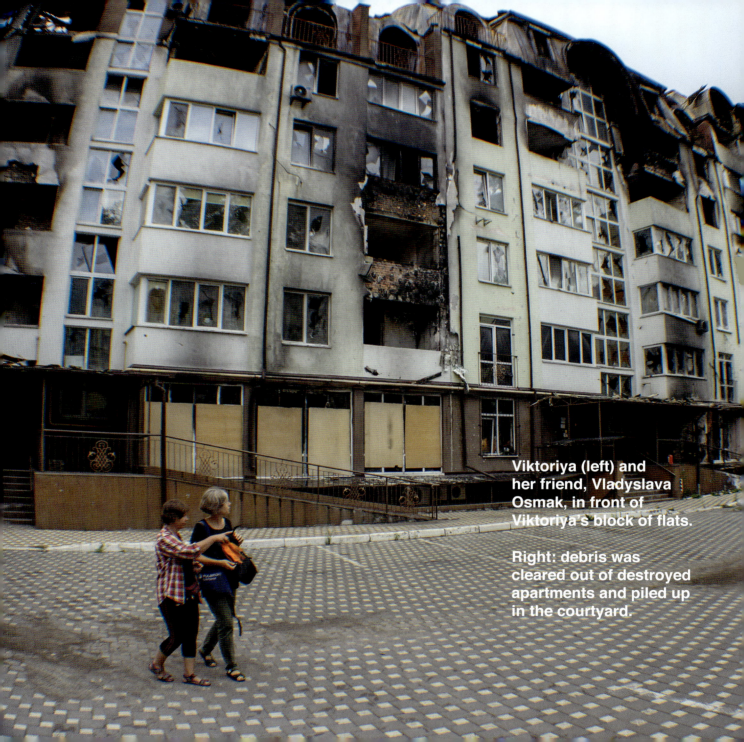

Viktoriya (left) and her friend, Vladyslava Osmak, in front of Viktoriya's block of flats.

Right: debris was cleared out of destroyed apartments and piled up in the courtyard.

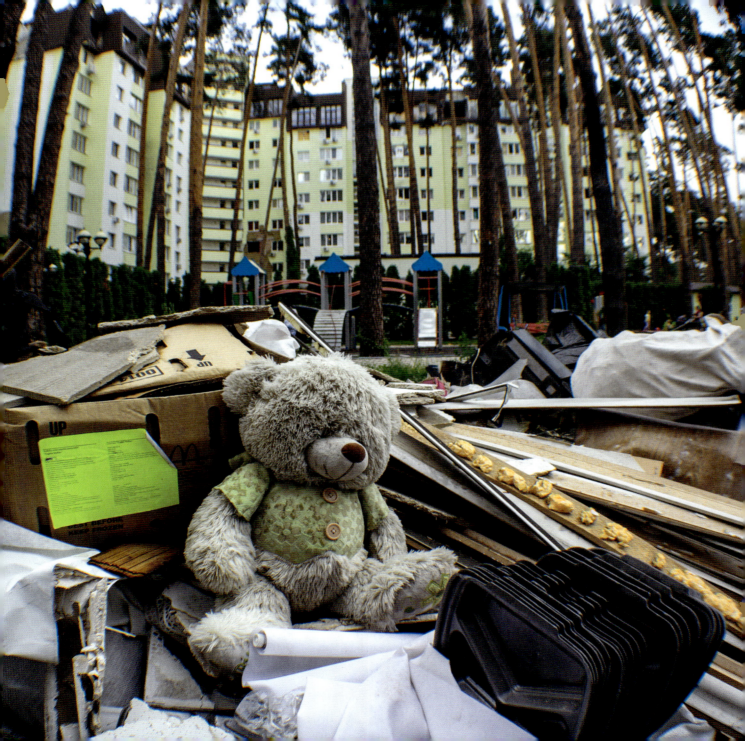

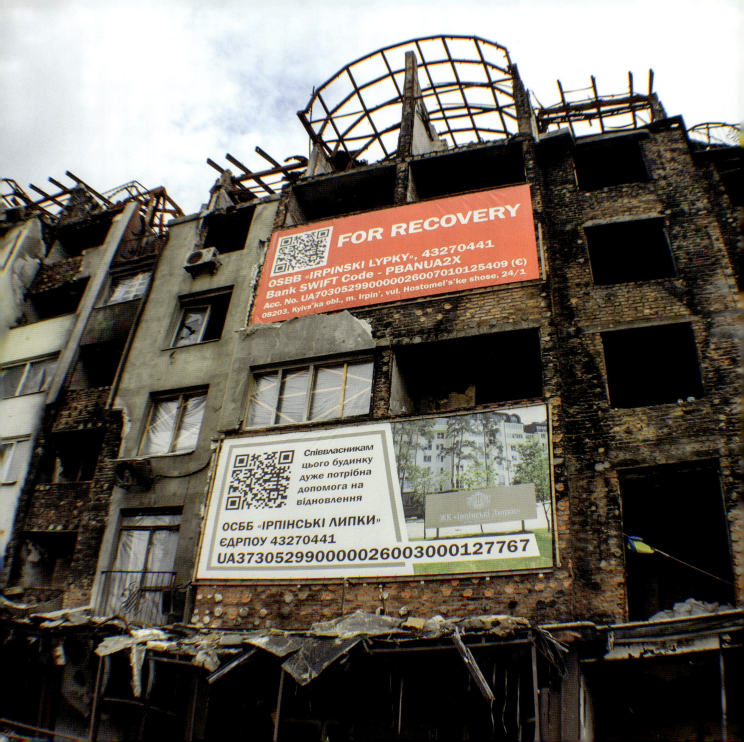

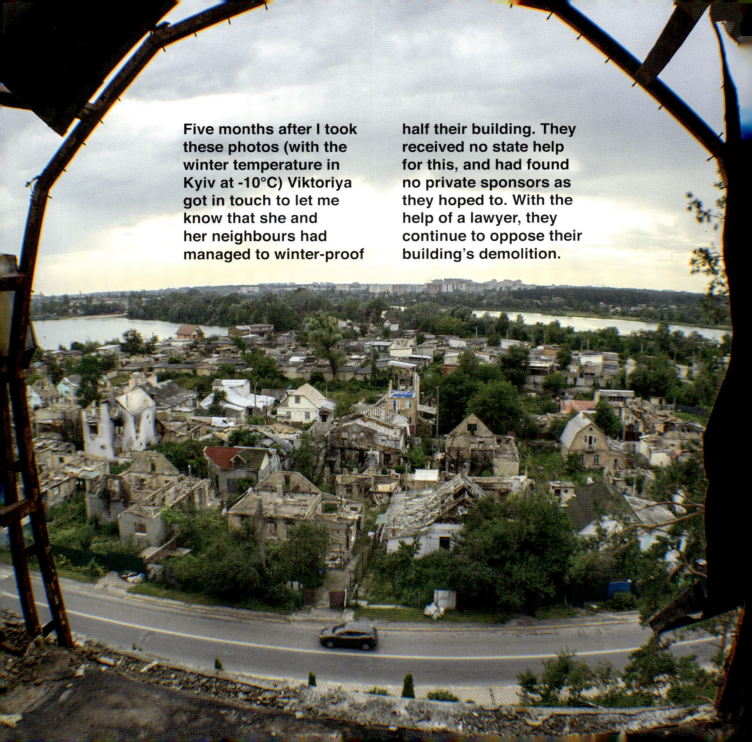

Five months after I took these photos (with the winter temperature in Kyiv at -10°C) Viktoriya got in touch to let me know that she and her neighbours had managed to winter-proof half their building. They received no state help for this, and had found no private sponsors as they hoped to. With the help of a lawyer, they continue to oppose their building's demolition.

THAT VERY DAY
Daryna Belmega

On that very day we'll get drunk on joy
We'll forget about bad weather and our troubles
We'll put on yellow-and-blue armbands
And be Ukrainians forever.

Then everything we do will work out fine
We'll go for a stroll along Khreshchatyk
A quiet day will seem more vibrant
Russian soldiers won't attack us.

Then and only then shall we start to appreciate
Touch, words of love and those of farewell
Our language will have the power of a drug
And each of our encounters will be so profound.

Khreshchatyk is one of Kyiv's main and most elegant streets. It runs through the historic side of the city.

See page 19 for information about the source of this poem, which is written in rhyming verse in Ukrainian language.

Right: President Vladimir Putin attends a military parade in Moscow in 2021. Sergei Shoigu, who became Russia's Minister of Defence in 2012, stands on Putin's left. Shoigu oversaw the annexation of Crimea in 2014 and helped launch the invasion of Ukraine in 2022. Despite his parade uniform and gleaming medals, Shoigu has never served in Russia's military and is said to know little about soldiering. Photograph from the official Kremlin website (www.en.kremlin.ru), 2021 (public domain).

On 17 March 2023, President Vladimir Putin and the Presidential Commissioner for Children's Rights, Maria Lvova-Belova, were the first Russians to be sought by the International Criminal Court in The Hague. Arrest warrants were issued for them in connection with the deportation of thousands of Ukrainian children from occupied territories to the Russian Federation. This is classed as a crime against humanity. Putin is also the first head of a permanent member of the UN's Security Council to be indicted by the Court since it was founded in 2002.

PUTIN'S PARADE
& OTHER WAR DEBRIS

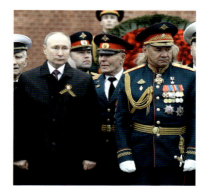

САМЕ В ТОЙ ДЕНЬ
Дарина Бельмега

Саме в той день ми нап'ємо́сь від щастя,
Забудемо негоди й негаразди,
Зачепим синьо-жовтий на зап'ястя
І станемо вже українцями назавжди.

Саме тоді у нас все точно вдасться,
Ми підемо гуляти на Хрещатик.
Нам тихий день тоді гучнішим здасться,
Не піде вже на нас рускій солдатик.

І лиш тоді почнемо цінувати дотик,
Слова любові і слова прощання.
А наша мова буде як наркотик,
І наша зустріч буде як остання.

President Vladimir Putin was so confident that his "special military operation" would be over within days—imagining Kyiv conquered soon after 24 February—that some invading Russian soldiers even packed their parade uniforms.

As the world now knows, however, Kyiv was not overrun and Russia was soon forced to abandon its attempt to capture Ukraine's sprawling capital city. Thanks to the bravery and ingenuity of the Ukrainian people, the remarkable leadership of President Volodymyr Zelenskyy, and a steady supply of NATO weapons, as this book goes to press Ukraine is still hanging on and fighting back. Ukraine's coat of arms appears in the top left of the photograph of President Zelenskyy. It is a golden trident (known as the *tryzub* in Ukrainian language) on a blue background. Although the trident is a medieval symbol, it only started to be widely used after 1914. In the present era, this coat of arms was officially adopted on 19 February 1992.

It is unclear what the trident originally symbolised. Some say it depicts a diving falcon, while others believe it signifies the three raised fingers of the Holy Trinity salute. One thing is sure, however: Ukrainians of all generations, and from all walks of life, adore their mysterious trident coat of arms.

"The occupier believed that in a few days he would be on parade in our capital's downtown. Today, you can see this 'parade' on Khreshchatyk. The proof that enemy equipment can appear in the centre of Kyiv only in such form. Burnt, wrecked and destroyed."

President Zelenskyy

Above: from a speech broadcast on 24 August 2022: the 31st Independence Day of Ukraine. From the official website of the President of Ukraine (www.president.gov.ua/en).

Opposite, right: President Volodymyr Zelenskyy during an interview for the BBC, 2022.
 Left, top to bottom: Ukraine's trident coat of arms; this version was drawn by Alex Khristov in 2017. Engraving of falcons, by the American artist John James Audubon (1798–1851). Trident graffiti; photograph by Oleg Bozhko, Kyiv, 2017.

Apart from Oleg Bozhko's photo, all images on this spread are public domain.

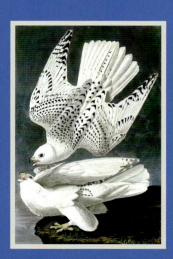
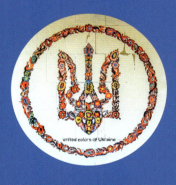
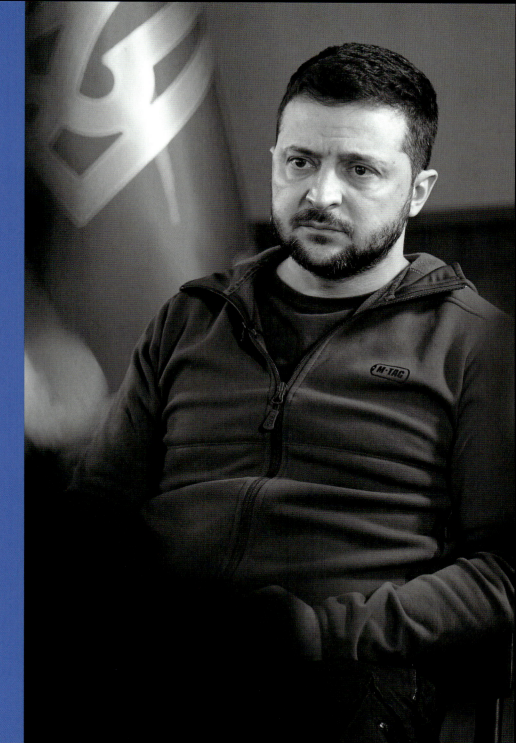

As part of Ukraine's 31st Independence Day celebrations on 24 August 2022, Kyiv mounted one of the most surreal exhibitions ever seen during an ongoing war. Many people ironically called it "Putin's Parade".

For a couple of days before the 24th, heavy cranes lifted dozens of burnt-out Russian tanks and armoured vehicles into place down Khreshchatyk, a main street in Old Kyiv that crosses Independence Square.

The Square was the site of the 2013–14 Euromaidan Revolution that ended post-Soviet Russian influence in Ukraine—making the parade more poignant.

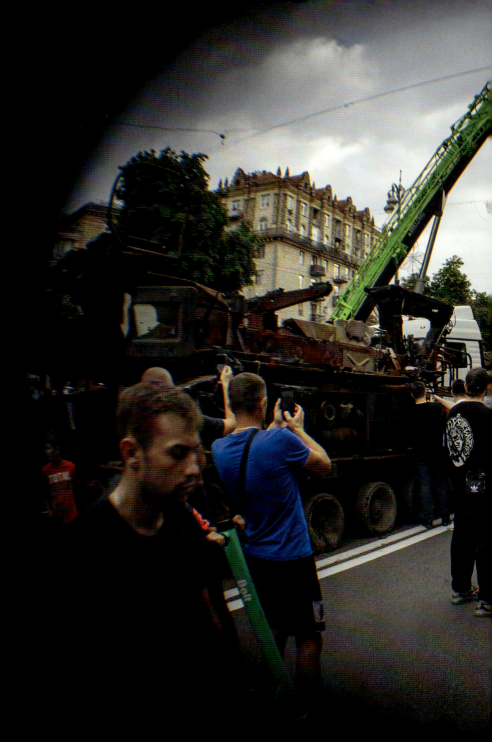

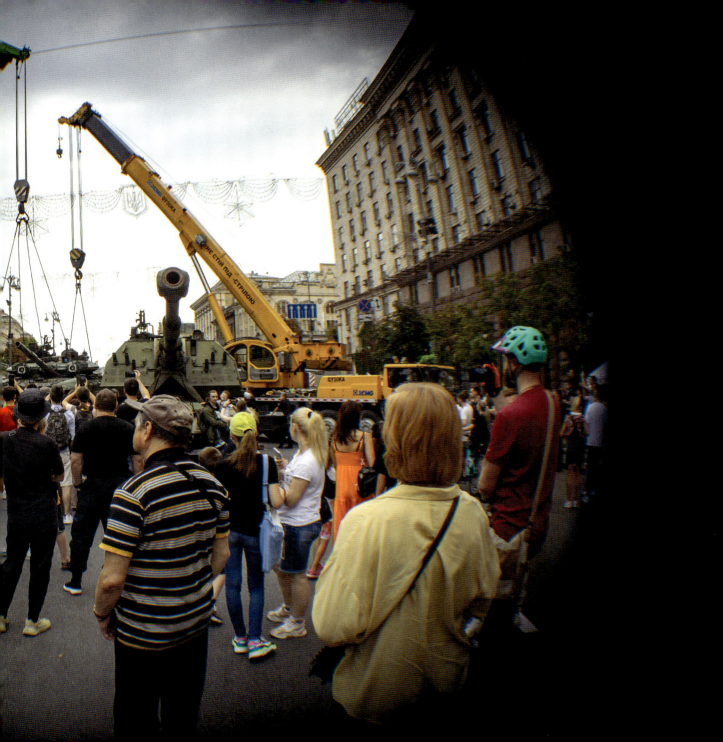

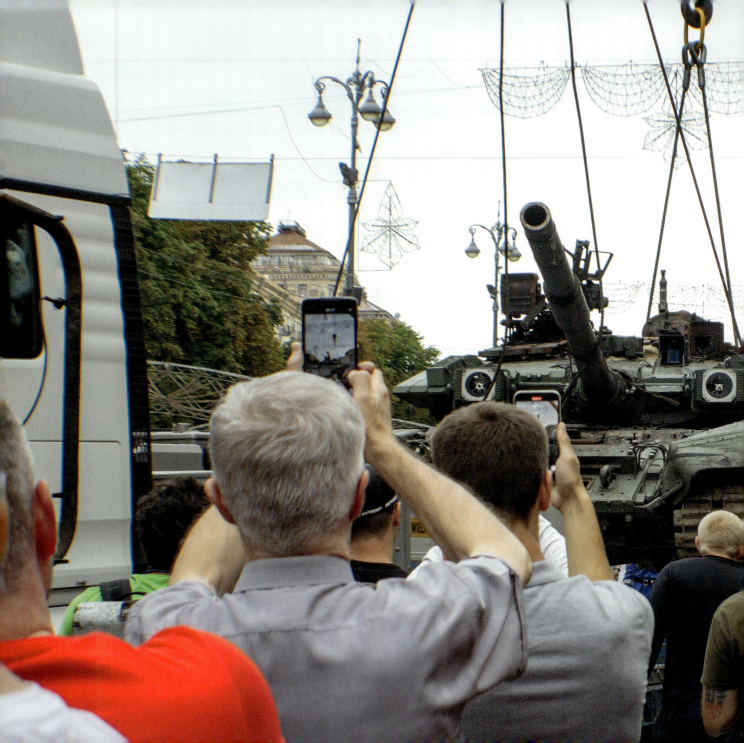

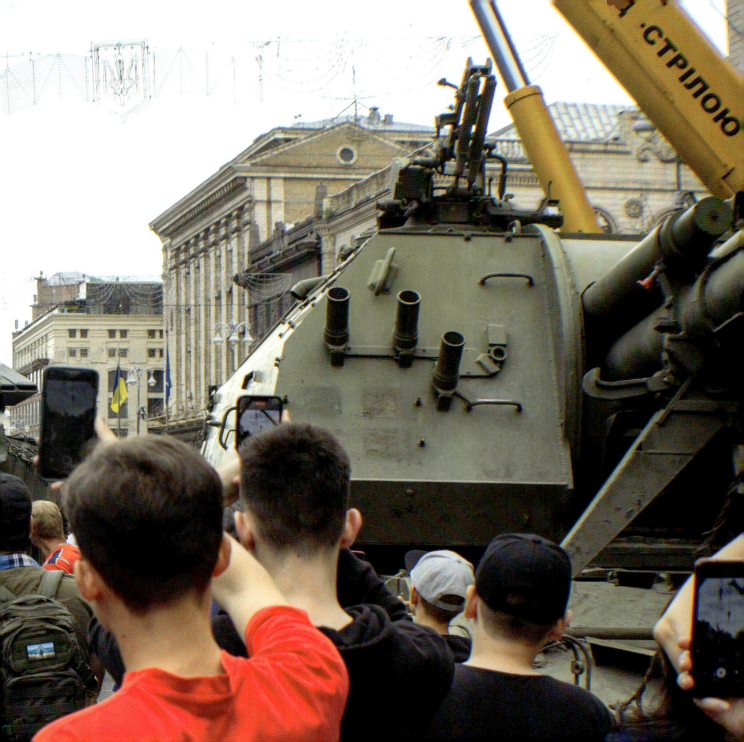

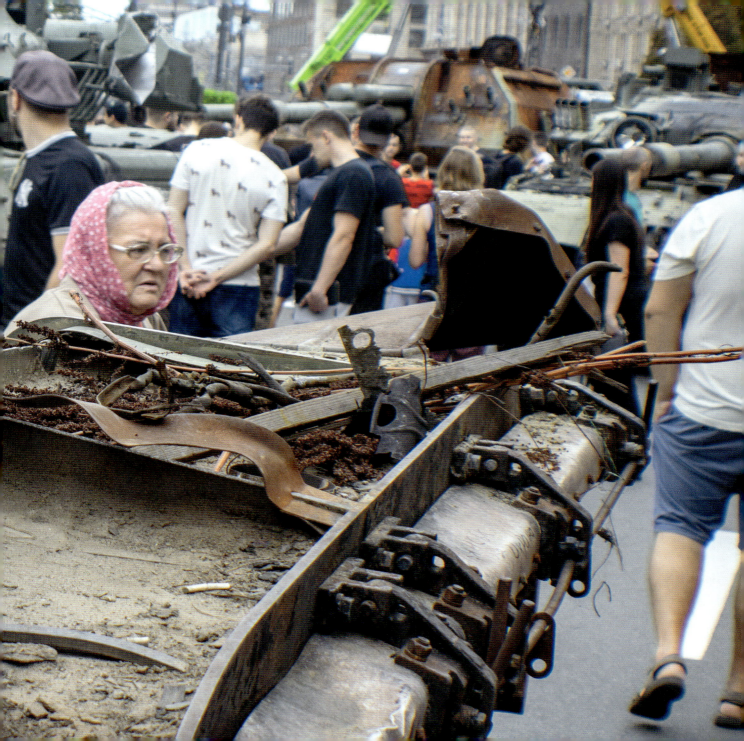

Coincidentally, I imagine, Independence Day on 24 August also marked the sixth-month anniversary of Russia's invasion.

Four days earlier, on 20 August, Darya Dugina—the daughter of a Russian far-right political demagogue—was assassinated in Moscow. The Kremlin blamed Ukraine, and so Kyiv was braced for air attacks.

The heightened risk didn't stop people going out to enjoy the parade on Khreshchatyk, however: the perfect place for a glamorous photo-shoot. A saying was even coined: *"Putin wanted a parade on Khreshchatyk. And he got one!"*

Putin's Parade was removed a few days after Independence Day so that traffic could once again flow along Khreshchatyk Street.

The Khreshchatyk exhibition, however, was a more ambitious version of a smaller, semi-permanent display of destroyed Russian armaments and military vehicles, seen here. This one also included two smashed up Ukrainian civilian cars.

The display was located in Mykhailivska Square, in front of St Michael's Golden-domed Monastery.

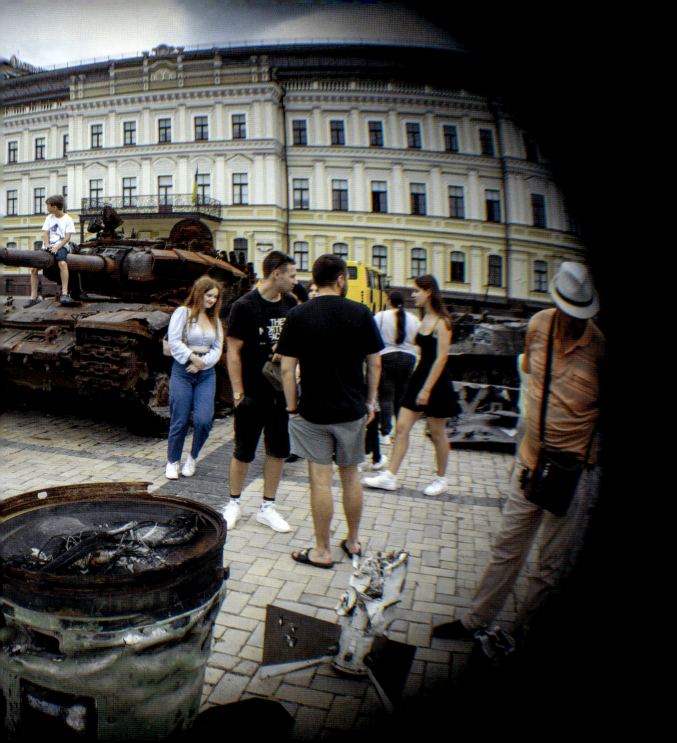

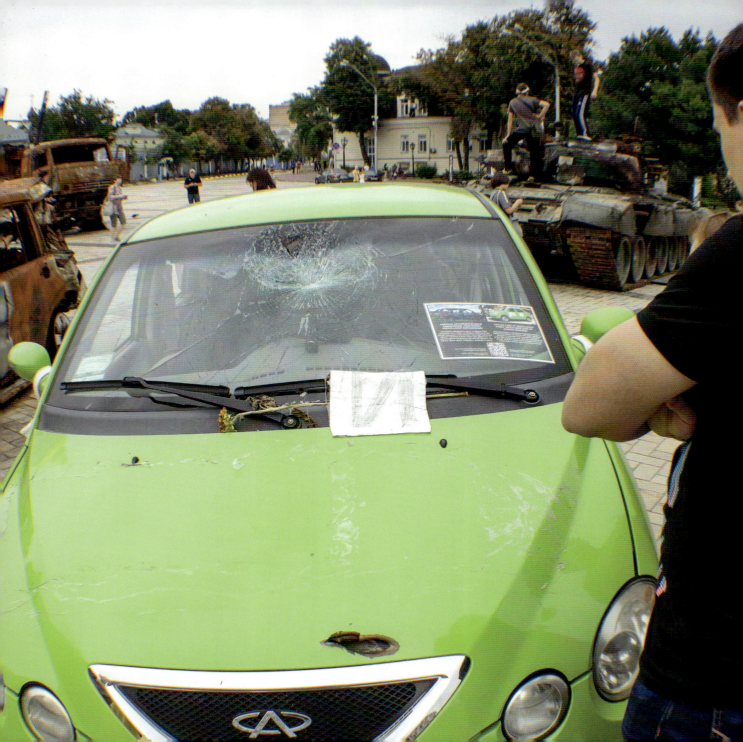

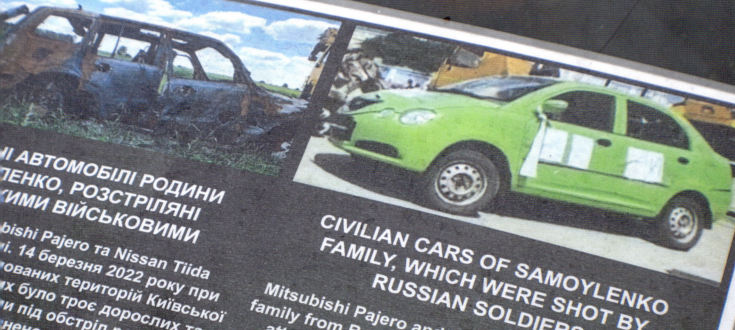

CIVILIAN CARS OF SAMOYLENKO FAMILY, WHICH WERE SHOT BY RUSSIAN SOLDIERS

Mitsubishi Pajero and Nissan Tiida belonged to a family from Bucha. On March 14th, 2022, during an attempt to evacuate from occupied territories of the Kyiv region, the cars were shot at by Russian troops. Out of 3 adults and 6 children in the cars a man and a woman were severely wounded.

Showpiece of the National Museum of the Military History of Ukraine
Kyiv, Hrushevskoho str., 30/1
mil_muz@ukr.net

Right: non-Ukrainians who wanted to join the country's Foreign Legion had to be under 50, have weapons experience, and be able to speak English. They were also required to bring their own uniform, helmet and flak-jacket.

I met an American volunteer soldier in Kyiv—just back from the frontline with a foot injury—who told me he had spent around 10,000 US dollars of his own money kitting himself out and flying to Poland to enter Ukraine.

He also told me that even after several tours in Afghanistan and Iraq, nothing had prepared him for the terror of trench warfare in eastern Ukraine: being under mortar fire for five days and nights was sheer hell.

Yet another exhibition of war-in-progress was taking place in Kyiv while I was there: this time at the vast National Museum of the History of Ukraine in the second world war.

Titled *Ukraine Crucifixion,* the exhibition's most striking work was *Occupier's Boot:* a Lenin's Star-shaped installation by Anton Logov, created out of invading Russian soldiers' footwear.

Below ground, in the museum's basement, there was a recreation of a claustrophobic bomb shelter—the type of cold, scary place millions of Ukrainians now spend their lives in, hoping to escape Russian missiles. (This installation was far too dark to photograph.)

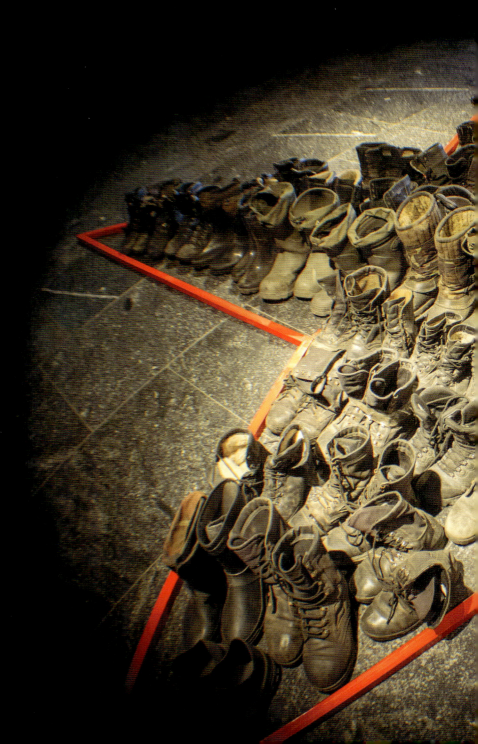

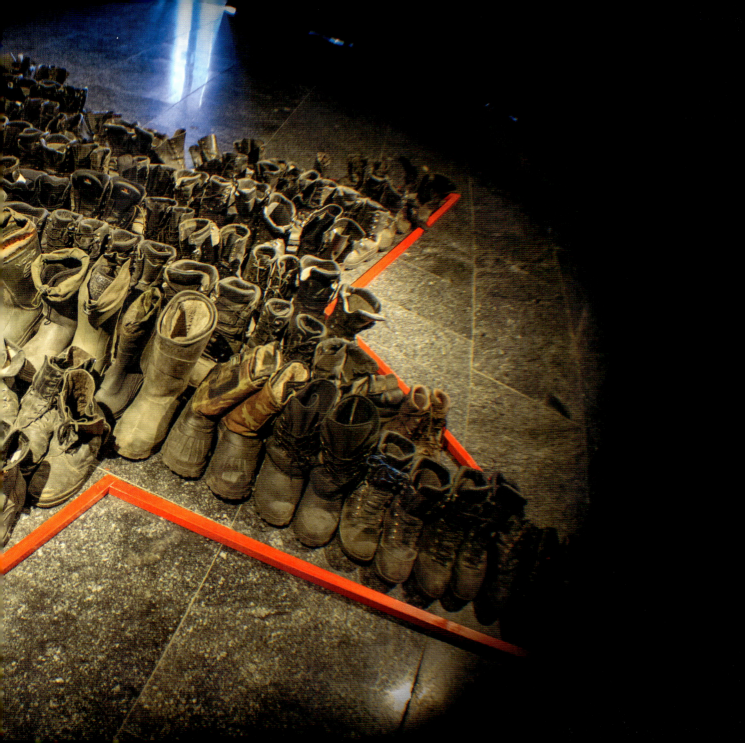

Unlike in Russia, fallen Ukrainian soldiers are publicly honoured, not cremated on the battlefield and under-reported by the state. Neither are there any mercenaries fighting for Ukraine.

When I visited Kyiv in the summer of 2022, the Memory Wall of Defenders of Ukraine ran all the way along St Michael's Golden-domed Monastery, on Triochsviatytelska Street.

Visiting foreign dignitaries—such as US President Joe Biden (bottom inset image), who visited President Zelenskyy on 20 February 2023—are brought here to pay their respects.

Right: seeing the faces and lifespans of so many Ukrainian defenders—killed from 2014 onwards—was very moving. This panel detail spans part of 2019–20, when fighting wasn't as intense as in 2014, or as lethal as it is as this book goes to press.

Left: President Biden lays a wreath at the memorial. Photograph from the official website of the President of Ukraine (www.president.gov.ua/en), 2023 (public domain).

I HAD A DREAM
Oksana Kindratyuk

I had a dream: guns roared
The enemy was approaching my land.
A soldier rushed into battle, a mother wailed
And the whistling of shells pierced the sky.

Everything exploded: houses and people
Innocent children fell from their wounds.
And everyone cried, "God, what will happen?
From which hell did this tyrant come?"

In a dream I heard the earth moaning.
She said, "Don't back down my Soldier!
Though enemies are many
Stand up and defend your land!"

And so the soldier walked on: without fear and fatigue
With love in his heart and firmness in his eyes.
Enemy battalions and columns
All around turned to dust.

The dream ended, I opened my eyes
Behind the windows: sunshine and song birds.
There is no more war—a beautiful day
Smiles at me so softly …

See page 19 for information about the source of this poem, which is written in rhyming verse in Ukrainian language.

Right: a protected statue, on Sophia Square, of Bohdan Khmelnytsky. He was a 17th-century Ukrainian Cossack military commander. Photograph by the author, Kyiv, 2022.

SANDBAGGING HISTORY

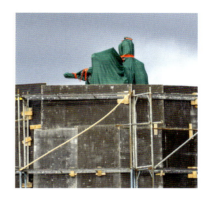

МЕНІ НАСНИВСЯ СОН
Оксана Кіндратюк

Мені наснився сон: гули гармати.
На мою землю ворог наступав.
І рвався в бій солдат, і голосила мати.
І свист снарядів небо розпинав.

Все вибухало: і будинки, й люди,
Безвинні діти падали від ран.
І кожен плакав: Боже, що то буде?!
З якого пекла виліз цей тиран?!

Вві сні я чула, як Земля стогнала,
Та все просила: лиш не відступай,
Солдате мій! Хоч ворогів чимало -
Ти вистоїш, свій оборониш Край!

І йшов солдат: без страху і утоми,
З любов'ю в серці й твердістю в очах.
Ворожі батальйони і колони
Довкола оберталися у прах!

Скінчився сон, я відкриваю очі:
У вікнах сонце і пташиний спів.
Нема війни. Погожий день, урочий
Так ніжно посміхається мені...

Across Kyiv and other parts of Ukraine, statues were covered in sandbags. They were piled high to protect cultural and political heroes from missiles, shrapnel and bullets.

One of these protected personages was Alighieri Dante (1265–1321)—the author of *Divine Comedy,* with its *Nine Circles of Hell.* He stands in a park in Kyiv.

The commissioning of Dante's statue in 2021 was an indication, some have said, that Ukraine was looking westward: away from Russian cultural influences, with European rather than Eurasian ambitions. Tragically, Russia had other plans for Ukraine.

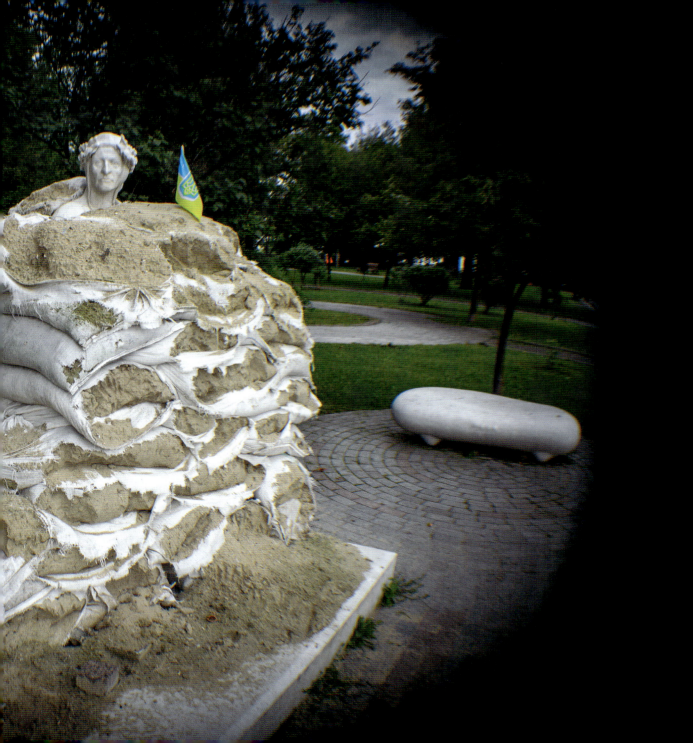

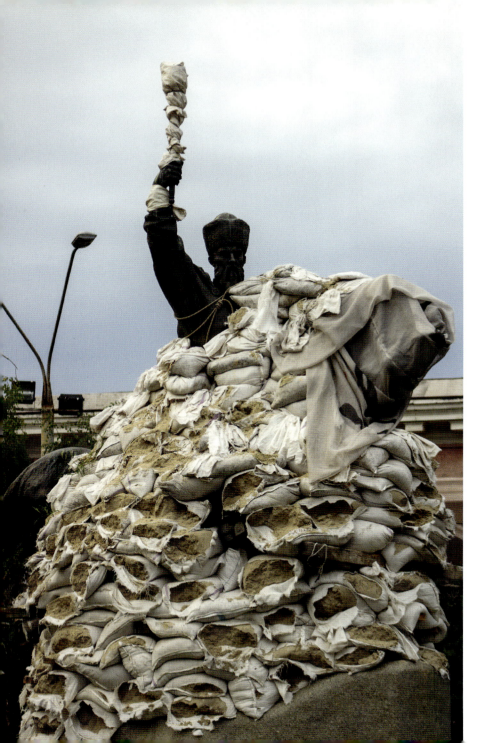

Left: Petro Konashevych-Sahaidachny was a 17th-century Ukrainian Cossack political and civic leader. His horse and his iconic mace were sandbagged on Kyiv's Kontraktova Square.

Opposite, top: packing tape stops windows being broken during attacks.

Bottom left: Mykola Hohol (1809–52)—or Nikolai Gogol as his name is spelled in Russian—is the author of *Dead Souls* (1842).

Bottom right: Mykhailo Bulgakov (1891–1940) in Kyiv, his hometown. The author of *The Master and Margarita* (1967) is now reviled by some due to his virulent hostility to Ukrainian statehood.

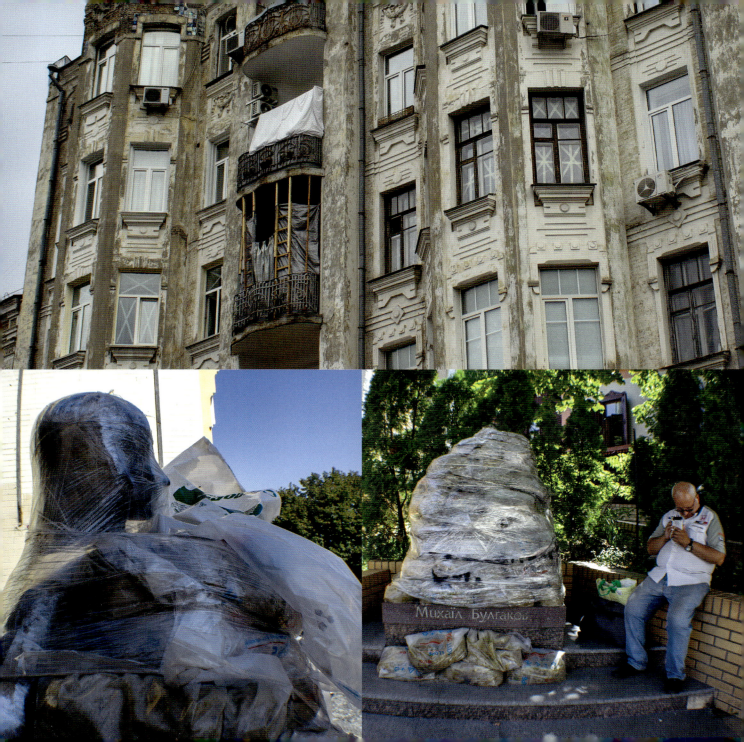

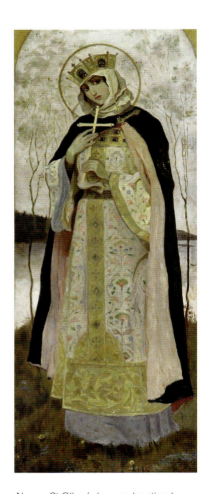

Above: St Olha (who was baptised Elena) by the Russian artist Mikhail Nesterov (1862–1942) (public domain).

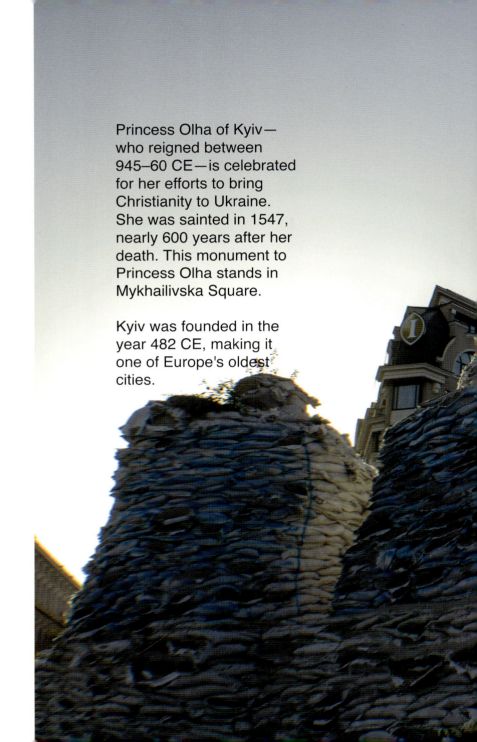

Princess Olha of Kyiv—who reigned between 945–60 CE—is celebrated for her efforts to bring Christianity to Ukraine. She was sainted in 1547, nearly 600 years after her death. This monument to Princess Olha stands in Mykhailivska Square.

Kyiv was founded in the year 482 CE, making it one of Europe's oldest cities.

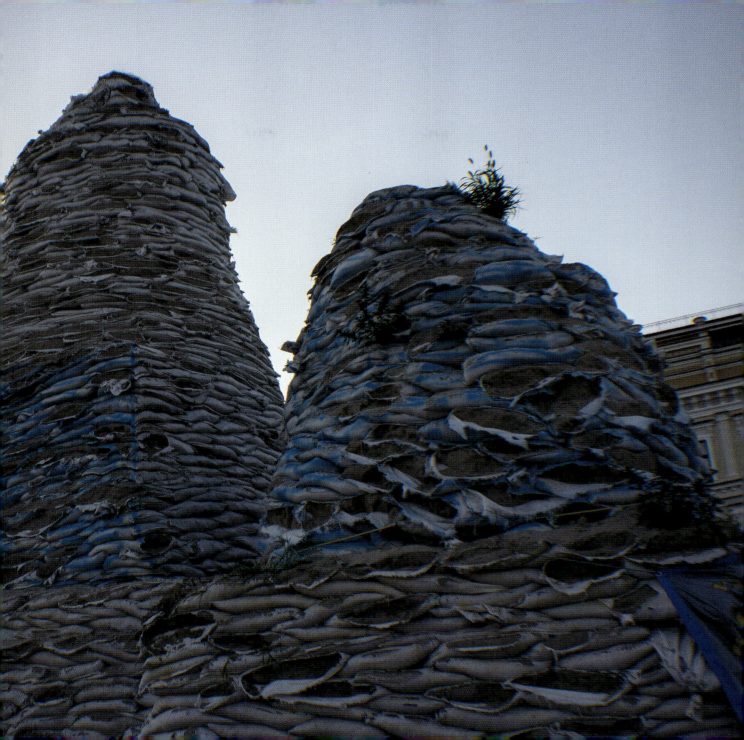

FOR YOU
Viktoriya

Hold my hand, please
Look at me—don't look away
And promise me we'll meet next spring or summer
Without the sound of explosions and these terrible nights.

Hold my hand, tightly
And promise me everything will be fine.
No more buzzing of planes
New days will dawn in silence.

Hold me, breathing in hope
Breathe life into my every heartbeat.
And protect me and glorious Ukraine!
Fate now depends on hands of steel.

Hold on, I'm begging you—I trust
And will pray to all the Saints for you.
All I ask for is that you hold on
To return safe and sound.

See page 19 for information about the source of this poem. Lines two and four in each verse rhyme in Ukrainian language.

Right: steel anti-tank obstacles—locally known as "hedgehogs"—on Independence Square. Photograph by Ihor Kucher, Kyiv, 2022.

BEAUTIFUL
HEDGEHOGS

ТОБІ
Вікторія

Тримай мене за руку, прошу,
Дивися прямо, не відводь очей,
І обіцяй зустріти весну й літо,
Без звуків вибухів, і цих страшних ночей.

Тримай мене за руку дуже міцно
І обіцяй, що буде добре все.
Нечутно буде літаків гудіння,
І новий ранок тишу принесе.

Тримай мене вдихаючи надію,
Вдихай життя у кожен серця стук.
І бережи мене і славну Україну!
Залежить доля від сталевих рук.

Тримай, молю тебе, благаю, сподіваюсь,
І всім Святим за тебе помолюсь,
Єдине, що прошу, тримай й тримайся,
Живим й здоровим щоб ти повернувсь.

I met Varvara Logvyn on the corner of Independence Square. She was painting an anti-tank obstacle, locally known as a "hedgehog". These improvised barricades are designed to impede Russian armoured vehicles. They were sprinkled across roads and around junctions throughout Kyiv when I visited in the summer of 2022.

Varvara isn't a professional artist. But she likes to practice Ukrainian *Petrykivka* folk painting.

Petrykivka, a village in the Dnipropetrovsk region of Ukraine, is the birthplace of this fine brush-stroke art form.

Varvara told me that she intended to paint four anti-tank hedgehogs in this style. She said they would serve as a permanent tribute to Ukraine, as well as a thank you to Poland, the UK and the USA: three foreign countries that in her opinion had helped Ukraine the most in these difficult times.

The barricade shown in this photograph (for reasons explained on page 105) features the flowering plant *viburnum*.

"I paint these ugly things because I want to make our city and country beautiful again. I also hope to show the world that Ukrainian culture is lovely, strong and historic … That we have our traditions and we are proud of them. This is more important now, during the war, than at any time I can remember. Each of these anti-tank hedgehogs takes me about three weeks to paint. Even though it's hot today, it's a pleasure for me to be here … on the street, with the people. The work is a kind of meditation for me. Petrykivka painting is something like making a mandala."

Varvara Logvyn

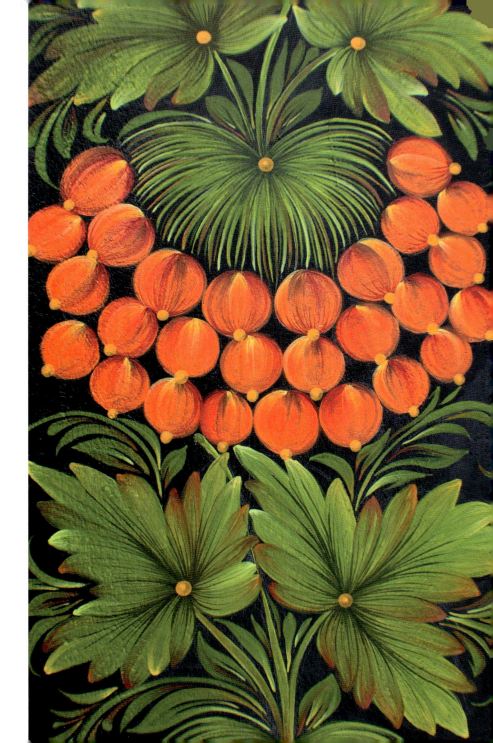

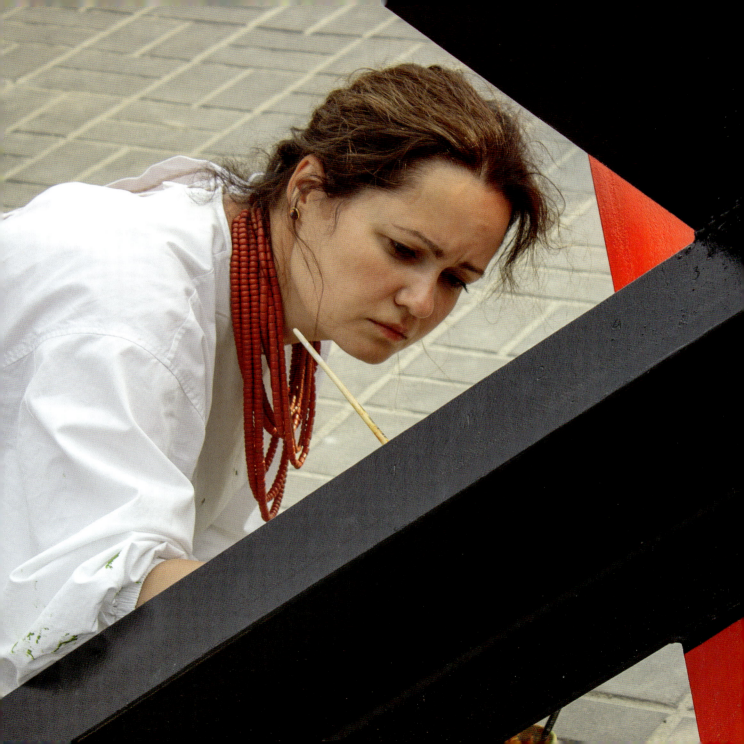

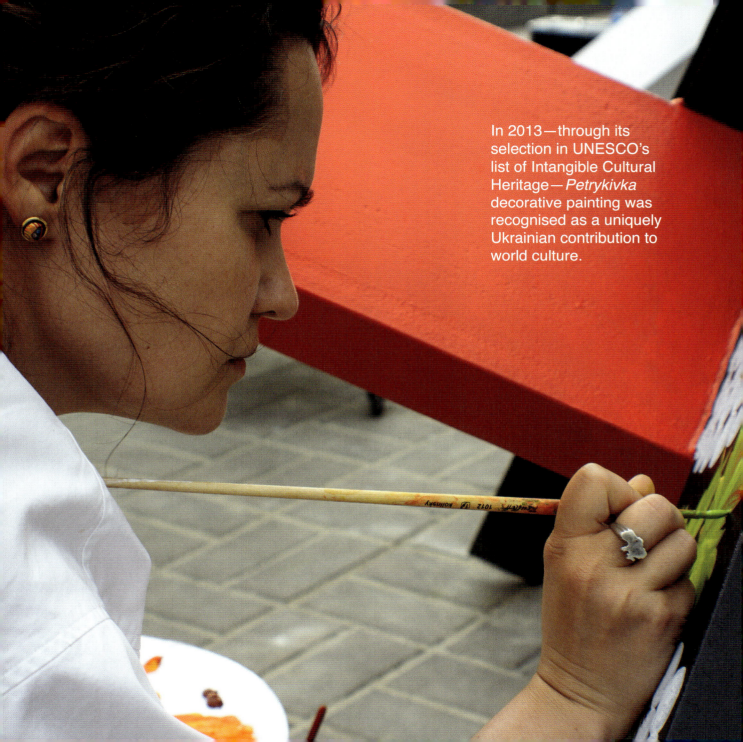

In 2013—through its selection in UNESCO's list of Intangible Cultural Heritage—*Petrykivka* decorative painting was recognised as a uniquely Ukrainian contribution to world culture.

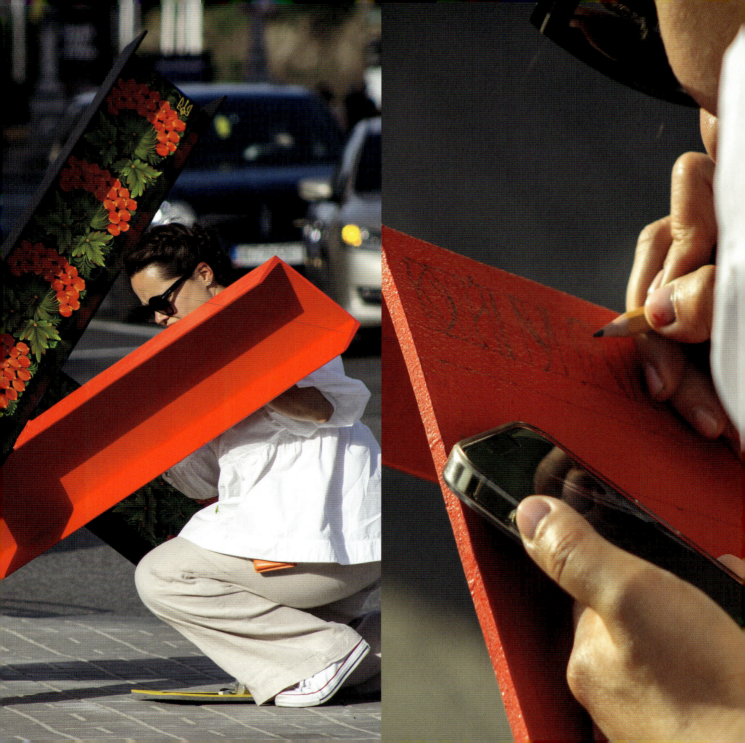

In elaborate calligraphy, this hedgehog carries the lyrics of *Chervona Kalyna* (*Red Viburnum*), a traditional song made famous during the war by Andrii Khlyvnyuk.
In the first days of the invasion he sang it as a new soldier in Kyiv in a video that went viral (right screengrab).

Soon after, the British band Pink Floyd reformed to record a rock version of this song for charity, with Khlyvnyuk's original vocals sampled. Pink Floyd's version is titled *Hey, Hey, Rise Up*!

Both recordings can easily be found on YouTube.

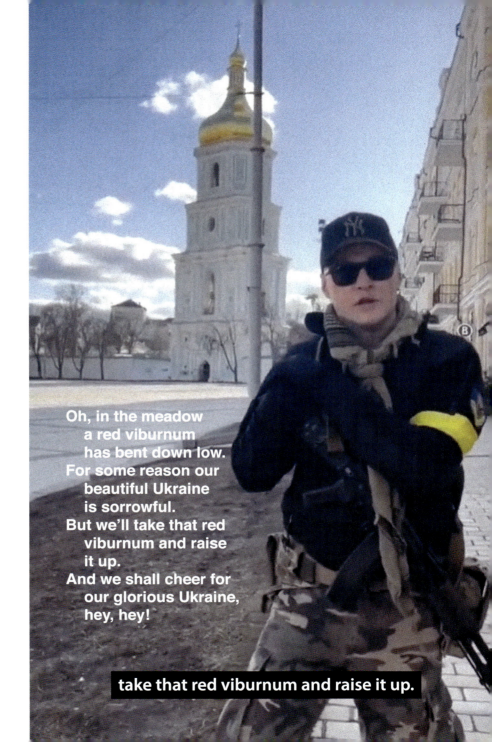

Oh, in the meadow a red viburnum has bent down low.
For some reason our beautiful Ukraine is sorrowful.
But we'll take that red viburnum and raise it up.
And we shall cheer for our glorious Ukraine, hey, hey!

take that red viburnum and raise it up.

I LOVED YOU EVEN BEFORE THE WAR
Koshychok (Olena Koshyk)

I loved you even before the war
And although there are now alarms
I need to say, "Take care of yourself
Because our paths will cross again."

So when you see me, please hug me
I shall recite all my monologues
Straight into your heart, accept me, please—
I need your support more than ever …

This poem was published under the pseudonym Koshychok, meaning "little basket". But the poet asked me to add her real name, too.
　See page 19 for information about the source of this poem, which is written in rhyming verse in Ukrainian language.

Right: a Ukrainian heart pierced by arrows in the colours of the Russian flag. An anonymous group of contemporary artists called Pomme de Boue (who do not like to be referred to as a "group" or even as "artists") started leaving miniature mosaics around Kyiv in 2014, after Russia annexed Crimea and started the war in the Donbas. Pomme de Boue prefer to call their works "visual injections" in the public space. There are now more than 200 of their mosaics dotted around the city. Photograph by Oleg Bozhko, Kyiv, 2017.

UNITED COLORS OF UKRAINE

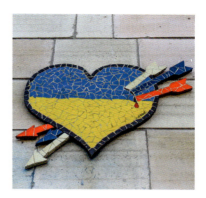

Я КОХАЛА ТЕБЕ Й ДО ВІЙНИ
Кошичок

я кохала тебе й до війни,
хоч і зараз лунають тривоги
я скажу: "ти себе бережи,
бо зійдуться ще наші дороги"

як побачиш, прошу - обійми
розповім всі свої монологи,
в своє серце, будь ласка, прийми...
як ніколи потребую підмоги...

The Ukrainian people have a deep affection for their cheerful national colours.

When I visited Kyiv in the summer of 2022, yellow-and-blue was everywhere. I was even told by a graffiti artist that it was often difficult to find these colours in paint shops because people were buying so much of them.

I came across this pretty residents' garden behind a run-down block of flats while strolling around Kyiv. It was a very hot day; I sat on the bench and drank some water. At that moment an air attack siren sounded somewhere in the city.

THE BRASS BAND
Vasyl Golovetskyi

Today I sent my ex-pupil, Vanya
On his final journey—
Throwing a few handfuls of dull earth
Lightly over him.

Vanya did not do so well at school
Although he did work hard!
But what he loved most of all, funny thing
Was when the brass band played.

When February's storm
Hit Ukraine
He left his mother at home
And went to fight.

He always said, "We won't die!"
But a bullet found him—
A sniper got to him in Irpin
And they brought him home in a coffin.

At the cemetery that day
The whole village came together like family
And held his young mother in their arms
His mother—pale, so very pale.

For some reason the sun turned crimson
And the regimental band
Tore my soul to shreds
When it began to play and play.

See page 19 for information about the source of this poem, which is written in rhyming verse in Ukrainian language.

Right: embracing dolls wedged into a door handle. Photograph by the author, Kyiv, 2022.

MADE IN UKRAINE

ВАСИЛЬ ГОЛОВЕЦЬКИЙ
Духовий оркестр

Я сьогодні у путь останню
Провів учня колишнього, Ваню,
І три жменьки сирої землі
Йому кинув легенько вслід.

Ваня в школі учивсь не дуже,
От до праці – був небайдужим!
А найбільше любив, смішний,
Як оркестр грав духовий!

Коли в лютому потрясіння
Громихнуло на Україну,
Маму вдома лишив одну
І бійцем пішов на війну.

Мав він приказку: «Не помремо!»,
Але куля знайшлась окрема –
Снайпер вистежив в Ірпені,
І привезли його в труні.

З ним на цвинтарі тої днини
Вся зібралась сільська родина,
І тримала ще молоду
Його маму, бліду-бліду.

Сонце стало чомусь багровим,
Та ще строгий оркестр військовий
Усю душу пороздирав –
Як заведений, грав і грав…

Walking through the recently devastated city of Bucha, I met these two girls selling their handmade jewellery. And I bought some for my kids.

Many people in Ukraine sell home-made products on the street. When I visited Ukraine, everybody doing this seemed to be giving a part of what they earned in this way to the army.

The same was true of these girls. They told me their names, which I wrote down. But I'm sorry to say I mislaid the piece of paper, and my memory fails me.

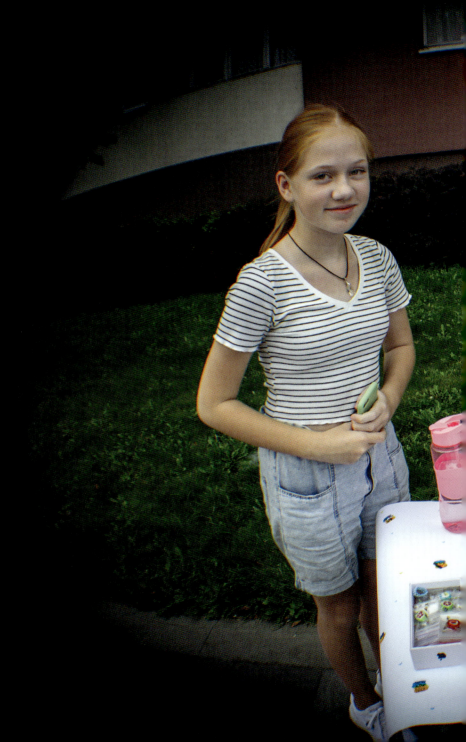

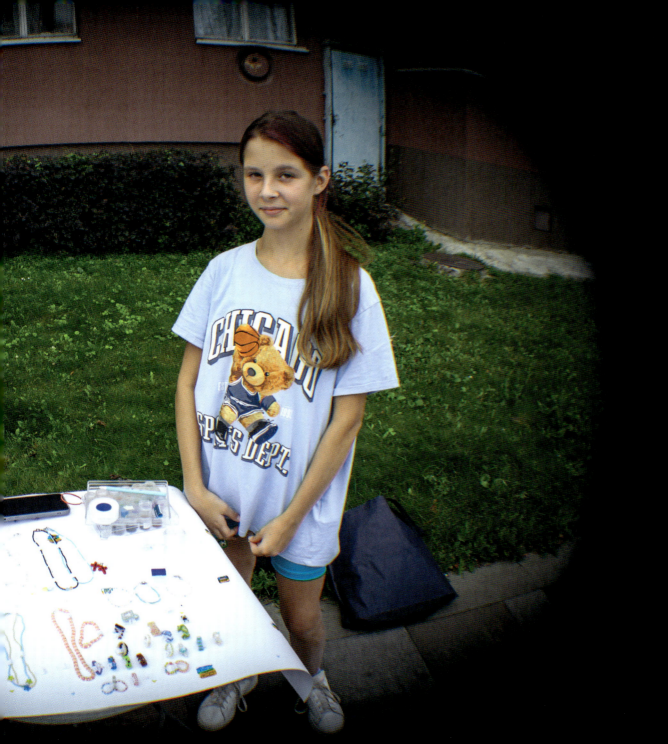

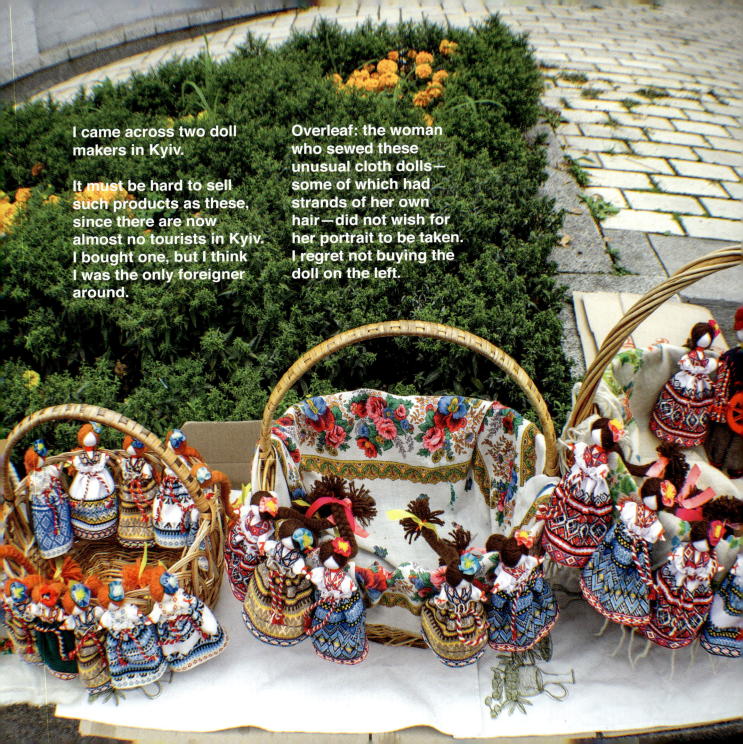

I came across two doll makers in Kyiv.

It must be hard to sell such products as these, since there are now almost no tourists in Kyiv. I bought one, but I think I was the only foreigner around.

Overleaf: the woman who sewed these unusual cloth dolls—some of which had strands of her own hair—did not wish for her portrait to be taken. I regret not buying the doll on the left.

SPRING SYMPHONY
Call-sign "Poet"

Peonies are blooming in the gardens
Acacias are blossoming.
The last spring symphony
Of nature. Perfection. Grace.

It is still night, and under clear stars
Summer tunes will soon commence.
We would not know pain or sorrow
If these thieves had not come to us.

They took away the spring, mocked it
Maimed it with dirty paws.
But storks returned everywhere
Wheeling over homes.

And under surviving roofs
Swallows filled the nests.
Covered by old walnut trees
Cathedral domes sparkle.

United by a common dream
We can break the back of the horde.
Let's enter the summer with faith—
A little more—and we shall win!

This poem was written by a Ukrainian soldier. His army call-sign is Poet. Before being translated into English, *Spring Symphony* was edited by Poet's friend, Nataliia Samruk. Nataliia also has a poem on page 276. Poet asked me to change the title of his poem, from *Peonies Are Blooming In The Gardens*.
See page 19 for information about the source of this poem, which is written in rhyming verse in Ukrainian language.

Right: a wreath of wild flowers at the site of a former mass grave. Photograph by the author, Bucha, 2022.

FLORAL TRIBUTES

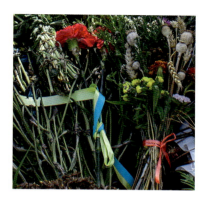

В САДКАХ ВІДЦВІТАЮТЬ ПІВОНІЇ...
Позивний "Поет"

В садках відцвітають півонії,
Усипані квітом акації.
Остання весняна симфонія
Природи. Довершеність. Грація.

Ще ніч, і під ясними зорями
Почнуться вже літні мелодії.
Не знали б ні болю, ні горя ми,
Коли б не прийшли до нас злодії.

Забрали весну, познущалися,
Брудними калічачи лапами.
Та всюди лелеки верталися,
Кружляли над рідними хатами.

А під уцілілими стріхами
Гніздечка заповнили ластівки.
Прикриті старими горіхами,
Соборів виблискують маківки.

Об'єднані спільною мрією,
Зламати хребта ордам зможемо.
У літо увійдемо з вірою -
Ще трішки - і ми переможемо!

Heroic dogs, armed drones, and a defiant retort to a Russian warship. These three war themes were honoured around Kyiv in elaborate floral designs. My friend Ihor Kucher helped me find them, which was something of a challenge.

The working dog celebrated here is named Patron. He is a Jack Russell terrier that serves the State Emergency Services of Ukraine. So successful did Patron become at detecting unexploded bombs, that in May 2022 President Zelenskyy awarded him the Order of Courage Third Class.

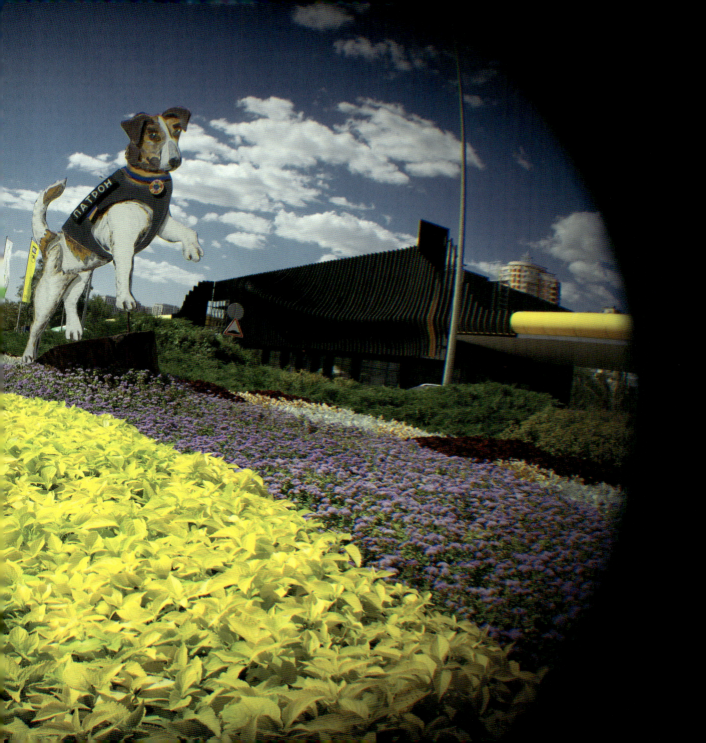

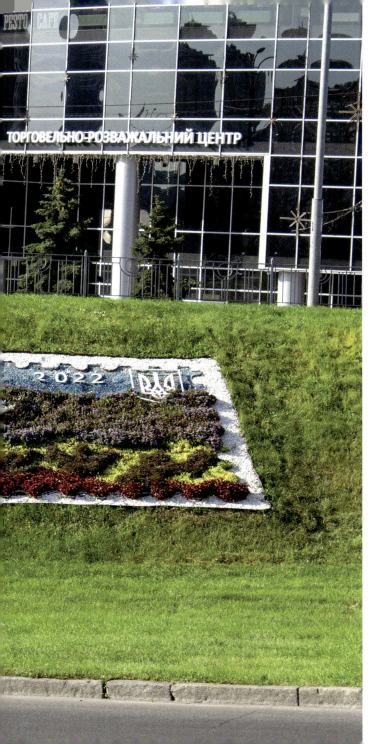

At the start of the invasion in February 2022, the captain of a Russian warship ordered a group of Ukrainian soldiers on the small but strategically important Snake Island in the Black Sea to lay down their arms. Border guard Roman Hrybov's retort, *"Russian warship, go fuck yourself!"* became a slogan that defined the heroic resistance to come. Ukrainian artist Boris Groh interpreted the event for an iconic postage stamp, which also went viral.

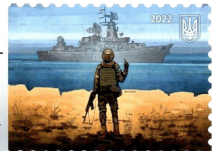

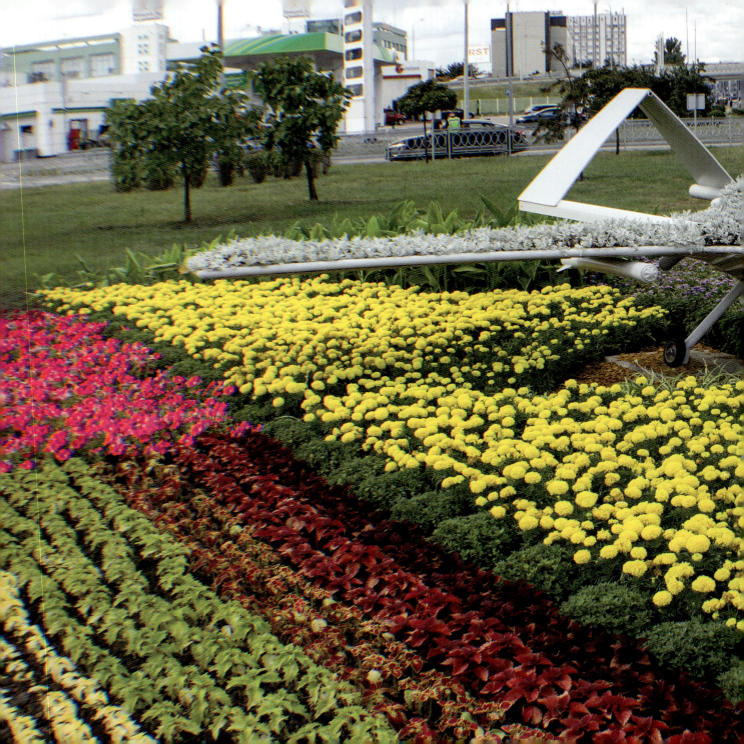

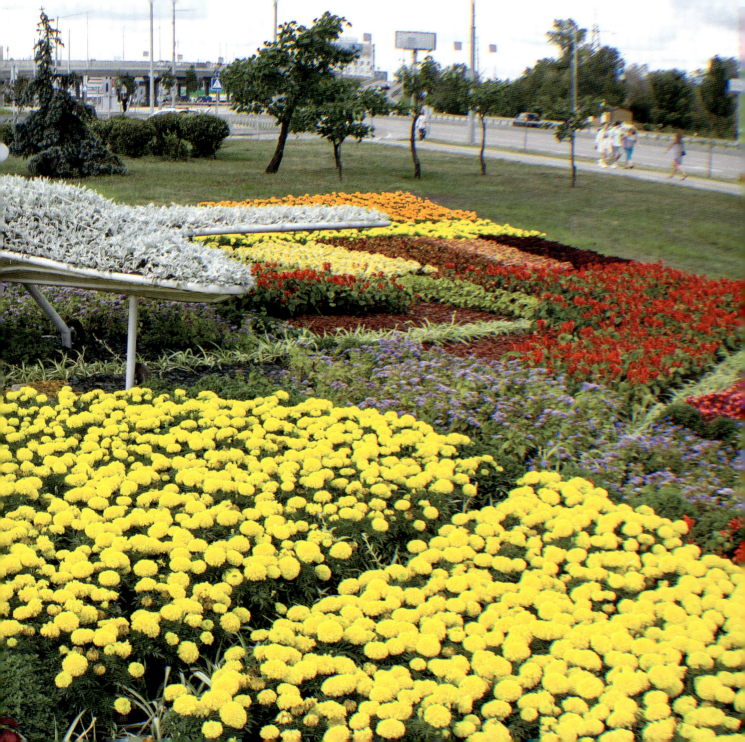

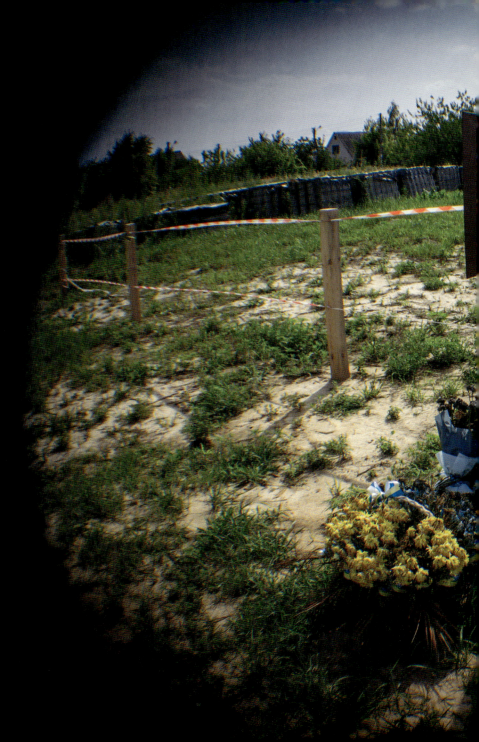

Previous spread: Turkish manufactured Bayrakter armed drones were an early battlefield game-changer for Ukraine; countless Russian vehicles were destroyed with them. And as this weapon's notoriety grew, people in Canada, Lithuania and Norway crowd-funded more Bayrakters to give to Ukraine. The word *bayrakter* means standard-bearer in Turkish language.

There are also floral tributes to people—like this one in Bucha at the Church of St Andrew the First-Called. Locals brought their dead here if and when the Russians let them. Over 450 citizens were murdered in Bucha by Russian forces.

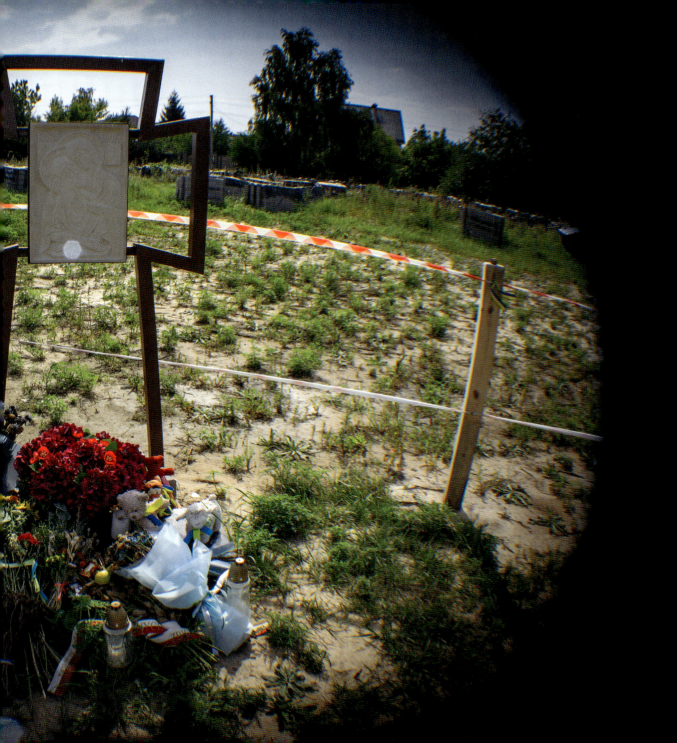

ON THAT BLACK MORNING …
Natalka Slobodyaniuk

On that black morning I was sound asleep
In my bed that is always so welcoming
On the peaceful side of town
Alone in my flat, quiet since the evening before.

But something worried and oppressed me
For instead of feeling happy
I saw birds with broken wings
Unable to reach the sky.

I ran to the abyss
I shouted, but it was silent.
A poor bird with a broken wing
Hit the window pane, despairing and helpless.

I woke up trembling all over
My soul still lost in this bad dream.
Stunned by such a bad premonition
I gazed at the February winter sky.

Dawn broke suspiciously grey
Leaden clouds hang in the gloom.
Uncertainly, I turn on the TV—
And time splits into before, and after.

See page 19 for information about the source of this poem. It is written in syllabic verse, with 11 syllables per line in Ukrainian language.

Right: one of the few caricature-type posters addressing the war I spotted in Kyiv during my many hours walking the streets in August 2022. Others in a similar style can be seen on page 316.

ANTI-WAR GRAPHICS

В ТОЙ ЧОРНИЙ РАНОК…
Слободянюк Наталка

В той чорний ранок спала я так міцно
в завжди привітному до мене ліжку,
в спокійно-тихому районі міста,
одна в квартирі, звечора принишклій.

Та щось таки тривожило й гнітило,
бо замість того, щоб життю радіти,
я бачила – птахам ламали крила,
у небо не могли вони злетіти.

Я бігла до самісінької прірви,
кричала я, та не було ні звуку.
Сердешний птах у розпачі й зневірі
пораненим крилом у шибку стукав

Прокинулась – і геть уся тремтіла,
душа блукала в тому, що наснилось.
В передчутті біди оторопіло
в лютневе небо із вікна дивилась.

Відходив ранок підозріло сизий,
свинцеві хмари мороком нависли.
Невпевнено вмикаю телевізор…
розколюється час на до… і після…

I feel very fortunate to have been introduced to the anti-war posters of Mykola Honcharov, an independent designer from Kyiv.

Born in 1972, Mykola graduated from the Ukrainian Academy of Arts. His work is now represented at the National Art Museum of Ukraine; the National Centre of Folk Culture–Ivan Honchar Museum; and the Museum of the Revolution of Dignity.

Mykola's graphics are minimalistic but deeply meaningful. They are provocative in the most complete sense of that word: politically and emotionally. His often terrifying images speak volumes to a Ukrainian audience, and they need very little or no interpretation for non-Ukrainians. All this, along with their technical mastery, in my opinion makes them extraordinary.

Another thing about Mykola Honcharov is that he is highly prodigious: he has created more than 3,000 posters on various issues in the last five years alone.

I am grateful to Mykola's friend Michael Karlovski who assisted me by locating and sending the images reproduced here when Mykola was unable to do so himself. Finally, in October 2022, I sent Mykola (again through Michael) four questions to answer:

Q. Why do you design?

"I draw … I design … in order to prolong or extend a certain state … To capture a feeling that cannot be conveyed through photography, but only in a drawing."

Q. What do you feel is the strength of your design?

"My strength is in my skill. If I had no skill, there would be no strength … no power. It would be like … Pff … Like a bubble in water. This skill is also necessary to ensure people react to the world around them when they see my work."

Right: Mykola Honcharov. Photograph by Michael Karlovski, Kyiv, 2019.

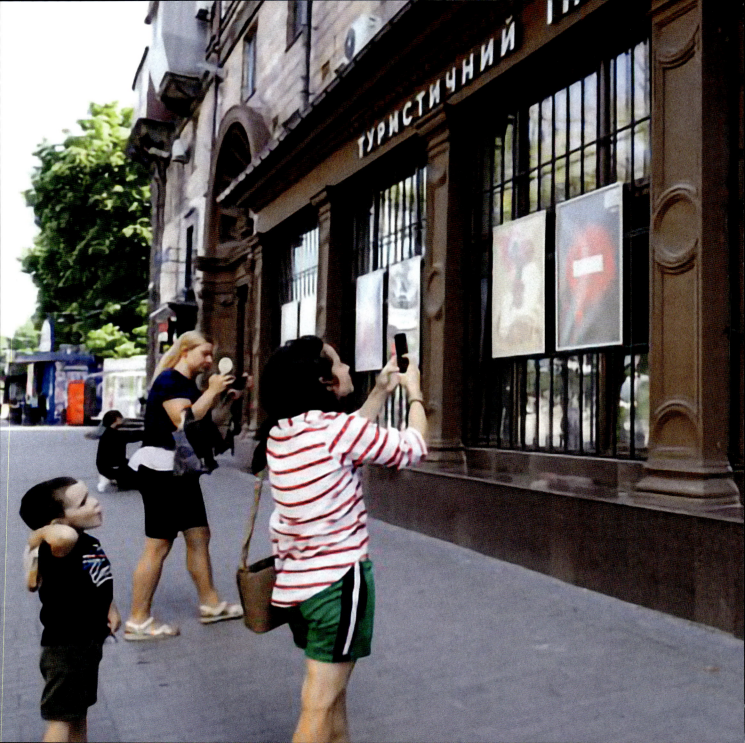

Q. What do you want to achieve with design?

"Firstly, I want others to feel the same things I do. I also want people to simply enjoy looking at my art. If we discuss the political component of my posters, then I think that politics begins from the place where the poster is displayed … where it's placed. It can either be posted on a bus that meets people at the airport … or at a bus stop next to a rubbish bin. Each situation will provoke a different reaction."

Q. What does design mean to you in the context of Ukraine and the ongoing war?

"My works are drawn by a Ukrainian, in Ukraine, and they are about Ukraine. They deal with what surrounds, oppresses and crushes us. My design is a reflection on the world around us Ukrainians. Finally, my art works do their job: they state issues concerning Ukraine, and they declare my position regarding those issues."

Mykola Honcharov

Left: a street exhibition of Mykola Honcharov's posters in Zaporizhzhia. Photograph from the Tourist Information Centre of Zaporizhzhia, July 2022.

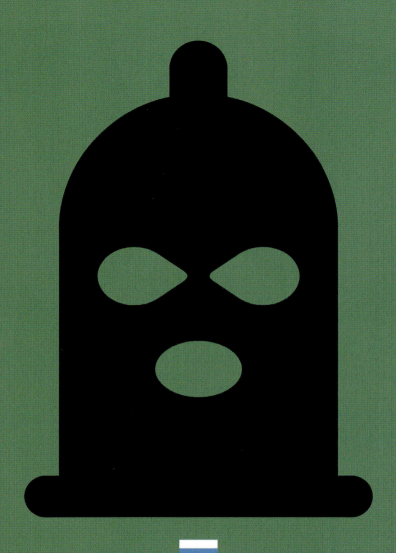

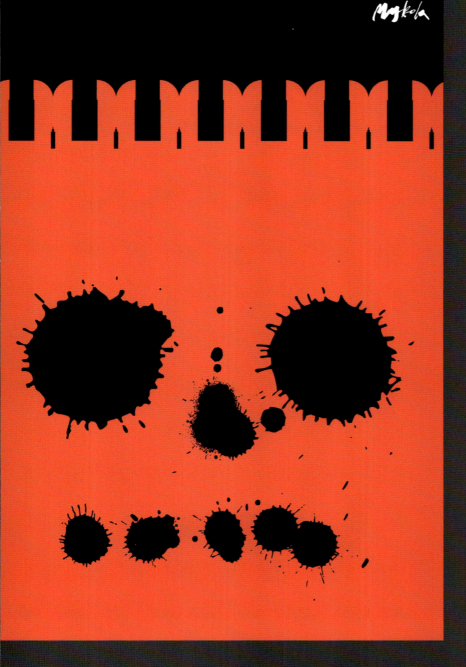

This page: the battlements and red brickwork of the Kremlin's famous Troika tower provide the inspiration for this terrifying mask.

Opposite: the concept of the Unknown Soldier is supposed to be a noble one. Here he is transformed into an assassin.

Russia's famous nesting dolls *(matryoshka)* reinterpreted in light of recent events in Ukraine — and (opposite) inside Russia, too, where there is almost no freedom of expression about the "special military operation".

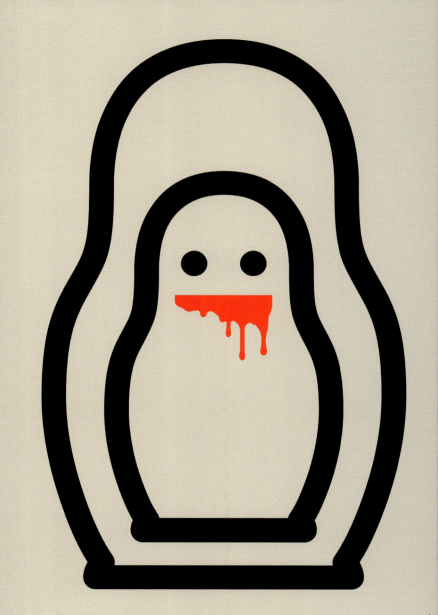

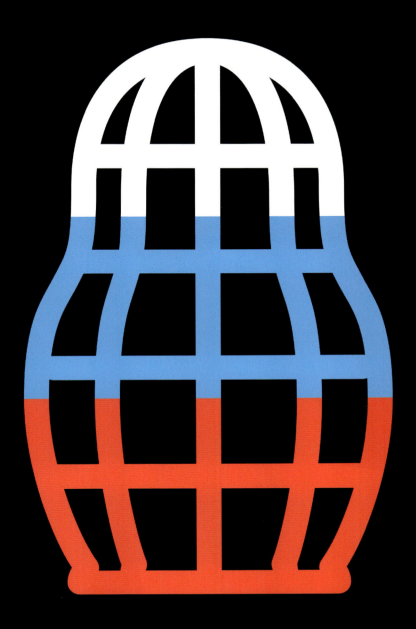

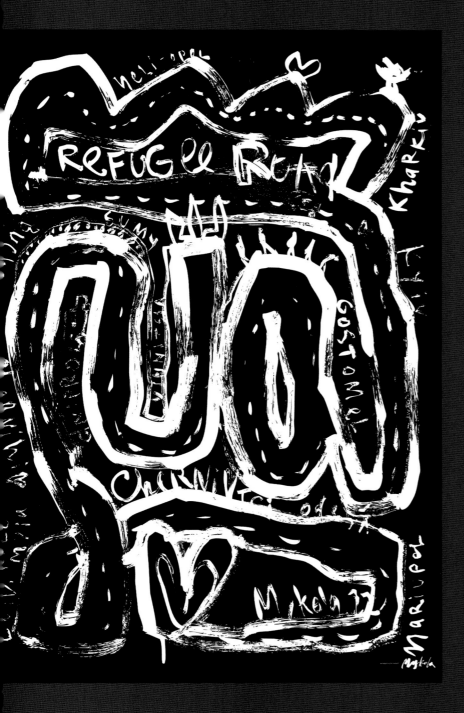

Cause and effect during the war in Ukraine:

This page: many Ukrainian cities and towns can be made out on a dark and labyrinthine *Refugee Road.*

Opposite: *RuSSia* typographed as the Nazi SS insignia. Before it grew in size and strength, the *Schutzstaffel* (SS) was a Personal Echelon loyal only to Adolf Hitler.

In Russia today, security and defence (indeed, all the organs of the state) are at the service of President Vladimir Putin: his nationalistic whims and historical obsessions, coupled with his insatiable desire to stay in power and go down in history as a latter-day Tsar.

"Fight and you will overcome!" proclaims this poster. It is advice penned by the revered 19th-century Ukrainian poet, Taras Shevchenko (1814–61).

The *shashka* is a curved sword that was first used by tribes in the Caucasus, and was later adopted by both Russian and Ukrainian Cossacks. Here, two crossed shashka have evolved into assault rifles in defence of Ukraine.

More about Taras Shevchenko can be read on pages 306–311. And a poem by him appears on page 319.

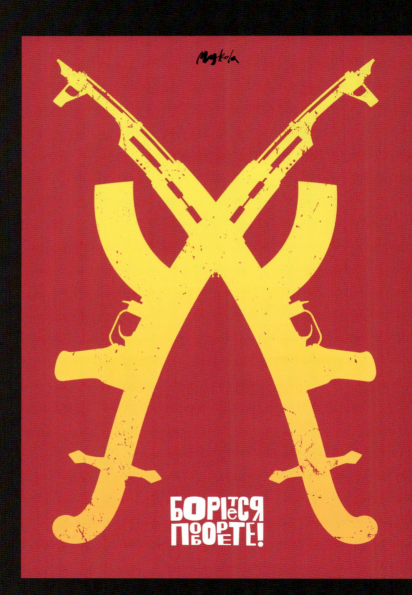

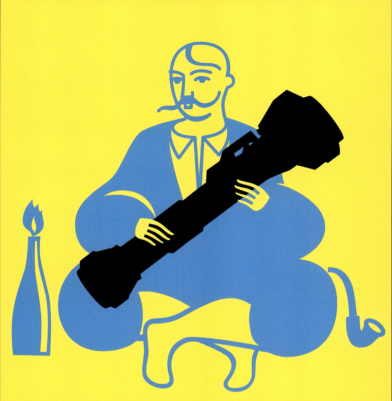

A Cossack puts aside his emblematic tobacco pipe and a Molotov cocktail, and embraces technology.

NLAW stands for Next-generation Light Anti-tank Weapon. Particularly in the early days of the invasion, when Ukraine had few cutting-edge weapons, this British/Swedish armament—along with British Javelin anti-tank missiles—helped Ukraine destroy countless Russian military vehicles.

Although the Ukrainian Cyrillic alphabet has no Latin letter W, most Ukrainians would pronounce it as an English V. The slogan, then, is a play on the Beatles' lyric, *All You Need Is Love*.

 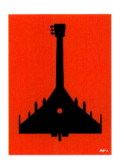 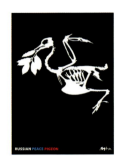

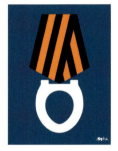 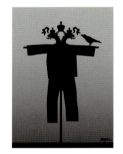 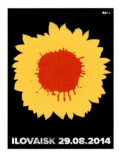 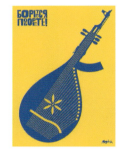 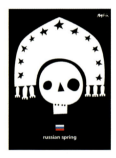

The Ribbon of St George is a prestigious Soviet-era military decoration that is still awarded in Russia today. In Ukraine it has become a hated symbol of Russian domination.

The 15th-century, double-headed Imperial eagle with three crowns represents Russian statehood. Mykola turns it into a ragged scarecrow that fails even to frighten birds.

In the summer of 2014, around 400 Ukrainian soldiers were trapped and then massacred by Russian forces after negotiating their unarmed retreat from the Donbas town of Ilovaisk. This betrayal still hurts.

"Fight and you will overcome!" reads the slogan by 19th-century poet Taras Shevchenko. The *bandura* is a folk instrument akin to a lute. Mykola morphs it into both a rifle and a warplane.

Top: a deathly, skeletal *Russian Peace Pigeon*.

Bottom: a death's-head dressed in a traditional Russian *kokoshniki* adorned with bombs.

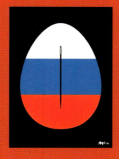 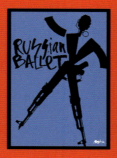 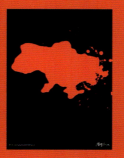 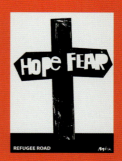

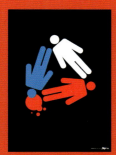 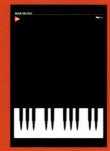 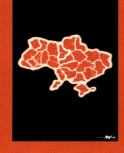 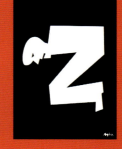

Top: parody of a jeweled Fabergé egg created in St Petersburg—here with something sharp inside that pricks if touched.

Bottom: recycling, Russian-style: death, death, and more death.

The piano keyboard formed out of bullets appears below the slogan WAR MUSIC. Since Russia invaded, Ukrainian musicians have played a vital role in raising moral.

The bottom poster was designed to get Oleg Sentsov released from a Russian prison. He is a Ukrainian filmmaker from Crimea who in 2015 was gaoled for 20 years, but is now free.

Ukraine's geographic shape suggests a pool of blood as well as raw steak. I am reminded of many posters from the Bosnian War, which played with the country's heart-shaped graphic form.

Top: the stark choice that faces refugees. Hope points westward, while Fear comes from the east.

Bottom: Russia's infamous Z-sign, here portrayed as a victim in a mass grave.

RETRIBUTION
Lyubov Zastavna

There will be retribution—
For every household
For a mother's tears
For a lost child
For a burnt building
For a broken tree
And for the wheat fields
Torn by shells.

There will be retribution—
For no tolerance
For your alien tongue
Which distorts our language.
And for lying words
Insidious, mean deeds.
And for the thoughtlessly silent—
You are also criminals.

There will be retribution—
For grey hair
For having lived a century
And still going barefoot.
And for the innocent child
Frozen in the womb
With Mummy's dead hands
Powerless to keep her safe.

There will be retribution—
For a burning tear
For a night full of fire
Thundering explosions.
For bitter separations
And for the loss of love—
This crimson-black war
Will be the last for the enemy.

See page 19 for information about the source of this poem, which is written in rhyming verse in Ukrainian language.

Right: a graphic image by Andrii Lesiv that appeared in large format in the foyer of Ukraine House during the illustration exhibition. Photograph by the author, Kyiv, 2022.

ILLUSTRATING RESISTANCE
AT UKRAINE HOUSE

ВІДПЛАТА
Любов Заставна

За все буде відплата:
За кожну домовину,
За материнські сльози,
За втрачену дитину,
За спалену будівлю,
За дерево розбите
І за пшеничне поле,
Снарядами розрите.

За все буде відплата.
Толерувань немає
За ваш «язик» чужинський,
Що мову утискає.
І за слова брехливі,
Підступні, підлі дії.
Ті, хто мовчать бездумно –
Ви також лиходії.

За все буде відплата:
За сивину в волоссі,
За те, що вік прожили,
А залишились босі.
І за дитя безвинне,
Яке застигло в лоні,
А мами мертві руки
Повисли на ослонні.

За все буде відплата:
І за сльозу пекучу,
За ніч, вогнями повну
Від вибухів гримучу.
І за гірку розлуку,
За втрачене кохання…
Війна багряно-чорна
Для ворога остання.

Illustration by Tania Yakunova on the facade of Ukraine House.

I arrived in Kyiv one day before the end of an impressive exhibition of illustrations. Creators of children's books and comics had focussed on the war. The exhibition, supported by Pictoric—a Ukrainian illustrators' club—took place in the cavernous Ukraine House, close to Independence Square. (Ukraine House served as a shelter from the riot police during the Euromaidan Revolution in 2013–14.)

Permission to reproduce the image on this spread, as well as those on pages 153, 158 and 162–166 was granted by Pictoric Illustrators' Club.

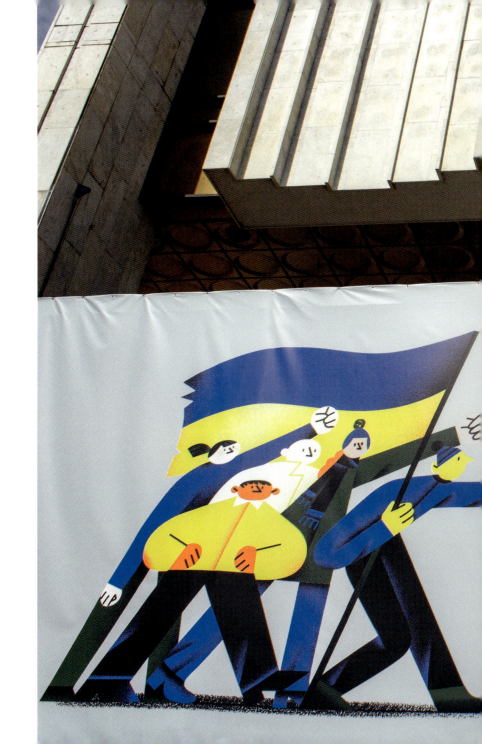

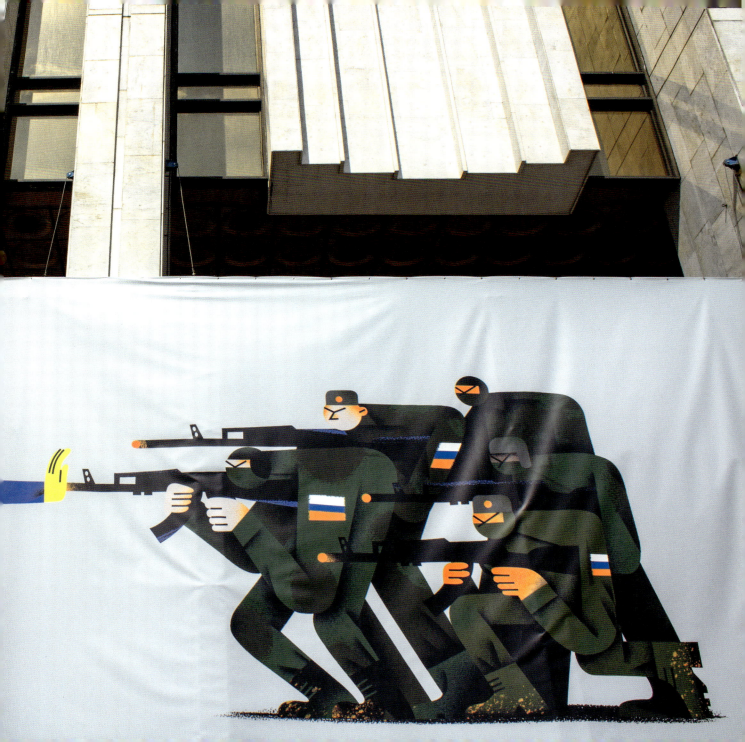

Two illustrations by Grasya Oliyko that need no commentary.

Most professional illustrators in Ukraine traditionally work on children's books. For this reason, children feature in many of their war illustrations.

Most illustrators were also women, which brought an authentic female perspective on war to the forefront of the exhibition.

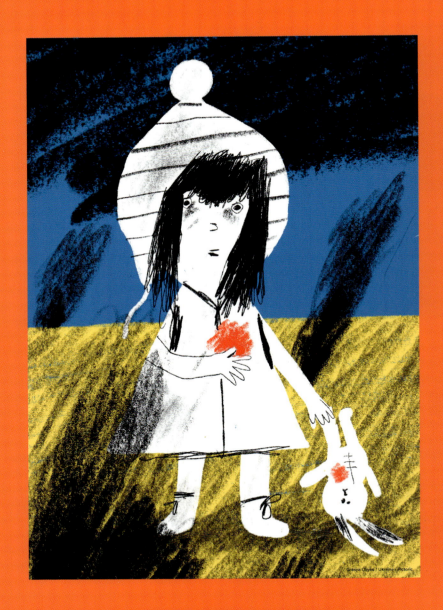

Grasya Oliyko / Ukraine / Pictoric

Two drawings by Anna Ivanenko that speak for themselves. From a series titled *Leaving Home*.

The exact number of Ukrainian refugees and internally displaced citizens fluctuates, and so it is hard to give exact figures. However, by the end of December 2022 it was thought that up to eight million people had left the country, while nearly 10 million may have relocated within Ukraine's borders.

The population of Ukraine was approximately 43.8 million before Russia invaded.

The vast majority of refugees are women and children, since the elderly often stay closer to home, and fighting-age men are forbidden to leave the country. There is also an indeterminate number of people (many of them children) who have been forcibly exiled to Russia or coerced into moving there.

On 17 March 2023, President Vladimir Putin and his Commissioner for Children's Rights, Maria Lvova-Belova, were the first Russians for whom arrest warrants were issued by the International Criminal Court. They are wanted for the crime of deporting children (nearly 20,000, Ukraine estimates) to the Russian Federation from occupied territories in the east.

Above: two Ukrainian child refugees in a train station in Poland. Photograph by Pakkin Leung, Przemyśl Główny, 2022 (Creative Commons).

Two illustrations by a female artist who signs her work Kinder Album (Children's Album). She is based in Lviv, in western Ukraine.

Left: *Civilian Targets Are War Crimes*.

Right: a detail from *Evacuation*.

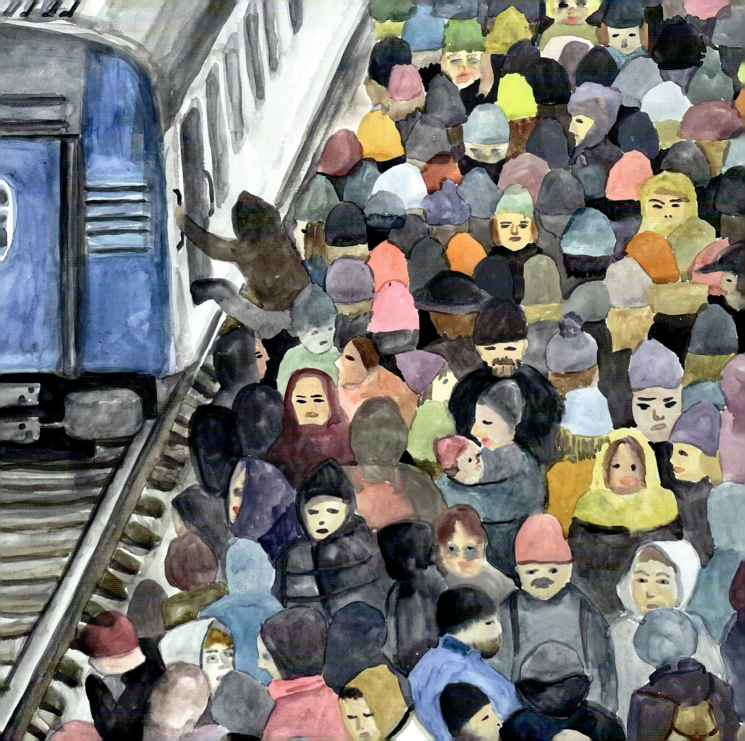

Two illustrations by Anastasiya Haidaienko.

Left: *Russian Woman*. The Russian poet Nikolái Alekséyevich Nekrásov (1821–78) wrote of the archetypal Russian woman: "She can stop a galloping horse and enter a burning peasant's hut." Haidaienko portrays Ukrainian women as dismissive of such myths. (See page 66 for information about the trident shield drawn on this figure's sleeve.)

Right: *Bride*. A young bride-soldier uses traditional embroidery skills to stitch a wound. The Cyrillic abbreviation on her badge (ЗСУ) stands for Armed Forces of Ukraine, in which many women are now fighting.

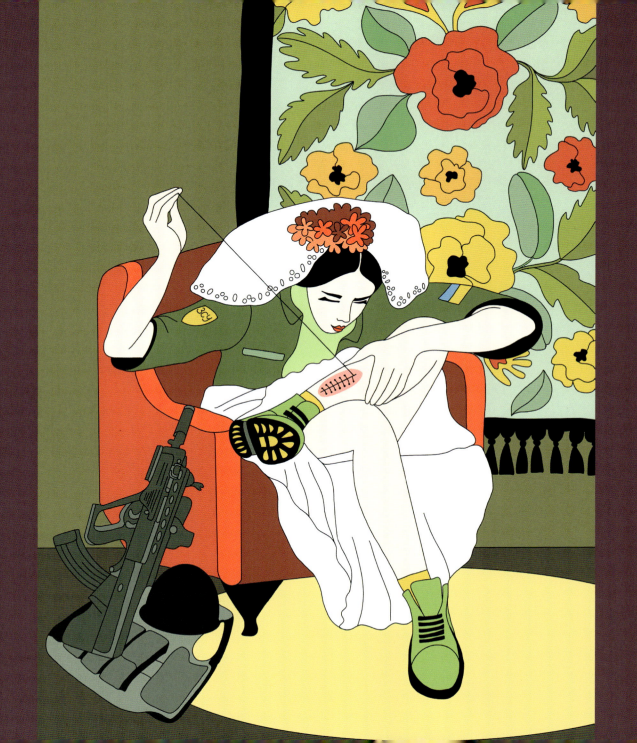

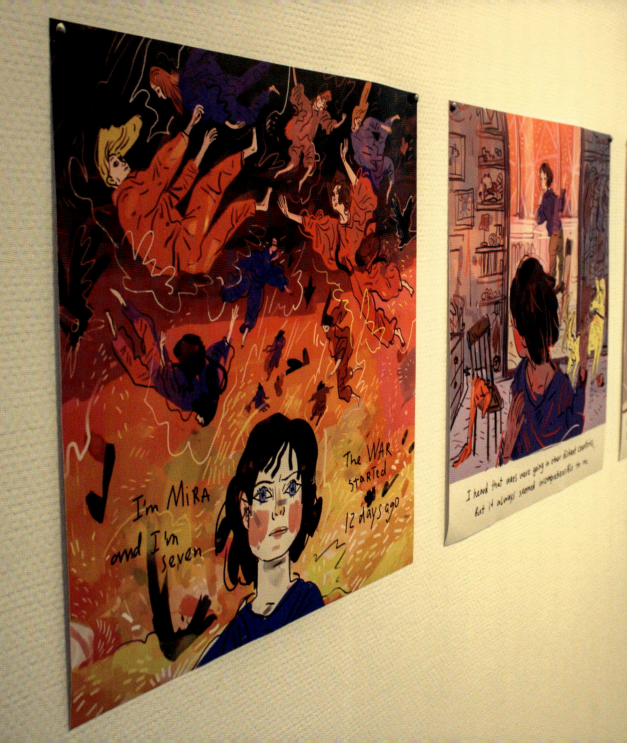

An untitled war comic by Yulia Tveritina.

Overleaf: *War Sounds*, by Zhenya Oliynyk. The dialogue reads:

I'M NOT A VERY MUSICAL PERSON. BUT I'M BECOMING GOOD AT SOUNDS.
(*"Oh my God, did you hear that? What was it? A bomb? Artillery? Air defence?"* / *"How on earth would I know?"* / *"Weren't you, as a man, assigned that knowledge at birth?"*)
THERE ARE LOTS OF THEM: A METAL THUNDER SOUND; THERE IS A DULL AND HEAVY SOUND; THERE'S THIS SOUND; AND THIS; THERE'S AN AIR RAID ALERT SOUND. SOME OF US BECAME REAL EXPERTS.
(Someone who fled Kharkiv: *"I know it's not a missile because the ground would have shaken differently."*)
BUT THEN THERE ARE OTHER SOUNDS, STILL.

War Sounds, by Zhenya Oliynyk. A transcript of the dialogue can be read on the previous page.

On 17 October 2022, I woke up listening to the BBC radio, as I often do, and heard a young woman named Kseniya, from Kyiv, being interviewed on the Today programme. She was speaking on the first day her city was attacked by Russia using waves of Iranian-made Shahed drones.

Kseniya's description immediately made me think of the comic opposite, which I had recently designed into this book.

"In the last two hours we can hear the explosions and the noise of the drones flying over our building almost constantly. Believe me once you've heard the sound of a rocket flying over your building, or a drone flying over your building, you can tell the difference … You can feel the difference. If we're talking about rockets it's more like a whistle. And if we're talking about the drones … imagine that some very huge 200 kg motorcycles are flying over your building. It's really freaking scary!"

Overleaf, left: *Air Alert,* by Mitya Fenechkin. Pets and zoo animals, as well as wild animals, suffer tremendous stress, and of course also die, during wars. Fenechkin studied design at the National Shipbuilding University in Mykolaiv, a port city in southern Ukraine.

Overleaf, right: throughout May 2023 and into June, Kyiv suffered wave after wave of drone, cruise and ballistic missile attacks. This screengrab from a public camera showing a large missile exploding in the city appeared on social media.

Images of destruction, geography, history and creativity, by Katya Lisova. I have included ten of her collages in the book (there is another on page 9) from a series of 16 titled *The Power of Memory*.

Lisova's collages are inspired by the *Rushnyk* tradition, described overleaf. The photographs used by the artist are from private family albums.

This page: *Borodianka*. The title is the name of a town close to Bucha that suffered greatly during the war. The face is a self-portrait, painted in 1840, by the important Ukrainian poet, Taras Shevchenko.

Opposite: *From the Ruins.*

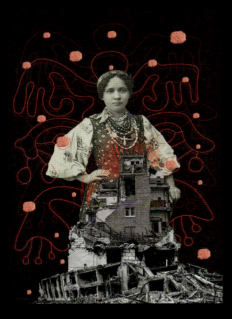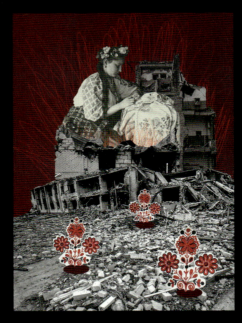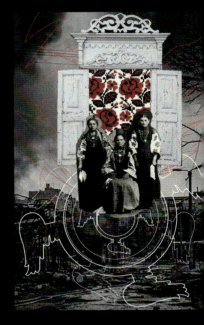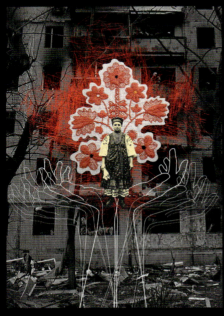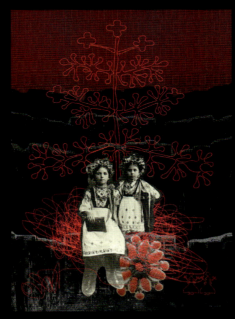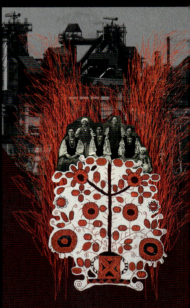

Rushnyk is an Eastern Slavic tradition that is highly valued in Ukraine. *Rushnyky* (plural) play many important functions during a person's life, accompanying him or her until death. There are various designs for different milestone life events, and red is the dominant colour of symbols and stitching—suggesting blood, fertility and good health. The rectangular shape also represents a person's journey through life, moving upwards from the Earth to the heavens.

Left: top row, left to right: *From Chernihiv; I Will Stay Home; Window.*

Bottom row, left to right: *The Power of Memory; Spring 2022; Shelter Tree.*

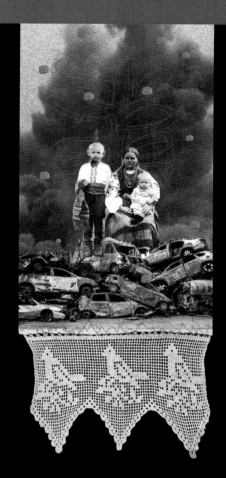

Above: *The Road to Irpin.*

A series of screengrabs from a mesmerising short animation in the form of a kaleidoscope that I watched playing in a loop at the Ukraine House exhibition.

Vengeful rhyming verse in Ukrainian language is whispered by a female protagonist. It is chillingly addressed to the Russian invaders, while the unsettling soundtrack has a deathly, watery atmosphere. To watch the video, please visit:

www.youtube.com/watch?v=Zw5urm5hFR8

REVENGE 22
Lilya Lylyk

The one who sits in a tank—
Boil up.
The one who sits in an APC—
Breathe your last.
The one who flies through
 the sky—
Collapse to the ground.
The one holding AK—
Chill it out.

You'll perish down in our lands.
You'll drown in our waters.
You'll desiccate in our steppes.
You'll vanish in our forests.

The one who's in a bunker—
God keeps an eye on.
The one who's in Kremlin—
Those be on dog shits.
The one on TV—
Be in a lifelong cell.
Devil already pressing
 the starter.

You'll perish down in our lands.
You'll drown in our waters.
You'll desiccate in our steppes.
You'll vanish in our forests.

APC stands for armoured personnel carrier; AK for the infamous AK-47 military assault rifle issued to almost every Russian soldier. This translation—including the title, *Revenge 22*—is by Aryna Asadcha, and is as it appears on the video. I have left the English as was, but added some punctuation.
 This curse is written in rhyming verse in Ukrainian language.

Right: *KAPA*, the original title in Ukrainian Cyrillic, also translates as punishment or chastisement.

Video direction and voice: Lilya Lylyk
Illustration: Inna Ruda
Animation: Yuriy Moka Motrych
Soundtrack: Mikhey Jelsomino Medvedev

КАРА

Ідея і шепіт — Ліля Лилик
Звук — Міхей Мєдвєдєв Джельсоміно
Анімація — Юрій Мотрич
Ілюстрації — Інна Руда

LULLABY
Pavlo

Sleep, baby, the night will pass
The bomb shelter is strong
The walls are bare but sturdy.
Nothing's going to disturb baby's sleep
Neither rockets nor bullets.
So sleep, baby, lullaby!

Herod the villain
Wants to destroy our children again
Wants to destroy our country.
So in this evil hour
In a bomb shelter—as in a shell
Sleep, baby, lullaby!

Sleep, baby, you are not alone—
The Son of God sleeps nearby.
And above this damned filth
Ukrainian heroes fight—
Brave, furious at the hordes.
So sleep, baby, lullaby!

See page 19 for information about the source of this poem, which is written in rhyming verse in Ukrainian language.

Right: a detail from *Woven,* by Oleksandr Britsev. Photograph by the author, Kyiv, 2022

OSOKORKY
METRO STATION

КОЛИСКОВА
Павло

Спи, дитинка, ніч мине,
бомбосховище міцне,
стіни голі, але путні.
Не порушать сон манюні
ні ракети, ані кулі.
Спи, дитятко, люлі-люлі!

Знову Ірод-скарабей
хоче знищити дітей,
хоче знищити країну,
та у цю лиху годину
в бомбосховищі, як в мушлі,
спи, дитятко, люлі-люлі!

Спи, малюк, ти не один –
поруч спить і Божий Син,
а вгорі навали свинські
б'ють герої українські –
мужні, до ординців люті.
Спи, дитятко, люлі-люлі!

Kyiv's exceptionally deep metro stations were no longer being used as bomb shelters by the time I arrived there.

War in Ukraine started when Russia invaded and annexed the Crimea peninsula in 2014. Reflecting events after that, in 2018 Osokorky metro station was transformed into a socio-political mural gallery.

Participating artists were from Costa Rica, Belgium, Brazil, Spain, Switzerland, Ukraine and the USA, and the project—dedicated to Ukraine's national unity—was titled *More Than Us*. Artists worked at night when Kyiv's metro stations are closed.

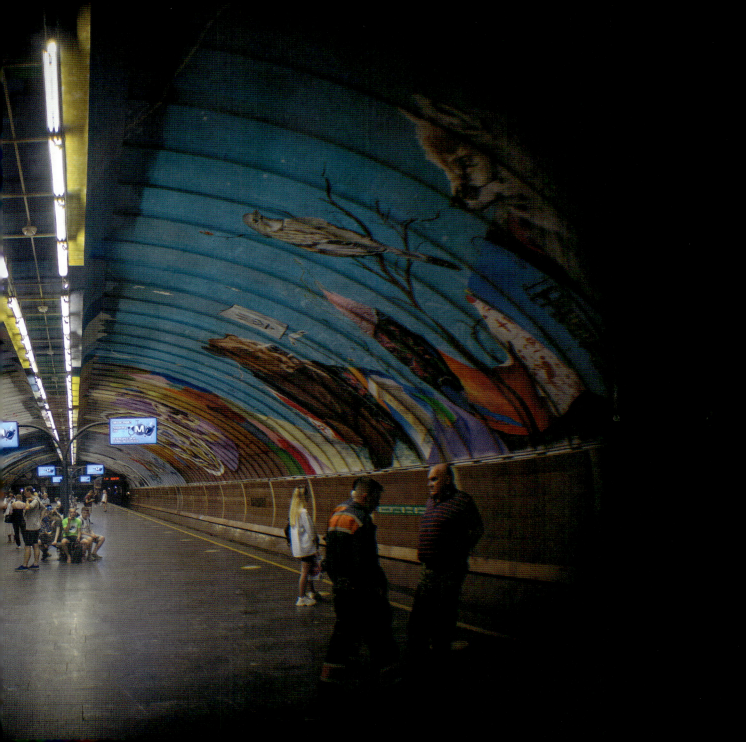

Clockwise, from top left:

United: Issam Rezgui (Switzerland). Ukrainian actor Bohdan Stupka offers a gift from the Carpathian Mountains.

Woven: Oleksandr Britsev (Ukraine). A woman weaves a carpet in the shape of Ukraine.

Avdiyvka: Matthew Down (Belgium). A Ukrainian town damaged in 2014. The red doodles represent children, who hold the promise of a brighter future.

Unfinished: BKFoxx (USA). A girl made of stained-glass constructs herself, fragment by fragment—symbolising the search for a national identity.

Clockwise, from top left:

Universal Language: Apolo Torres (Brazil). A pianist famously played in the street during the Euromaidan Revolution in 2013–14.

Knowledge is a Treasure: by an artist named Spear (Belgium). Volodymyr Donos, a teacher and soldier, was able to recover from serious battlefield injuries thanks to the books he had read in his life.

Autonomy: Mata Ruda (Costa Rica). Dedicated to the Tatars of Crimea: to their difficult past and current struggle in their annexed homeland.

Motherland: see the following spread.

Motherland: a Spanish artist named Kraser depicts Ukraine's endangered species.

The bear on the previous spread is part of this mural; it represents western Ukraine, and in particular the Carpathian Mountains. This normally powerful animal's broken arm is supported in a sling embroidered in the folkloric *Petrykivka* style.

The Corsac fox, along with Donetsk's destroyed airport tower, symbolises the east of the country.

It should be noted that the Osokorky metro station project was criticised by some. They complained that the concepts, the painting styles, as well as the way the commissioning and selection process was handled were all less than satisfactory.

However, I feel that the overall poetic premise of the project is interesting. The intention to air, through art, delicate national issues at a crucial historic moment, was a bold and admirable one. The project unites culture and politics in a meaningful way—and asserts the value of the former to help understand and interpret the latter.

KHARKIV
Esta Lye

It made sense to think about death.
If it happens, let it be fast.
Millions of human destinies torn to pieces.
Life seems thin, brittle.

Spring ice just about
To melt in native waters.
I would like only bright sorrows
And to have time to say goodbye to loved ones.

I, the author, am not yet twenty-three.
Why do I have to think about death
Worthless, in one of many
Grey, panelled, Kharkiv buildings?

How am I different from a friend or the sister
Of a ruthless Russian soldier?
Asking, I look up
At the bombs and rockets of the occupier.

Kharkiv is a large north-eastern Ukrainian city that was much fought over when Russia invaded in 2022. The full title of the poem in Ukrainian language is *Kharkiv, Kholodna Gora*. Kholodna Gora is a neighbourhood of the city.

See page 19 for information about the source of this poem, which is written in rhyming verse in Ukrainian language.

Right: hand-painted naïve art exhibited for sale on the pavement. Photograph by the author, Kyiv, 2022.

NAÏVE ART:
AN INTERLUDE

ХАРКІВ, ХОЛОДНА ГОРА
Еста Льє

З'явився сенс подумати про смерть.
Якщо це станеться, нехай буде швидкою.
Долі мільйонів летять шкереберть.
Життя здалось тоненькою, крихкою

Весняною крижиною: от-от
Розтане, в рідних водах розчиниться.
Лиш світлих я хотіла би скорбот,
І встигнути з коханими проститься.

Я авторка, нема двадцяти трьох.
Чому я мушу думать про загибель
Нікчемну, в одній з багатьох
Панельних, сірих харківських будівель?

"Чим я різнюсь від подруги, сестри
Жорстокого російського солдата?" -
Питаючись, дивлюся догори
На бомби і ракети окупанта.

One would expect that during a war nobody would have time for anything besides images related to the conflict; but that is not the case: many people still appreciate naïve, decorative art. Curiously, given all that was going on in Kyiv, such pictures appeared quite lovely to me.

I was particularly impressed by a black stallion galloping across the surf. It seemed on the verge of breaking through green cords that held the painting in place. That stallion struck me as highly symbolic when I took the photo overleaf. Freedom is a beautiful thing, I thought: once something (or someone) gets a taste for it, it's unstoppable.

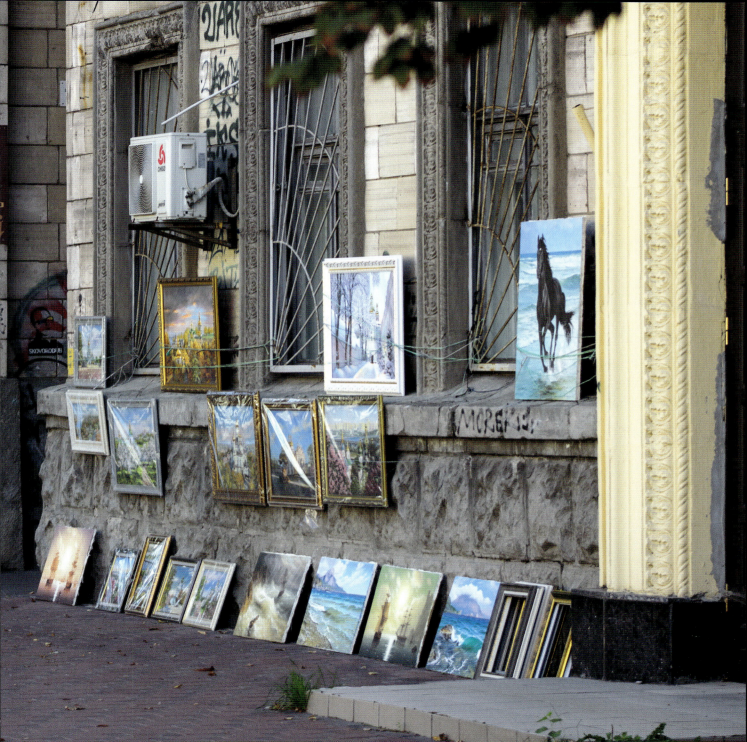

SON
Khaya

My only beloved son
We haven't seen each other for a long time
I know, my dear, that you are nearby
But I also know there's a fight going on.
Blows from the right, blows from the left
Home is burning, soul is burning.
A faint heart
Bellows, "Go away war!"
I stand alone in the field—
I'm scared here
But I'm standing
Feet rooted to the spot
I whisper to the agitated attackers,
"Take me, take only me—
With all the shooting, bombs and bullets
You will eat me alive, but I can take it
My soul will soar, there will be no pain
For everyone, for Peace—take Me!"
And still whispering, but louder now,
"We need Peace! Go away War!
After all, nobody wants to die …"

See page 19 for information about the source of this poem, which is written in rhyming verse in Ukrainian language.

Right: detail from a mural by Julien "Seth Globepainter" Malland, a highly accomplished French street artist. His murals often feature children in surreal situations. Photograph by the author, Kyiv, 2022.

MURALS MURALS
EVERYWHERE

СЫН
Хая

Единственный любимый сын,
Давно не виделись с тобой,
Я знаю, милый, что ты рядом,
Но также знаю идёт бой.
Удары справа, удары слева,
Горят дома- горит душа
И замирающее сердце
Кричит, кричит: " Уйди война!!!"
А я стою одна на поле
Мне страшно здесь,
Но я стою
Ногами вросшая с землею
Не мирному огню шепчу:
"Возьми меня, возьми одну
Всем градам, бомбами и пулей
Наешься мной, я потерплю.....
Взлетит душа, не станет боли ...
За всех, за мир возьми меня"
Ещё шепчу, но уже громче:
"Нам нужен мир -уйди война!
Никто ведь умирать не хочет..."

The mayor of Kyiv, Vitali Klitschko, is largely responsible for the city's mural culture. He was elected shortly after the youth-led Euromaidan Revolution in 2013–14, which changed the country's politics for good. Murals connected Klitschko with the youth, bolstering his image and increasing his popularity further.

Vitali Klitschko had lived in Berlin during his former career as a professional heavyweight boxer, and he believed Ukraine should follow a liberal path similar to Berlin's. He also saw murals as a way to make the city stand out.

While not all Kyiv's murals are political, in a way they are, since in part the ideological intention was to underline—to foreigners and local citizens—that Ukraine's capital had turned away from a drab post-Soviet present. It was looking westward: to Germany and beyond—to an enlightened European future. In this way, murals played their part in establishing an atmosphere that undoubtedly irritated Russia, desperate as it was *not* to see a liberal, modern, westernised Ukraine on its doorstep.

This page: a banner hung just under Mayor Klitschko's office window on the facade of Kyiv's City Hall, in support of the those fighting at the Azovstal Iron and Steel Works in Mariupol. The graphic image is shaped as a human heart.

Opposite: Mayor of Kyiv, Vitali Klitschko. Photograph by Olaf Kosinsky, Berlin, 2015 (Creative Commons).

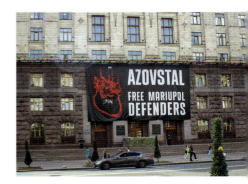

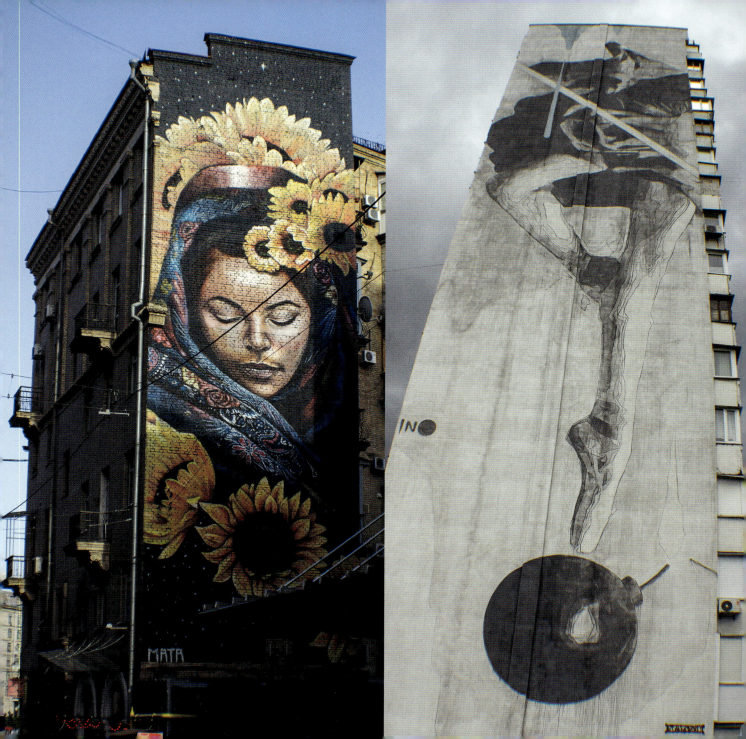

The wide river Dnipro divides Kyiv into two distinct halves. The largely residential left-bank is flat and mostly comprises of high-rise blocks, whereas the right-bank is hilly and historical. The difference between the dominant architectural styles of the two sides (brick vs concrete; rectangular vs square) means that left- and right-bank murals feel quite different.

Many of Kyiv's murals are very large—especially on the left-bank where they can be 15 or more storeys high. But all the murals are impressive when one rounds a corner and they loom into view. There are thought to be more than 150 full-size murals dotted around the city.

Left: one of downtown Kyiv's best-known murals, by the Costa Rican artist, Mata Ruda. And next to it, a ballerina dancing on a bomb in new Kyiv, by the Greek muralist, iNO.

Below: mural painting could be said to have begun long before the current trend set in. This faded iconographic mural is from the entrance to the sprawling 11th-century Kyiv-Pechersk Lavra Monastery.

Incidentally, in November 2022, Ukrainian police raided the Lavra monastery and other Orthodox Church premises. Several clerics, whose church has ties to Russia, were charged with conspiring with the enemy against Ukraine.

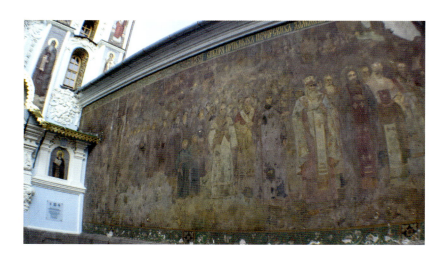

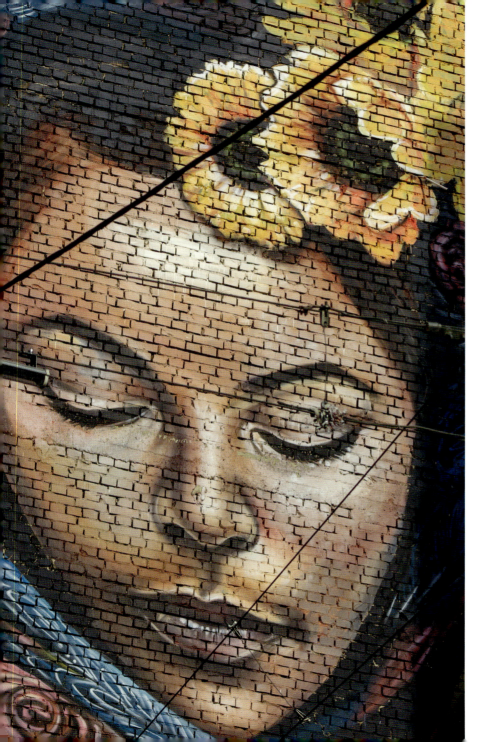

Being as large as they are, it is often a real challenge to photograph some of the murals in their entirety. But they also make an impact when viewed through a telephoto lens.

The texture of the walls they are painted on is also part of their character and charm—as are the windows, cables, lamps and other objects that litter the walls of buildings especially in Old Kyiv.

Women—such as this Costa Rican-Ukrainian fusion by Mata Ruda—are well represented in the murals. They appear confident, strong and beautiful by equal measure.

Since many of the guest artists come from outside Ukraine, their subjects' features are sometimes not ethnically Ukrainian. Many people, locals included, find this fusion modern and attractive. To me it felt refreshing: inclusive and non-nationalistic.

One Spanish artist, however, recalls a negative reaction from some residents when, in 2017, he painted this 70-metre high mural of an happy African boy on their building in Kyiv. Javier "Xav" Robledo says that work had to be halted for a couple of weeks while discussions took place. Finally, however, it was accepted—and when I photographed the mural in 2022 it was intact.

A mural by Fintan Magee. Magee is from Australia. Originally a graffitist, he subsequently studied fine art.

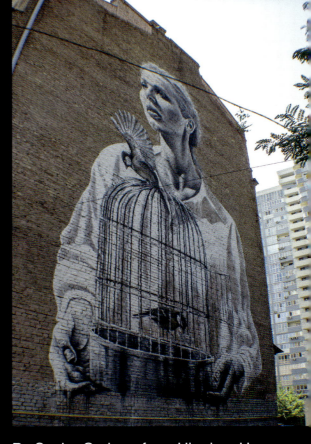

By Sasha Corban, from Ukraine. He was a miner before becoming an artist. (See a detail from this mural on page 217.)

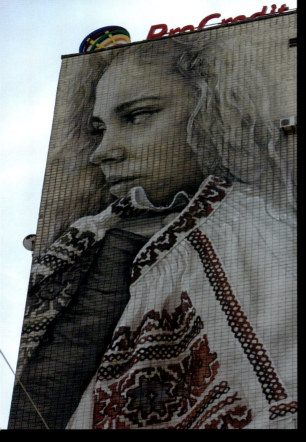

The muralist Guido van Helten is from Australia. The woman wears a traditional Ukrainian shirt, called a *vyshyvanka*.

A mural by Paola Delfín Gaytán. Delfín is a Mexican visual artist. Her striking work appears in cities around the world.

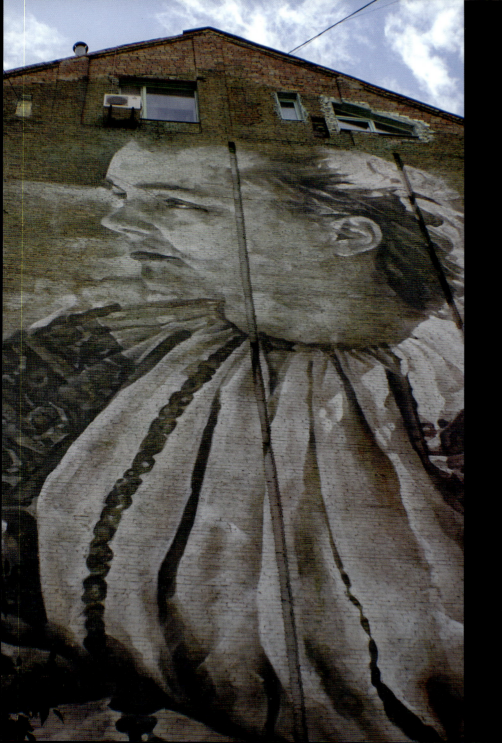

Lesya Ukrainka (1871–1913) is a vitally important Ukrainian poet. See pages 309–311 for more information about her.

In 1890, when Ukrainka was only 19 years old—the same year that the Ukrainian Radical party was established and the country was in political and social turmoil—she wrote *Contra Spem Spero! (Hope Against Hope!)*

In many ways this poem of resistance and optimism (which the poet titled in Latin) represents an anthem for today's youth during the current war waged against Ukraine.

CONTRA SPEM SPERO!
(HOPE AGAINST HOPE!)
Lesya Ukrainka

Thoughts away, you heavy clouds of autumn!
For now springtime comes, agleam with gold!
Shall thus in grief and wailing for ill-fortune
All the tale of my young years be told?

No, I want to smile through tears and weeping,
Sing my songs where evil holds its sway,
Hopeless, a steadfast hope forever keeping,
I want to live! You thoughts of grief, away!

On poor sad fallow land unused to tilling
I'll sow blossoms, brilliant in hue,
I'll sow blossoms where the frost lies, chilling,
I'll pour bitter tears on them as due.

And those burning tears shall melt, dissolving
All that mighty crust of ice away.
Maybe blossoms will come up, unfolding
Singing springtime too for me, some day.

Up the flinty steep and craggy mountain
A weighty ponderous boulder I shall raise,
And bearing this dread burden, a resounding
Song I'll sing, a song of joyous praise.

In the long dark ever-viewless night-time
Not one instant shall I close my eyes,
I'll seek ever for the star to guide me,
She that reigns bright mistress of dark skies.

Yes, I'll smile, indeed, through tears and weeping
Sing my songs where evil holds its sway,
Hopeless, a steadfast hope forever keeping,
I shall live! You thoughts of grief, away!

This translation, by Vera Rich, is from www.allpoetry.com.

Left: a mural of Lesya Ukrainka by the Australian artist, Guido van Helten.

Overleaf: Innerfields, an art collective founded in Berlin in 1998, painted this very tall mural on Kyiv's contemporary left-bank.

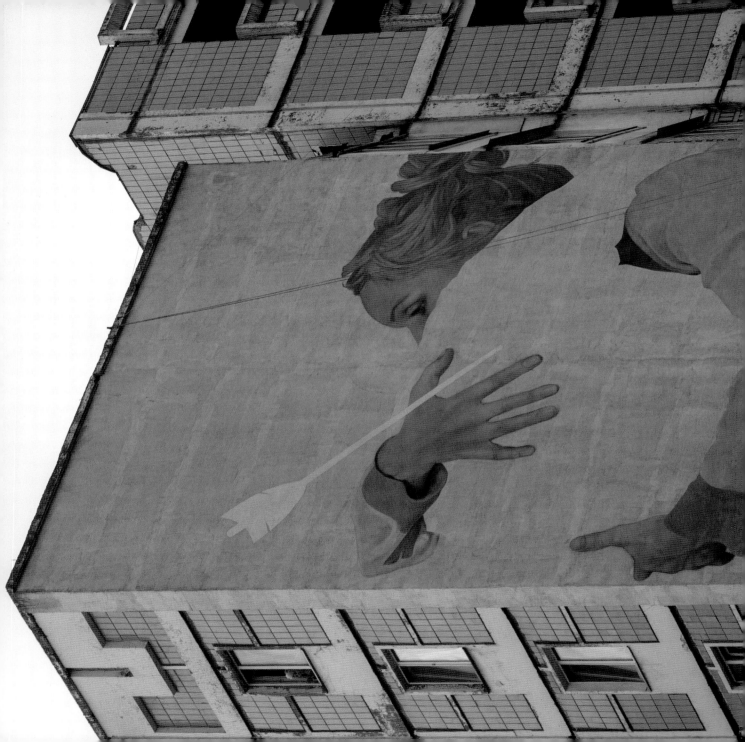

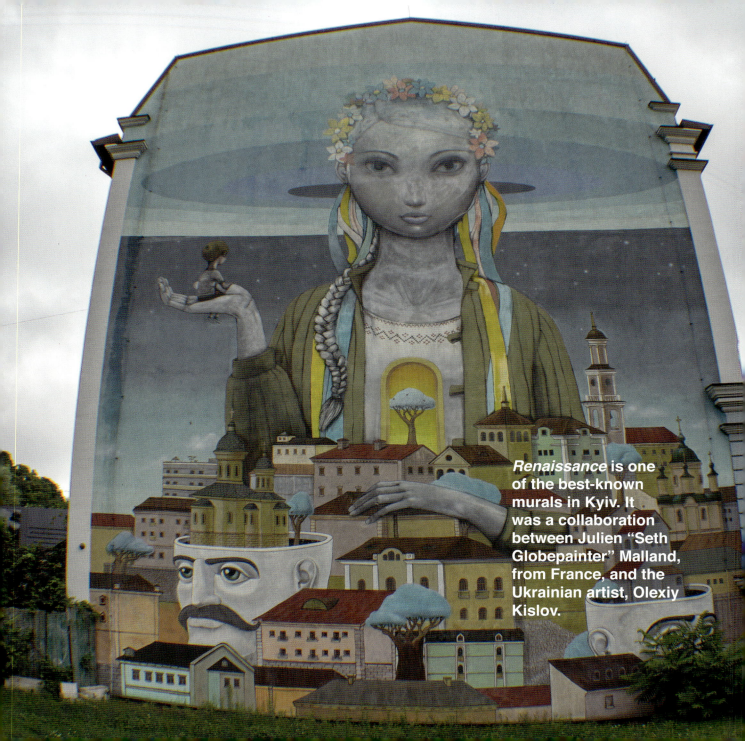

Renaissance is one of the best-known murals in Kyiv. It was a collaboration between Julien "Seth Globepainter" Malland, from France, and the Ukrainian artist, Olexiy Kislov.

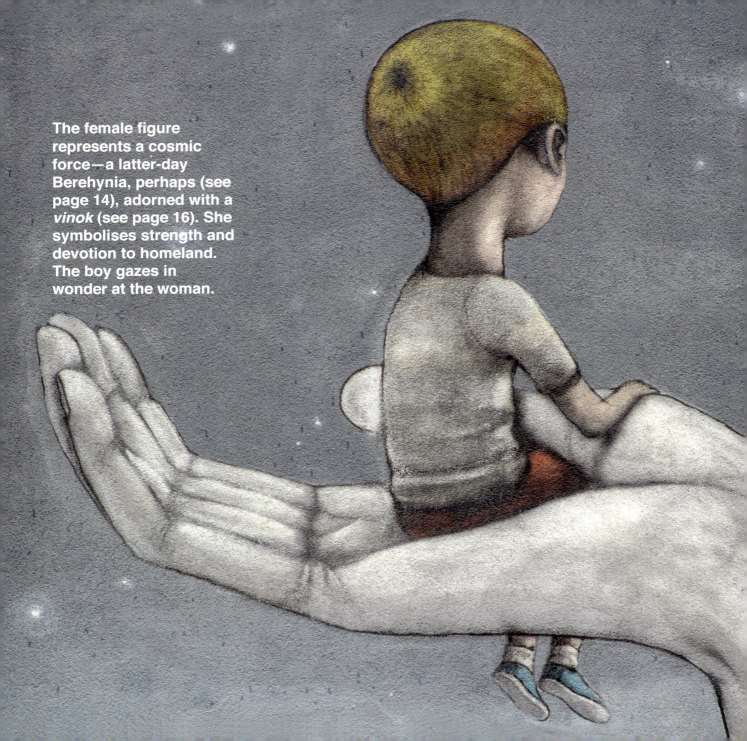

The female figure represents a cosmic force—a latter-day Berehynia, perhaps (see page 14), adorned with a *vinok* (see page 16). She symbolises strength and devotion to homeland. The boy gazes in wonder at the woman.

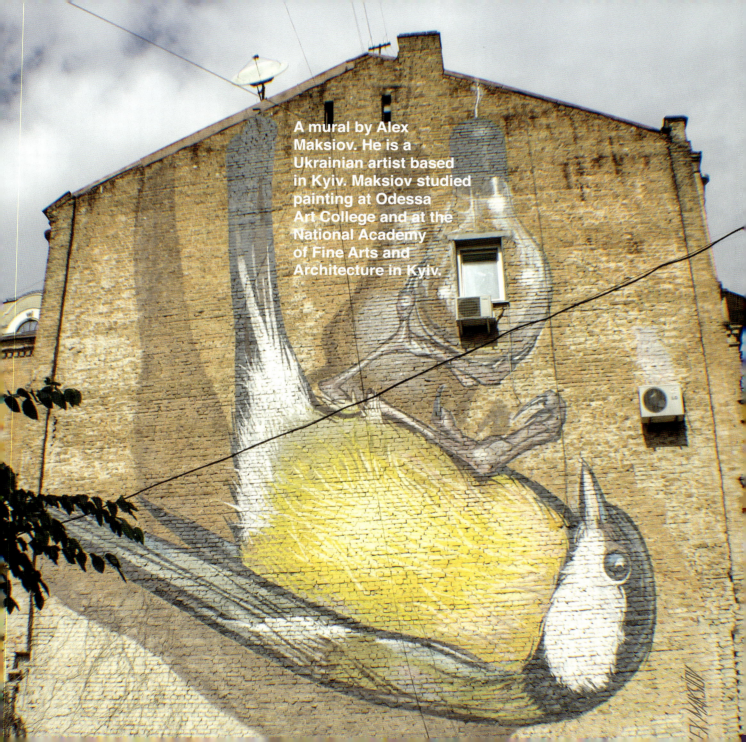

A mural by Alex Maksiov. He is a Ukrainian artist based in Kyiv. Maksiov studied painting at Odessa Art College and at the National Academy of Fine Arts and Architecture in Kyiv.

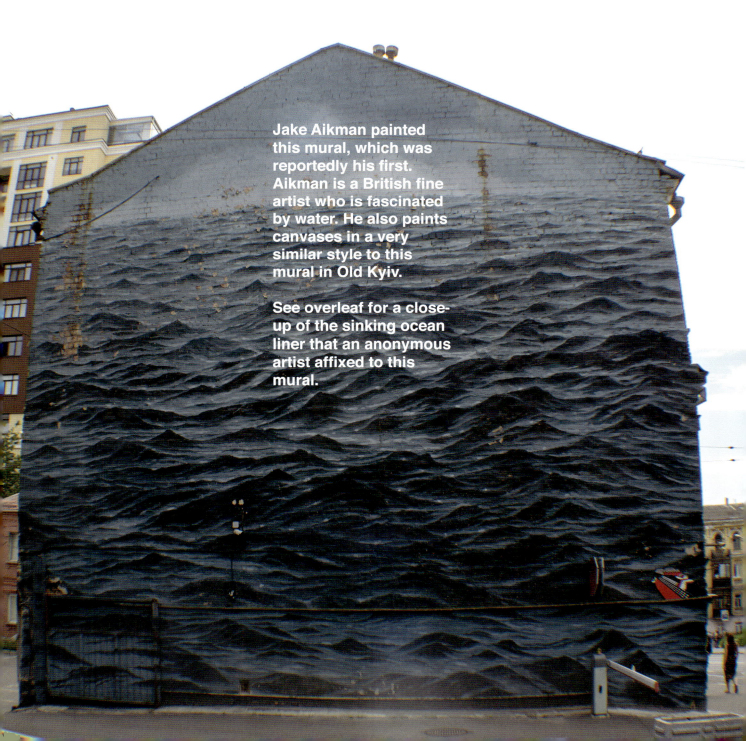

Jake Aikman painted this mural, which was reportedly his first. Aikman is a British fine artist who is fascinated by water. He also paints canvases in a very similar style to this mural in Old Kyiv.

See overleaf for a close-up of the sinking ocean liner that an anonymous artist affixed to this mural.

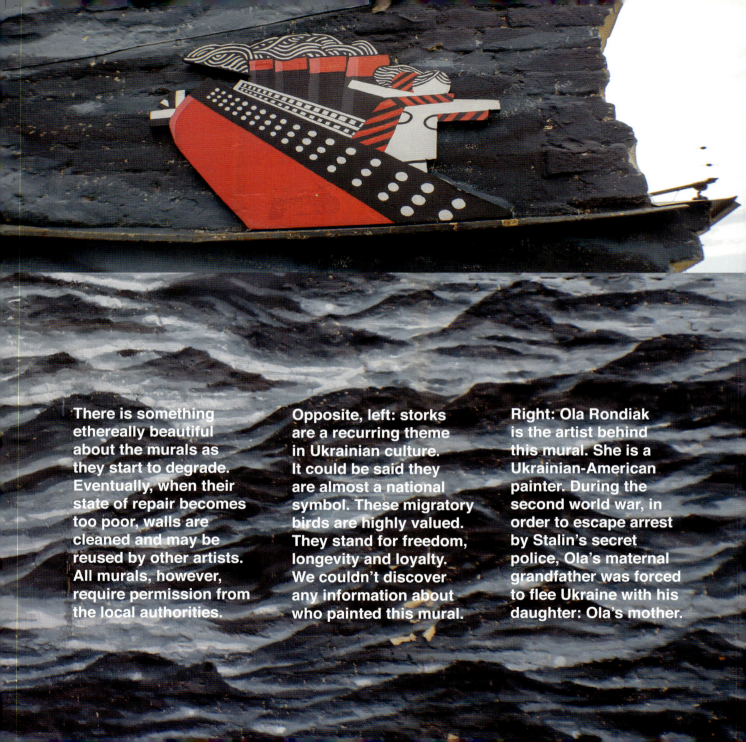

There is something ethereally beautiful about the murals as they start to degrade. Eventually, when their state of repair becomes too poor, walls are cleaned and may be reused by other artists. All murals, however, require permission from the local authorities.

Opposite, left: storks are a recurring theme in Ukrainian culture. It could be said they are almost a national symbol. These migratory birds are highly valued. They stand for freedom, longevity and loyalty. We couldn't discover any information about who painted this mural.

Right: Ola Rondiak is the artist behind this mural. She is a Ukrainian-American painter. During the second world war, in order to escape arrest by Stalin's secret police, Ola's maternal grandfather was forced to flee Ukraine with his daughter: Ola's mother.

I was impressed with how many murals in abstract or surrealist style are painted in ordinary (i.e., not fashionable) neighbourhoods. And local residents seem really proud to have them. This mural was hidden away on a sprawling Soviet-era housing estate on Kyiv's left-bank. The title—КОЛО, in Ukrainian Cyrillic on the wall—translates as *Circle.*

Finding this urban art is quite time- and labour-intensive. Having a guide and a driver certainly helps, since the murals are spread out over a wide area intersected with long highways. It wasn't possible for us to discover who painted this very well-executed mural.

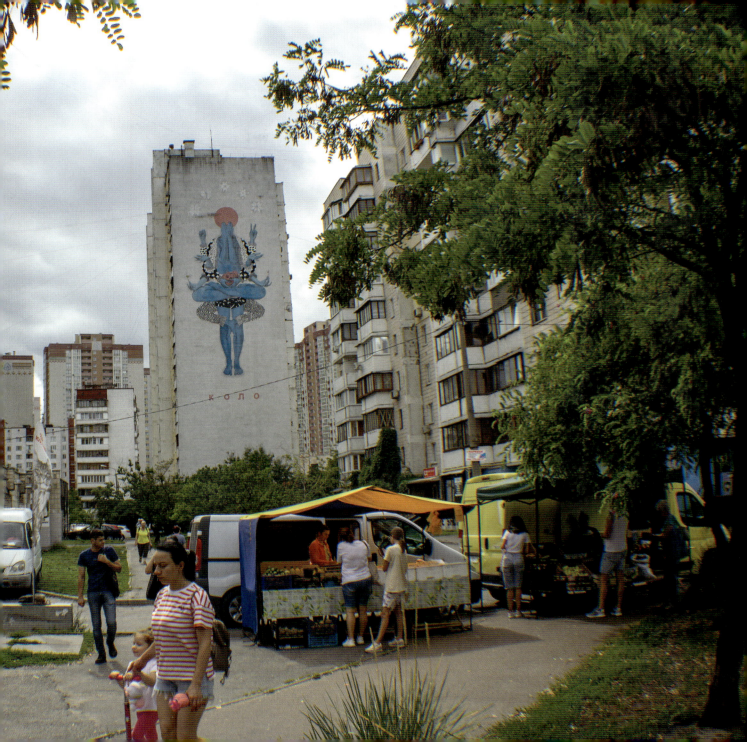

Animals, birds and plants feature heavily in Ukrainian murals.

This page: a mural by the Australian artist Fintan Magee. The complete image shows a swimming deer helping a man stay afloat in choppy water.

Opposite, top left: Oleksandr Britz, from Kharkiv, painted this mural. In Slavic folklore, black crows signify death; they are considered to be God's messengers on earth. A white crow (like a black sheep) symbolises non-conformity.

Top right: this vibrant mural by the US artist Ernesto Maranje depicts flowers and plants entwined into the form of an exotic bird.

Bottom: a detail from the mural by Sasha Corban on page 200 of a woman holding a bird cage.

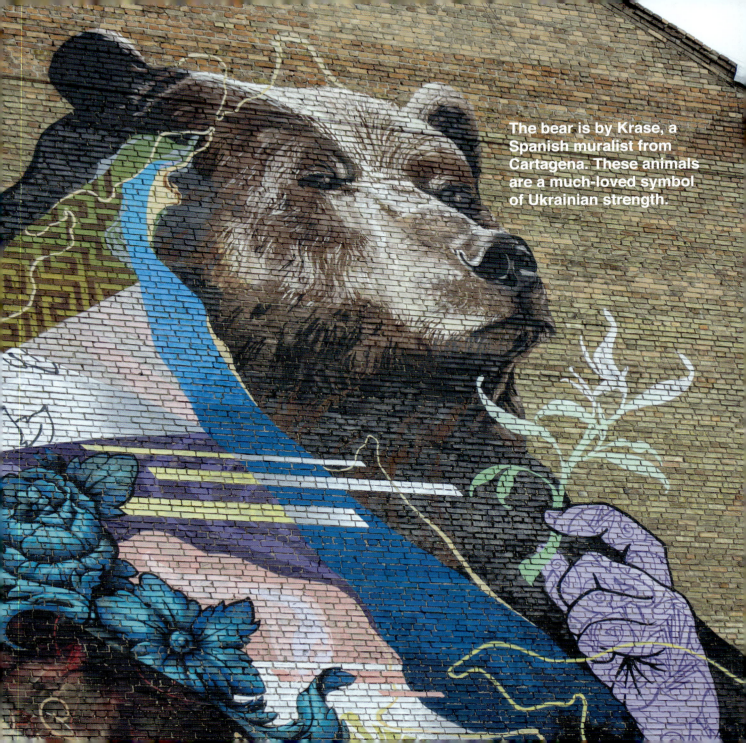

The bear is by Krase, a Spanish muralist from Cartagena. These animals are a much-loved symbol of Ukrainian strength.

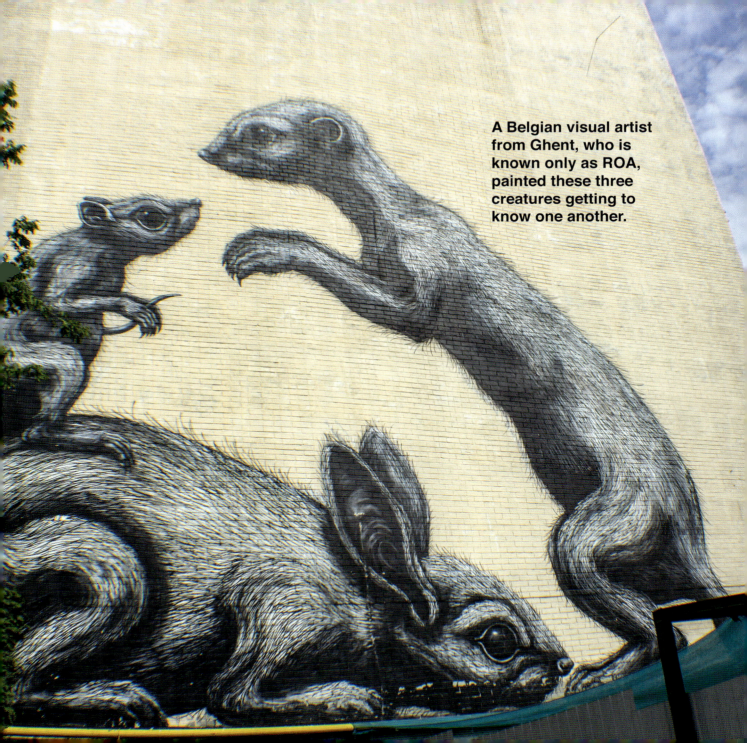

A Belgian visual artist from Ghent, who is known only as ROA, painted these three creatures getting to know one another.

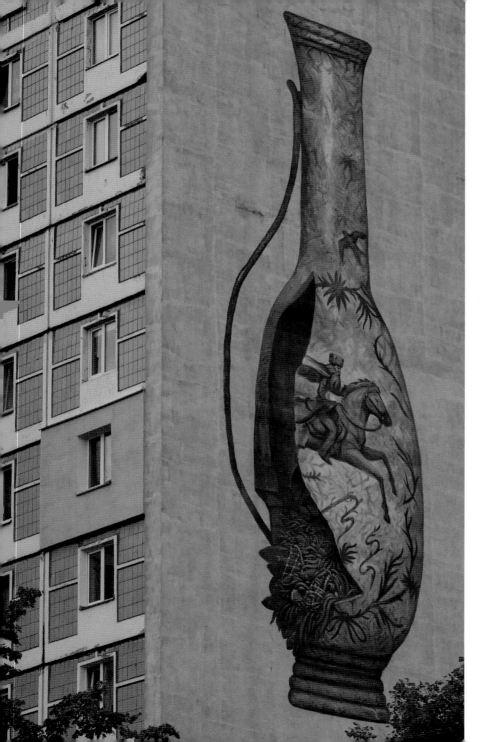

Historic themes are present in murals, but there are not as many of these as I expected.

Left: a mural by Olivier Bonnard, from Canada. The image speaks about the impact of human activity on the environment: in this case, Cossack activity on the Black Sea region.

Right: this mural by Andrii Parval, who is originally from Kharkiv, depicts the Battle of Kruty, fought on Ukraine's northern border in 1918. A well-equipped Russian Bolshevik force was halted for a few days by Ukrainian soldiers and students. Ukraine has been fighting against Russian domination for more than a century.

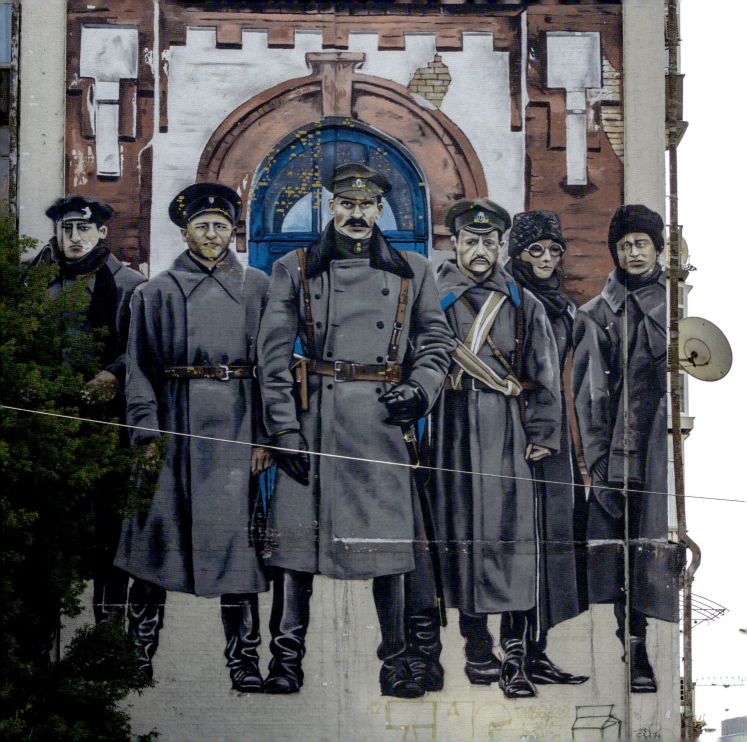

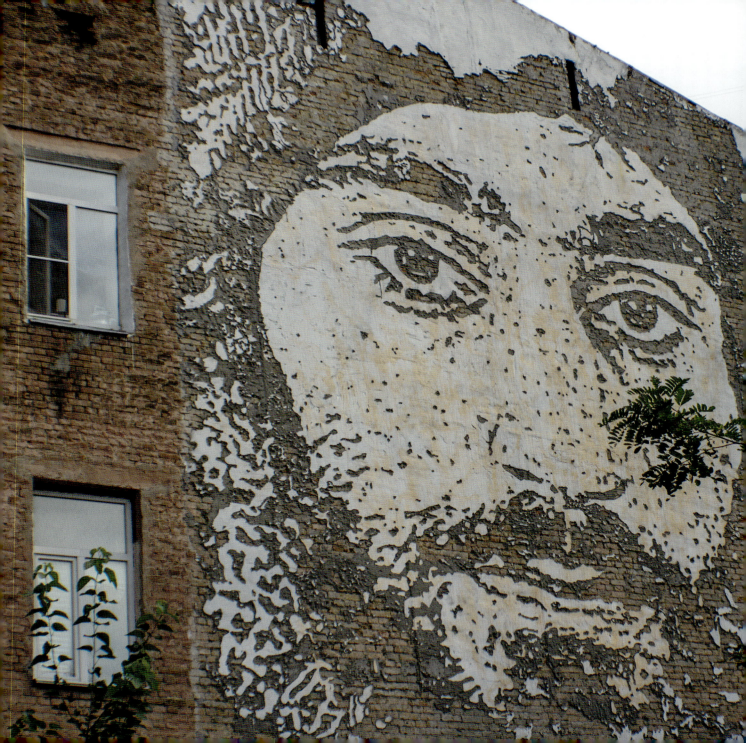

This textured and painted mural is a portrait of Serhii Nihoian. It was created by the Portugese artist, Alesandre "Vhils" Fartu.

Nihoian's parents were from Armenia, but for their son home was a village in the Dnipropetrovsk region of Ukraine. Nihoian first participated in the Euromaidan Revolution on 8 December 2013. Six weeks later, on 22 January, he was shot dead by President Yanukovych's riot police. Yanukovych was the Kremlin's man.

Serhii Nihoian is one of 112 demonstrators to have been killed during Euromaidan. Each is commemorated with a niche and a plaque close to Independence Square.

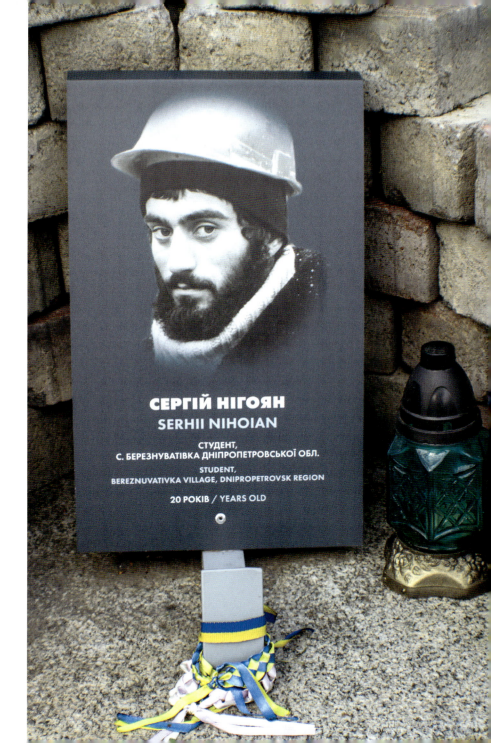

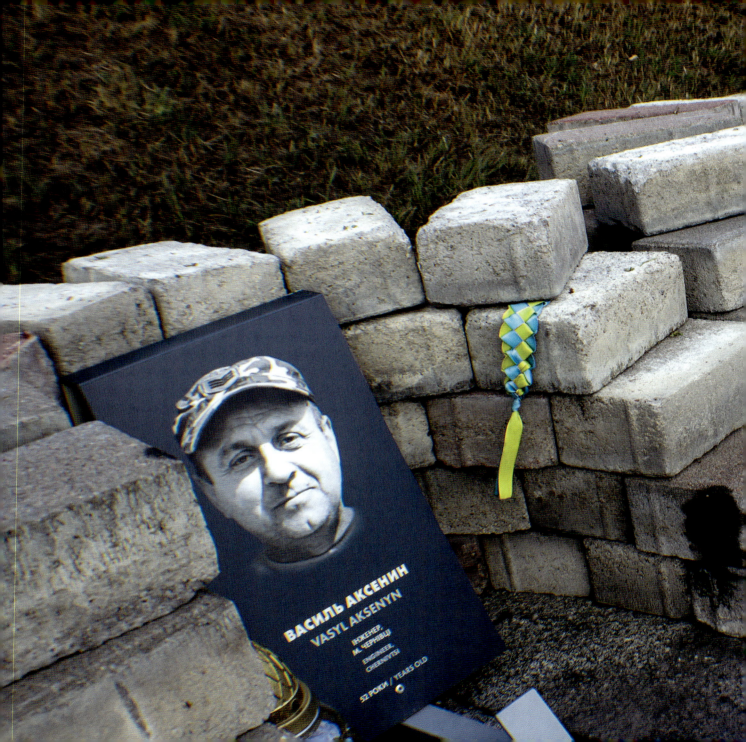

All those who died in 2014 (including three non-Ukrainians) were posthumously declared National Heroes.
20 February is the official day of mourning for them.

In alphabetical order, Vasyl Aksenyn is the first in line to be commemorated.

Overleaf: the celebration of nature and a softer search for Ukrainian identity seem to be receding from recent murals. This is not surprising, perhaps, given all that happened after Russia invaded. However, although the meta-theme of many new murals is patently War, gestures traditionally considered feminine still break through.

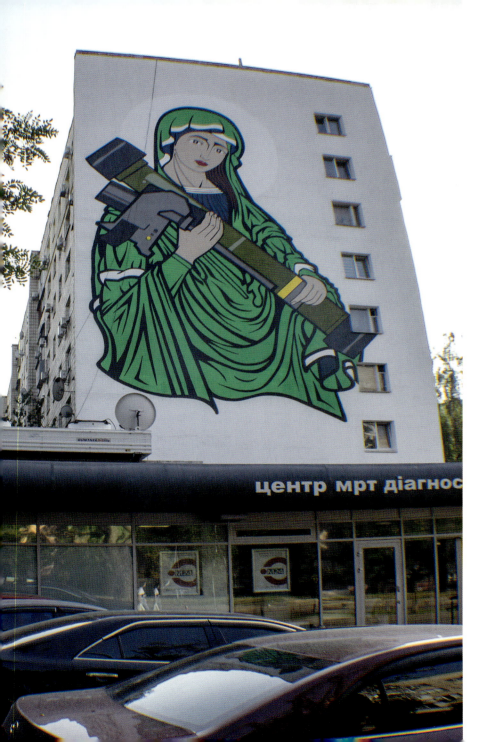

Left: titled *Saint Javelin,* this mural (above a supermarket in Kyiv) is by design group Kailas-V Art & Marketing. The image offended the World Council of Churches, which asked for a blue halo around the saint's head to be erased. The artists claim that Vitali Klitschko, Kyiv's mayor, "vandalised" the mural in this way to appease religious leaders.

Top right: a plaster and paint mural by Sasha Corban. This was a new image when I photographed it in 2022.

Bottom right: BKFoxx, an artist from New York, painted this onto a police academy in Kyiv. BKFoxx only uses aerosol paints, and strictly no brushes.

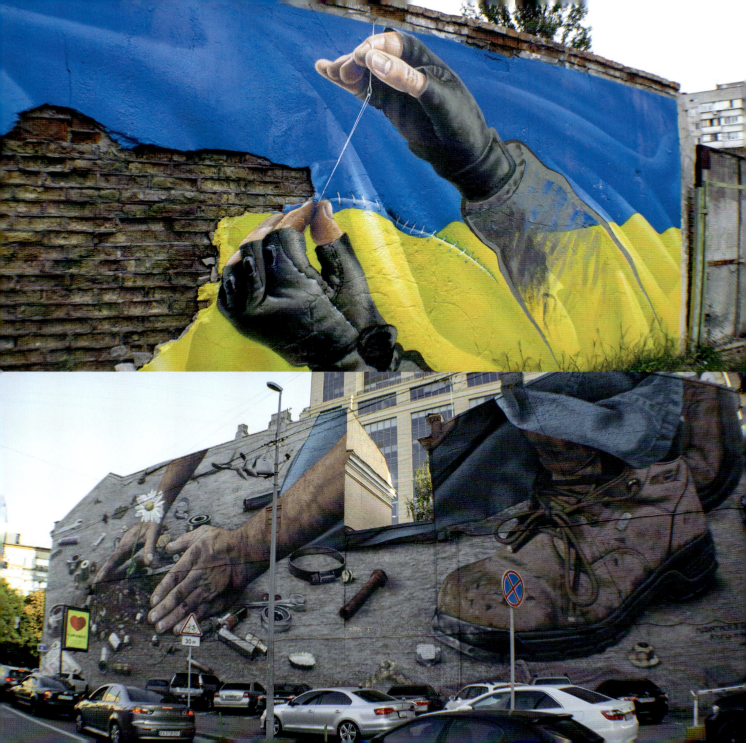

The slogan reads: WE ARE HERE TO CONTRIBUTE TO THE WORLD. OTHERWISE WHY ARE WE HERE?

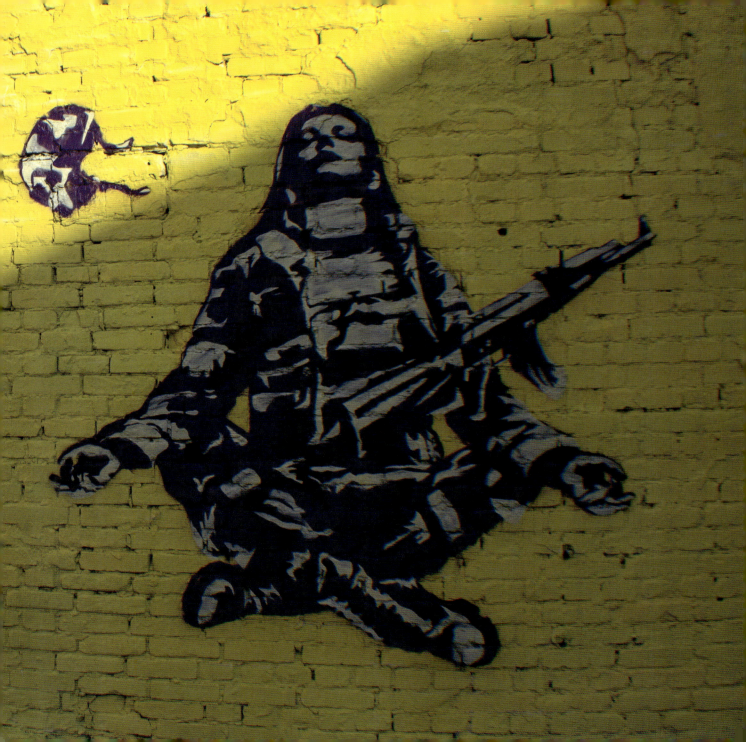

DO YOU HEAR ME, MUMMY?
Julia Bazya

I'll sing you a lullaby
As you once sang to me
And then I shall rise into the sky again
To appear to you in a dream.

I'll tiptoe around the room
Looking for my bear.
Why can't I hug you?
Mummy, tell me, why?

I want to hug you so much
Do you remember how we used to live?
You, our naughty cat and Dad—
We were so happy.

We were lying in bed with you
You were stroking my hair.
Mum, can I come to you "for a little while"?
Wait, I'll ask Him.

He says that I can't
That there's danger all around.
He says it isn't safe down there
Not an easy time on earth.

Mummy, I don't know why this happened
I'm somewhere here, but you are—far away.
I'm trying to get down to you
But in vain. Do you hear me, Mummy?

I'll try again. Perhaps I'll manage it
Just believe in my strength.
Mum, a little bit more—and the sun will rise
And you and Dad will have some peace again.

I probably won't come back
That's what happened to you and me.
But I'm really worried about you.
Take care, do you hear me, Mummy?

See page 19 for information about the source of this poem, which is written in rhyming verse in Ukrainian language.

Right: Andrii Kovtun painting the *Ghost of Kyiv* mural. Photograph by the author, Kyiv, 2022.

GHOST OF KYIV

ЧУЄШ, МАМ?
Юлія Базя

Заспіваю тобі колискову,
Як колись ти співала мені,
Ну а потім здіймусь в небо знову,
Щоб з'явитись тобі уві сні.

Я навшпиньках пройдусь по кімнаті,
Пошукаю ведмедя свого.
Чом не можу тебе обійняти?
Мам, скажи мені, ну чого?

Я так хочу тебе обійняти,
Пам'ятаєш, як ми жили?
Ти, наш кіт неслухняний і тато –
Ми такі щасливі були.

Ми лежали з тобою у ліжку,
Ти торкалась волосся мого.
Мам, чи можна до тебе «на трішки»?
Почекай, я спитаю Його.

Він сказав, що мені не можна,
Небезпека повсюди у вас.
Він говорить, що знизу тривожно,
Нелегкий на землі зараз час.

Мам, не знаю, чому так сталось,
Я десь тут, ви – далеко там.
Я спуститись до вас намагаюсь,
Не виходить! Ти чуєш, мам?

Я ще спробую. Може, вийде,
Просто ти в мої сили вір.
Мам, ще трохи - і сонце зійде,
І ви з татом побачите мир.

Я, мабуть, уже не повернуся,
Так судилось мені і вам.
Та за вас я дуже боюся.
Бережіть себе, чуєш, мам?

Ghost of Kyiv is the first of a series of large-scale street murals that will appear in Ukraine and abroad during the realisation of a project called Art Against War! It is coordinated by Serhii Moskalyuk, the founder of the charity For My Ukraine, together with the creative team of the Charity Hub agency. Leading Ukrainian and world artists are involved in Art Against War! For more about this project, please visit www.4myukraine.com.

A few days after I arrived in Ukraine, I was told that a new mural was about to be painted in Podil, in Old Kyiv. I was excited to observe the process. The mural was called *Ghost of Kyiv.*

The mural was built around a documentary photo of a Ukrainian fighter pilot seated in his MiG-29 jet. Legend has it he shot down six Russian planes on 24 February 2022: the first day of the invasion.

Ukraine's Air Force, which seems to have initiated this story, later conceded that it wasn't exactly true. But it seemed to help people cope—so they allowed it to spread.

People I met in Kyiv in the summer of 2022 were still reluctant to acknowledge this superhero story was more fiction than fact. In reality, there was a small squadron of fighter pilots protecting Kyiv, several of whom were shot down and died, I believe.

For My Ukraine, a local humanitarian organisation, commissioned this mural in honour of the Ukrainian Air Force. Andrii Kovtun designed it, and he, Anton Kondrashov and Grisha Shokole painted it between 19–27 August.

Along with the *Saint Javelin* mural (see page 224), I believe *Ghost of Kyiv* was one of the first large, overtly militaristic murals to be painted in the capital.

On the first day of painting the wall was inspected and repaired. An old fluorescent lamp was removed, and a window that would have opened in the middle of the fighter pilot's helmet was bricked up by a local workman.

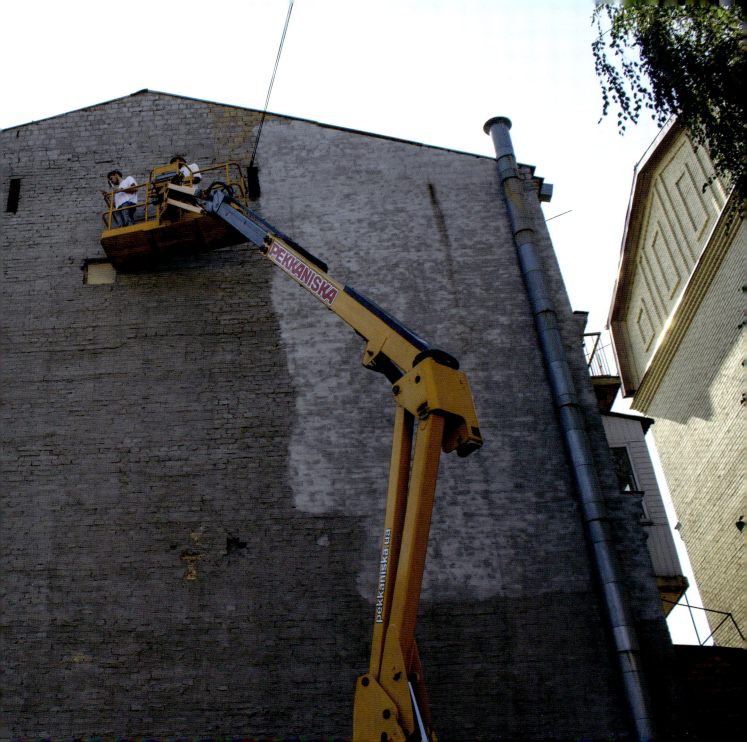

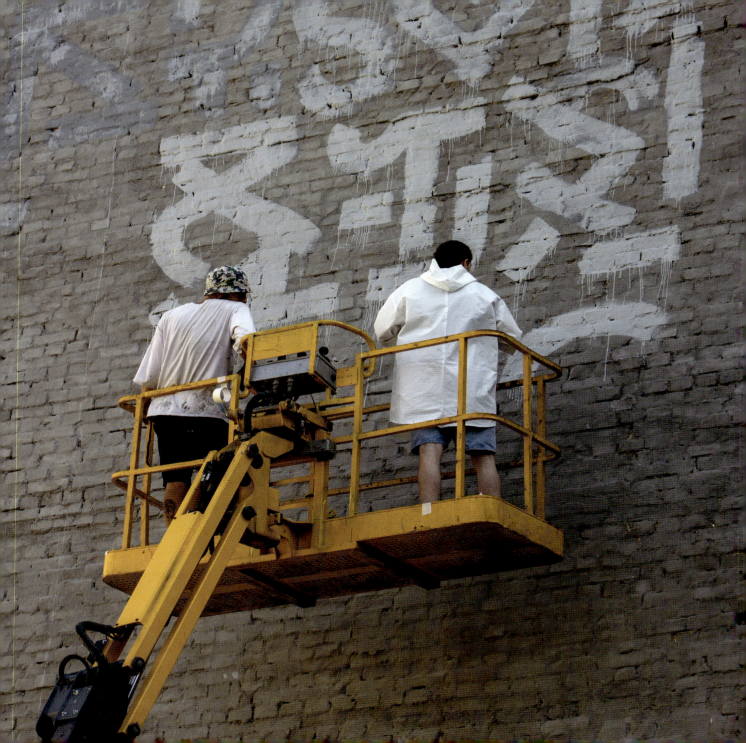

A light grey forest of what looked like hieroglyphics was painted across the whole wall with a wide brush and a roller.

I was told that these shapes are used by the artists to comprehend the space. But I honestly didn't understand how, since to me they seemed quite random and unintelligible. The artists seemed to know what they were doing, though.

Sometimes, large murals are projected onto the wall from a facing building, and then copied as a line drawing. However, since Kyiv had a curfew in place, this wasn't possible. So the *Ghost of Kyiv* was hand-drawn onto the wall by the lead artist, Andrii Kovtun.

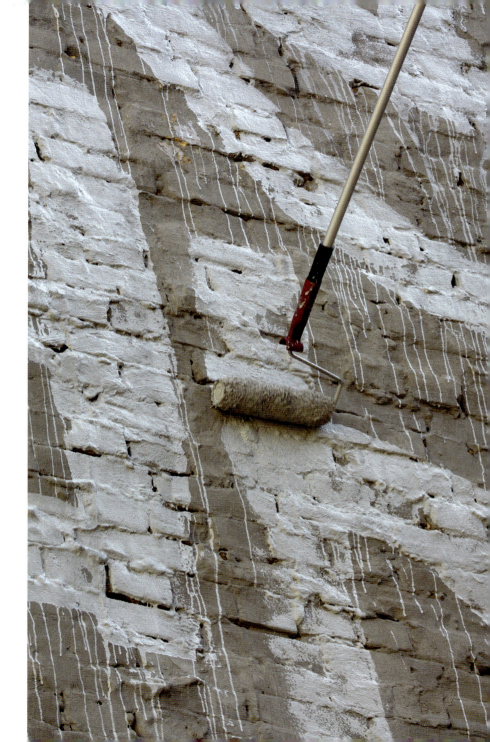

During the initial design process, Andrii overlaid his artwork in Photoshop onto a picture of the building. He then drew a series of plot lines over the image. These lines were later copied onto the wall.

Working up close to such a large surface can be very disorientating. I went up on the crane with the artists, and a few centimetres from the building I could see nothing more than a vast expanse of dirty brickwork stretching out all around.

Imperfections on the surface of the wall are also disconcerting for artists who aren't used to painting murals or graffiti.

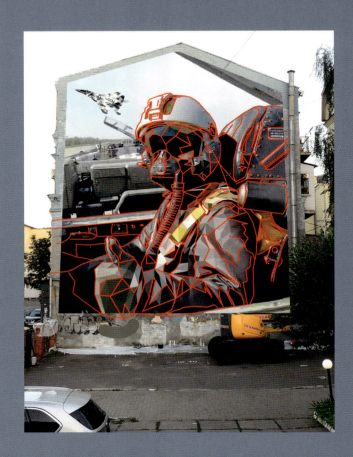

The sky, a fighter plane and black plot lines were drawn onto the wall. The next step was to refine the black lines with more precise white lines. Andrii had to work under pressure: one week—which is all he had—is a very short time to paint such a large mural.

Overleaf, left: members of the For My Ukraine charity hung out, drank coffee, and watched work progress. Serhii Moskalyuk (in the centre of the group of three) is the director of For My Ukraine as well as the Art Against War! project.

Overleaf, right: it seemed impossible to me that Andrii could transpose such a tiny reference image onto this giant wall.

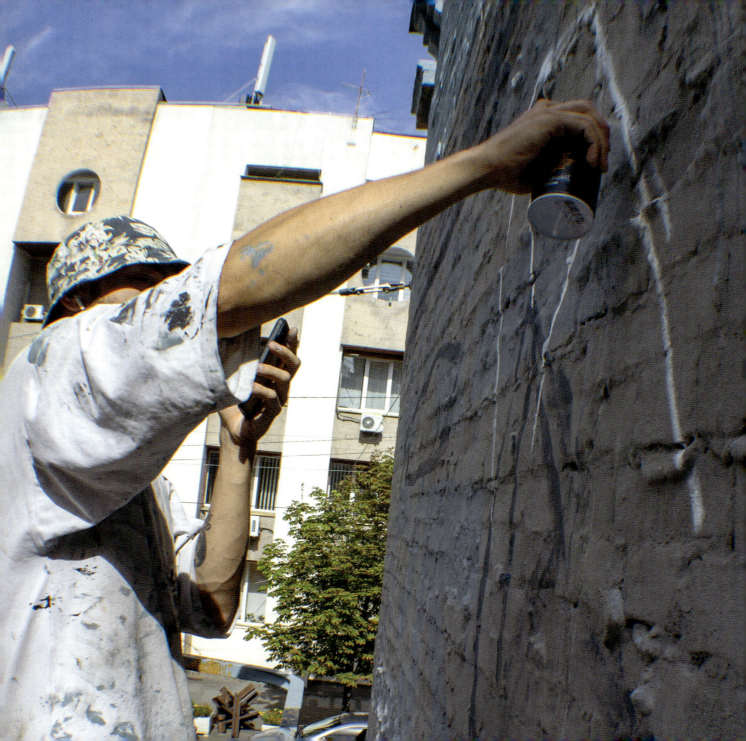

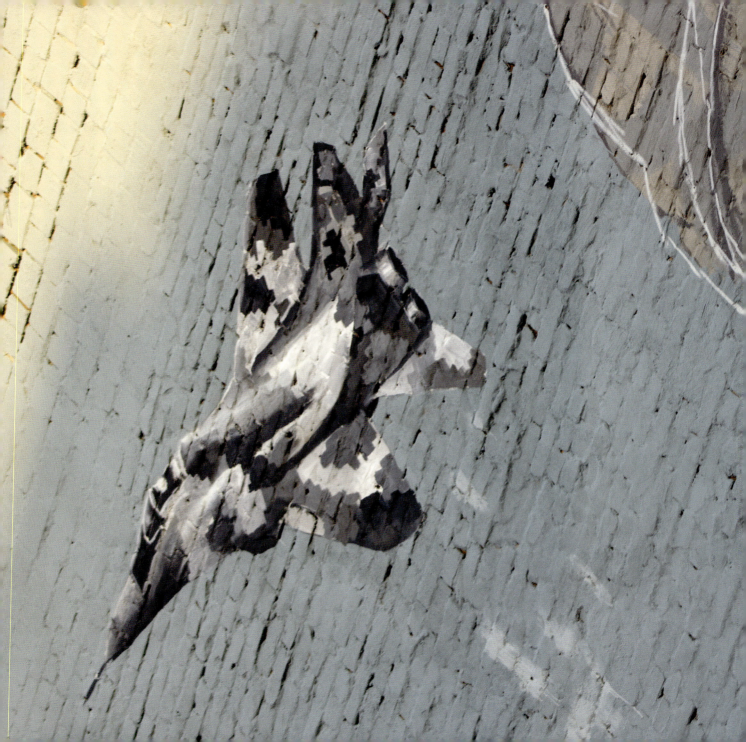

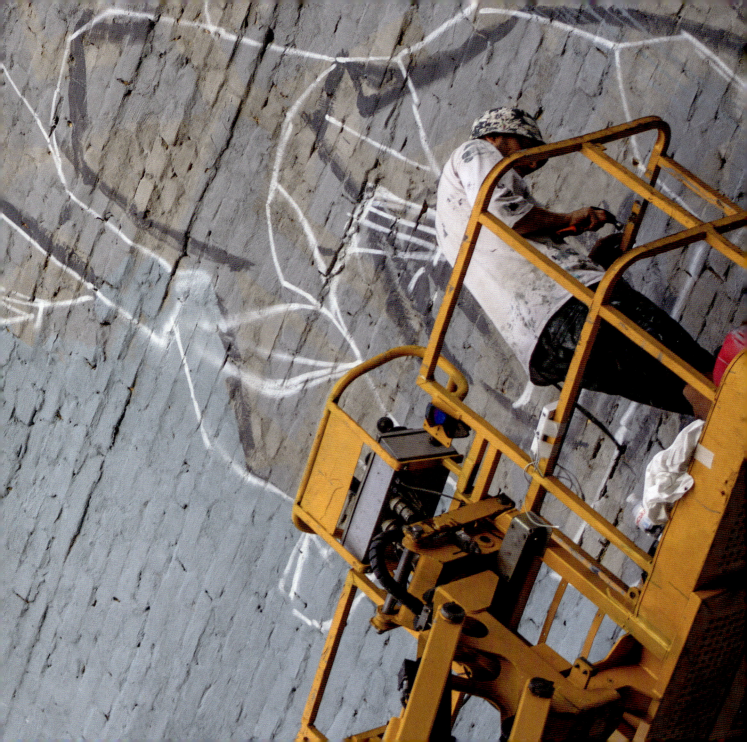

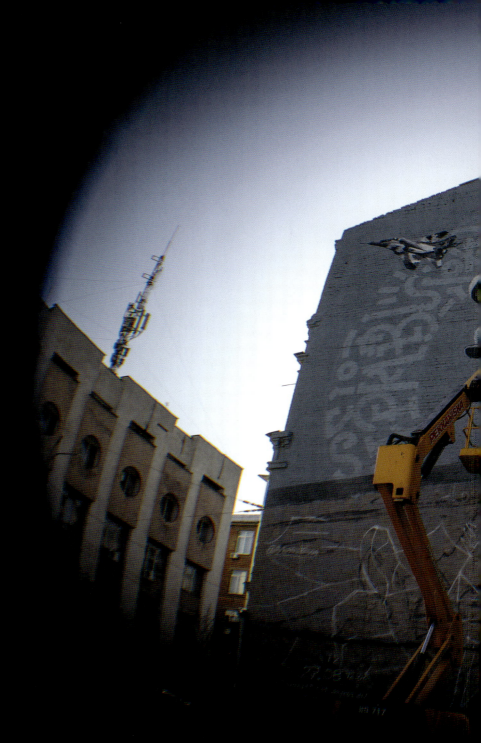

Once portions of the image looked complete, Andrii started to add a fractal effect over them. Later, a circular calligraphic motif was painted into the sky.

With only one day left until the opening—on National Air Force Day, Saturday 27 August—the artists were working flat out in shifts. They started at five in the morning, when the nightly curfew ended and the sun came up.

Then, at midday on Saturday, *Ghost of Kyiv* was finished …

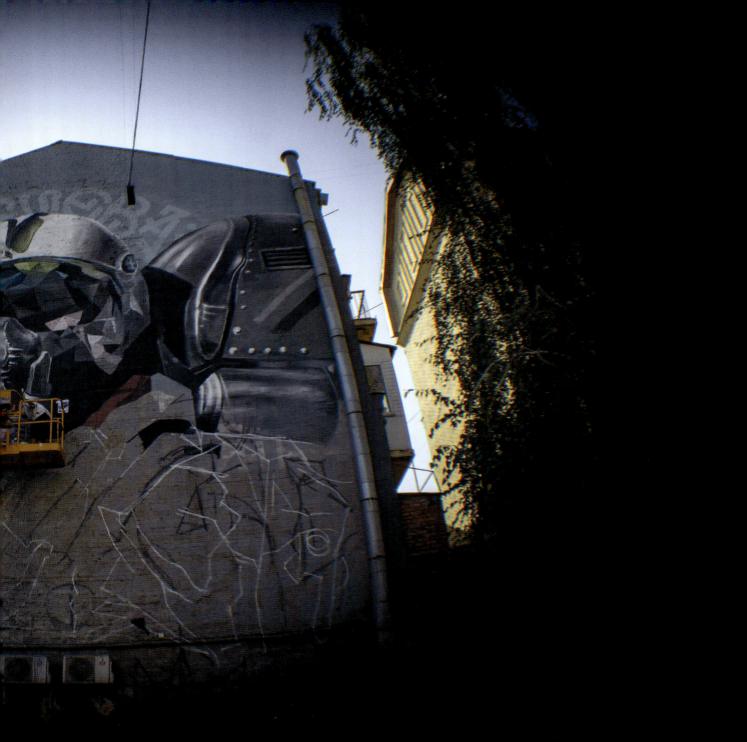

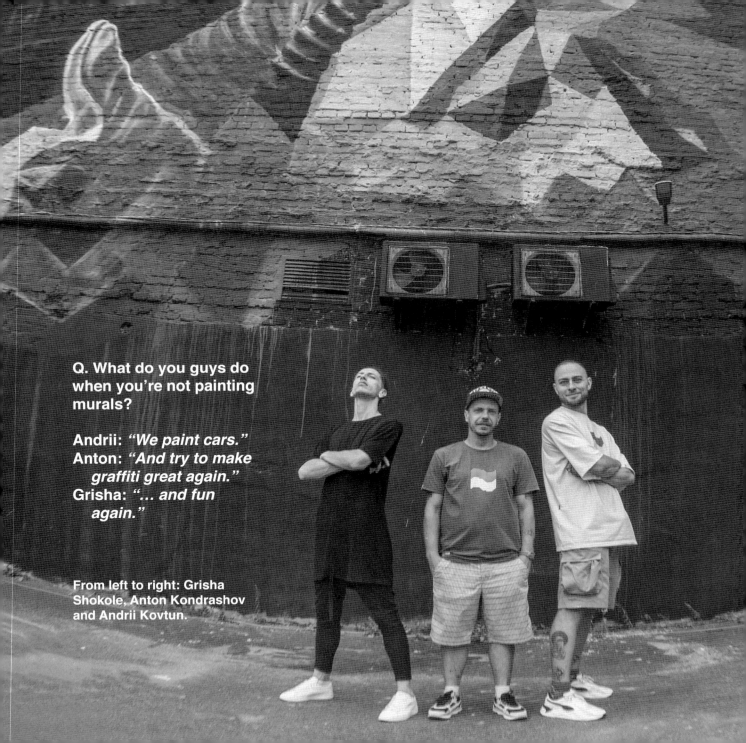

Q. What do you guys do when you're not painting murals?

Andrii: *"We paint cars."*
Anton: *"And try to make graffiti great again."*
Grisha: *"… and fun again."*

From left to right: Grisha Shokole, Anton Kondrashov and Andrii Kovtun.

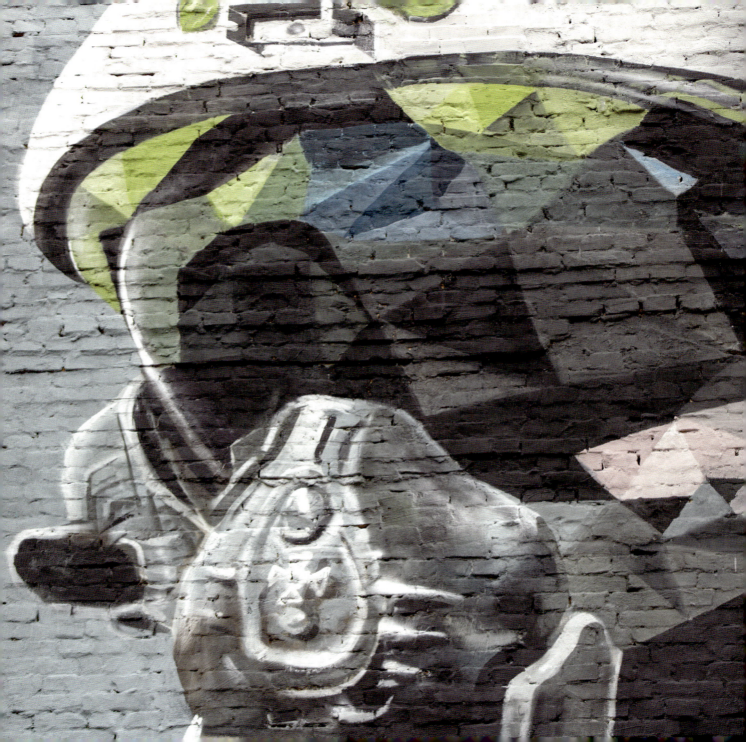

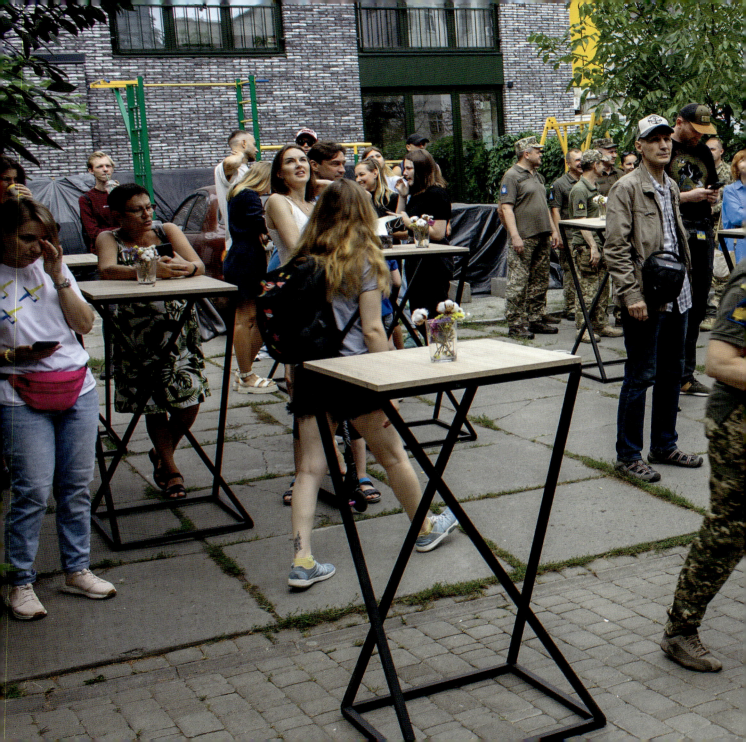

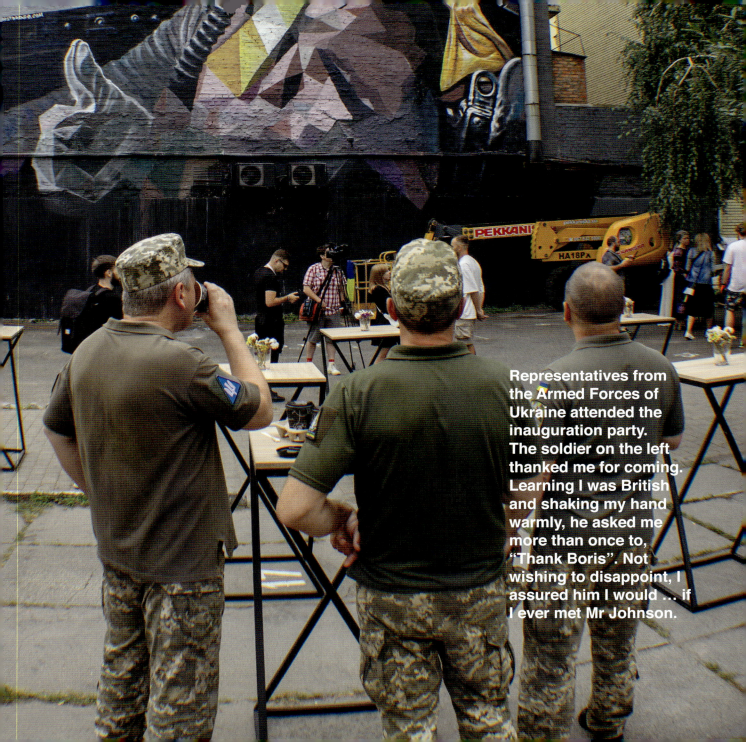

Representatives from the Armed Forces of Ukraine attended the inauguration party. The soldier on the left thanked me for coming. Learning I was British and shaking my hand warmly, he asked me more than once to, "Thank Boris". Not wishing to disappoint, I assured him I would … if I ever met Mr Johnson.

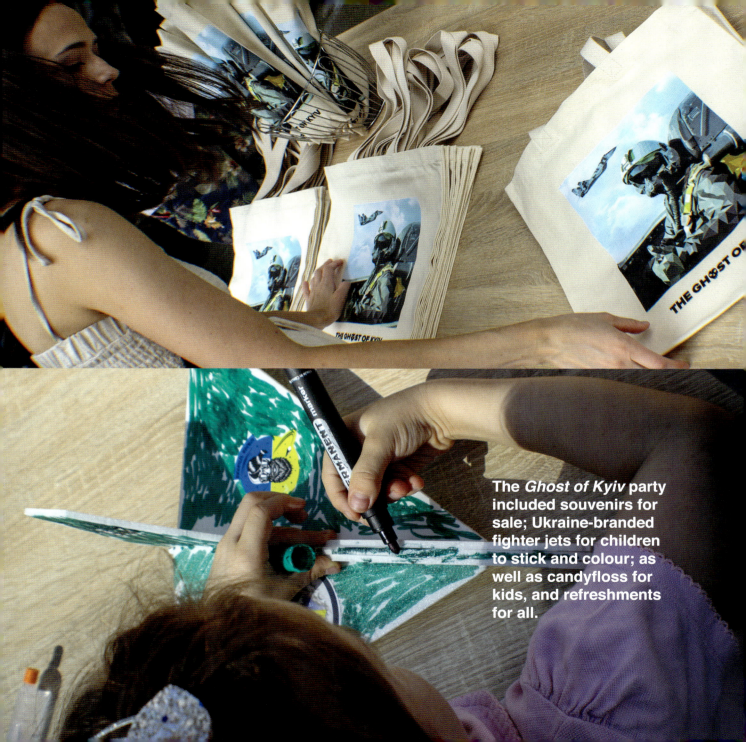

The *Ghost of Kyiv* party included souvenirs for sale; Ukraine-branded fighter jets for children to stick and colour; as well as candyfloss for kids, and refreshments for all.

There was also a haunting coffee table made from a highly polished tree trunk, hollowed out and filled with clear resin. Abandoned toys from a destroyed building in Bucha floated alongside bullet casings and shrapnel collected from the streets.

The table was being sold to raise money for the Ukrainian army.

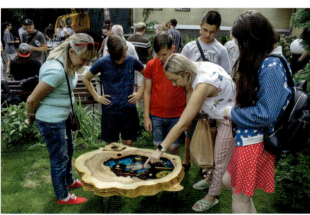

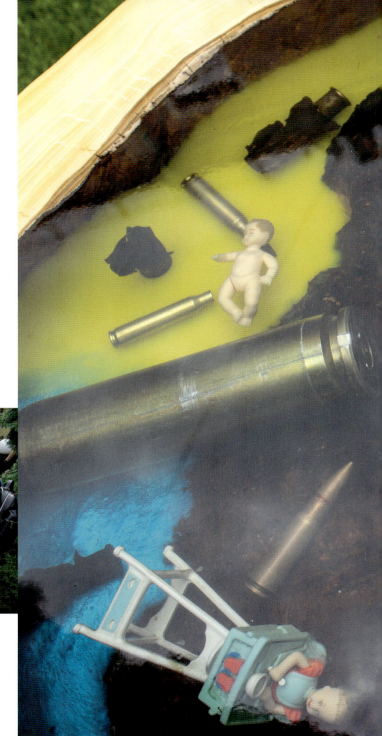

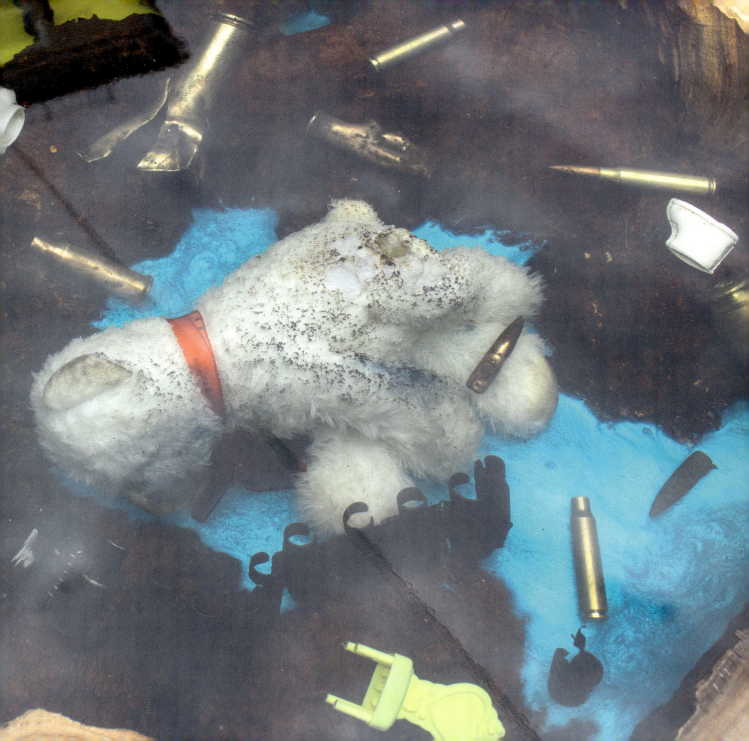

To end an enjoyable day, hand printing was organised on the wall beneath the mural. Disposable gloves were thoughtfully provided.

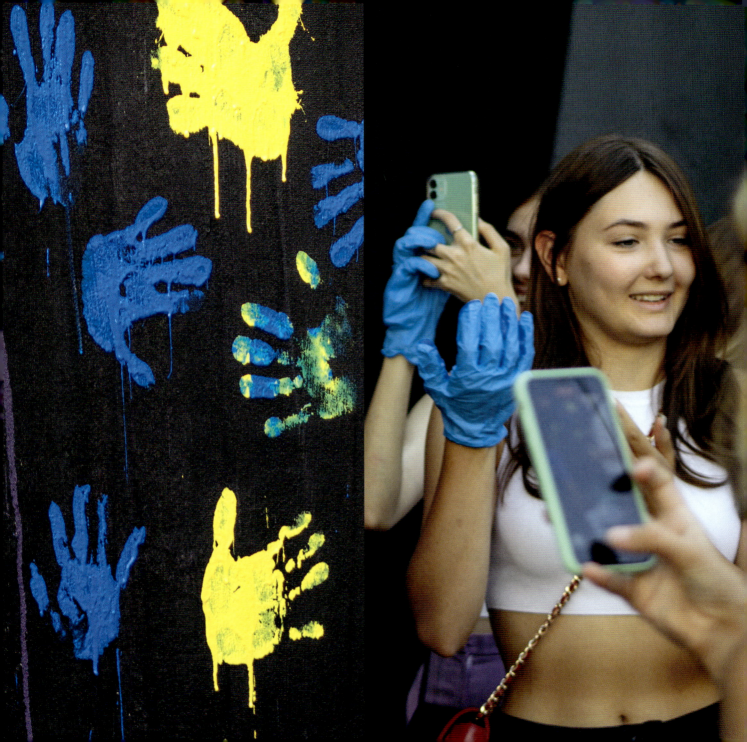

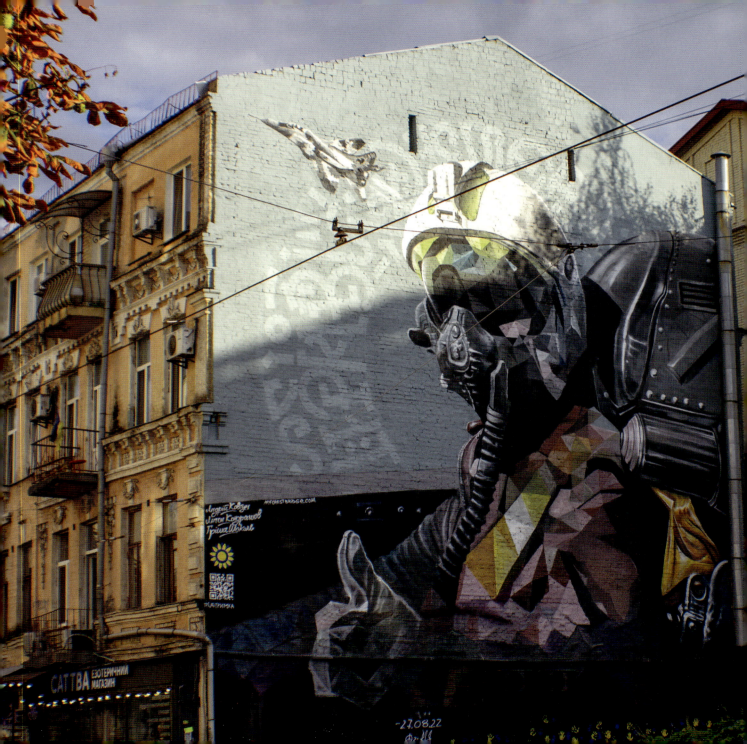

When I passed by the mural a few days before leaving Kyiv, I couldn't help but feel a sense of foreboding about such an overt display of *Top Gun*-style military prowess on the lovely streets of Old Kyiv. Were these the themes people were going to have to get used to living with? And for how long? Suddenly, it didn't seem like so much fun, although I recognise that keeping people's spirits up is vitally important.

On 9 February 2023, Ukraine's President Volodymyr Zelenskyy visited London to petition the government for fighter jets. In Westminster Hall, he presented the speaker of the parliament, Sir Lindsay Hoyle, with a Ukrainian fighter pilot's helmet emblazoned with the words, "We have freedom, give us wings to protect it." It has been reported that the helmet belonged to the legendary Ghost of Kyiv.

We will have to wait and see whether this highly theatrical gesture helps Ukraine acquire the war planes it so desperately needs to fulfil its battlefield objectives.

Below: photograph from the official website of the President of Ukraine (www.president.gov.ua/en), 2023 (public domain).

EXILE
Natalya Mraka

A girl with a burnt wing
And a dream that no longer flies.
The sound of whistling fades away
And then a siren rises again.

Silence that broke into a scream.
March did not begin with rain.
Rockets sounded through the window.
The girl leaned against her mother.

The city—a blackened canvas
Storks' nests were destroyed.
At the station they peer through the glass
Small eyes and thin shoulders.

See page 19 for information about the source of this poem, which is written in rhyming verse in Ukrainian language.

Right: giant pixel stencils, used for painting cars. Photograph by the author, Kyiv, 2022.

GRAFFITI ARTISTS
PAINT CARS

ВИГНАНКА
Наталя Мрака

Дівчинка з обпеченим крилом
З мрією, що більше не літає..
відсвистіло в вухах, відгуло
та сирена знов наздоганяє.

Тиша, що зірвалася на зойк.
Березень почався не дощами.
Гримали ракети у вікно.
Дівчинка тулилася до мами.

Місто – почорніле полотно,
гнізда поруйновано лелечі.
На вокзалі дивляться в вікно
оченята і худенькі плечі.

When Andrii Kovtum finished painting the *Ghost of Kyiv* mural, I asked him what else he did. *"We paint cars,"* he replied—explaining that when volunteers go to fight on the eastern front they often have to supply their own vehicles. They buy these privately, usually outside Ukraine—and typically in the UK, where used cars are cheaper and better maintained—and must then get them camouflaged. I was intrigued, and asked Andrii if I could take some photos of the process.

A few days later he called and said that a British 4x4 had just arrived; I should meet him and his friends in downtown Kyiv at 5:30 p.m.

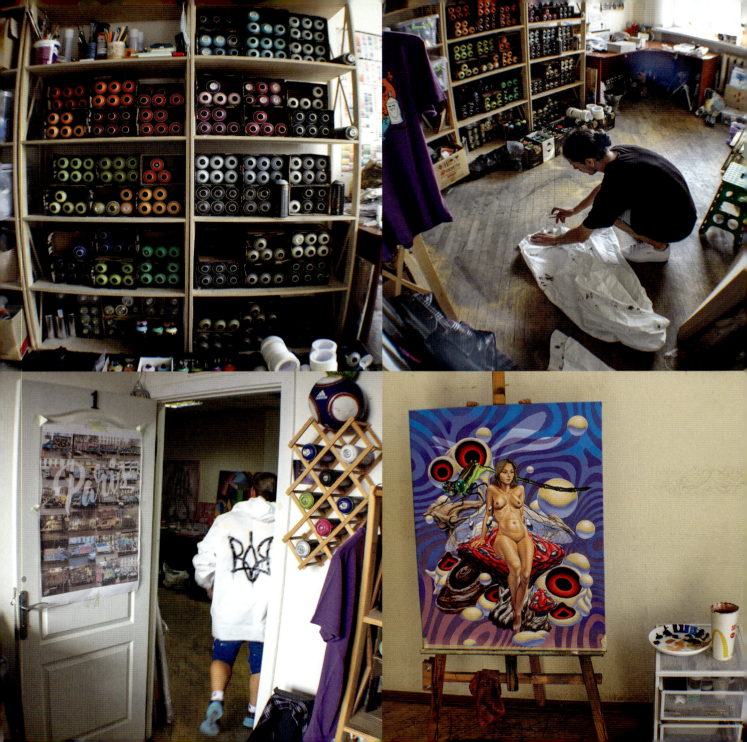

While Andrii got the 4x4 cleaned at a local car wash, Anton and Grisha prepared to paint.

To make a little extra cash, the artists stock good quality spray paint to sell to fellow graffiti artists.

Andrii said that painting is a voluntary activity to support the military effort. What they get paid only covers the cost of the paint, and a little extra. If they're lucky, maybe they make about 10 euros per car each, he said—with a meal thrown in if they're *extra* lucky. (On this occasion they were, and I was invited to eat too.)

After spraying an endless stream of military cars, Andrii got so obsessed with camouflage that he even started painting camouflaged canvases—such as this one I spotted in the corner of his studio. It was propped up in front of a much more vibrant nude study (opposite).

Looking at these two images side by side, the 1960s counter-culture slogan MAKE LOVE NOT WAR came to mind; never had this saying struck me as *less* superficial. Anyone who has spent time in any war zone realises that camouflage colours are thoroughly deadening to mind and soul.

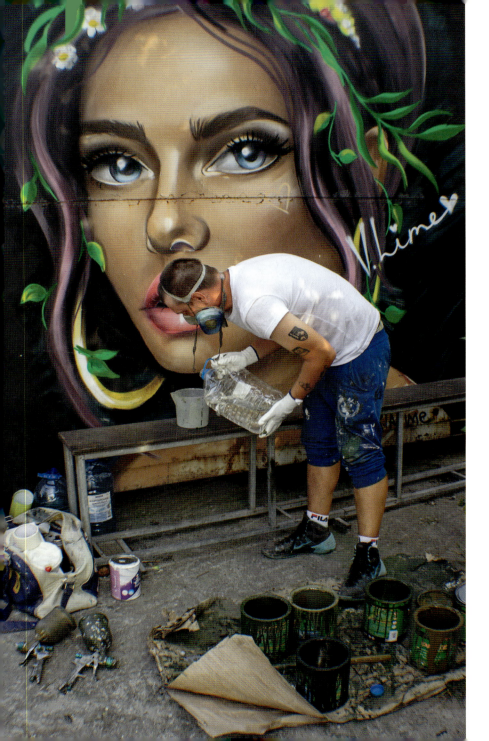

Andrii's studio building is in an industrial zone on the edge of Kyiv. An elderly security guard drank tea and watched the artists work. And while they did, several soldiers drove in enquiring about camouflage. One of these was a sniper fighting in Bakhmut, in the Donbas. His call-sign was Jewel, he told me, flashing a knife engraved with this nickname. He really had been a jeweller before the war. Jewel is Russian, but in Stalin's time his mother's Ukrainian parents were deported to a Siberian Gulag. He told me he was doing Russian soldiers *"a spiritual favour by sending them to a better place than home"* with his sniper rifle. *"I'm another kind of jeweller now,"* he said.

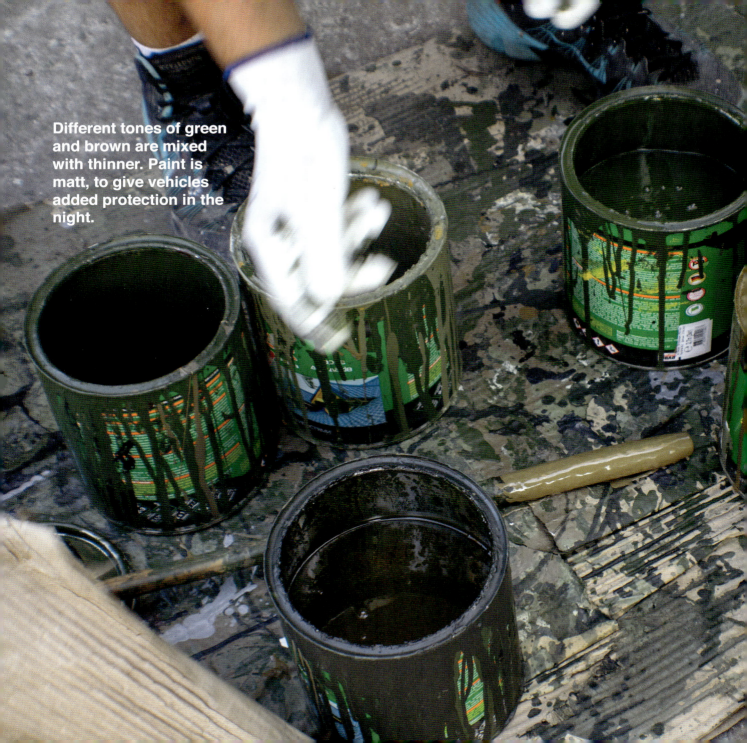

Different tones of green and brown are mixed with thinner. Paint is matt, to give vehicles added protection in the night.

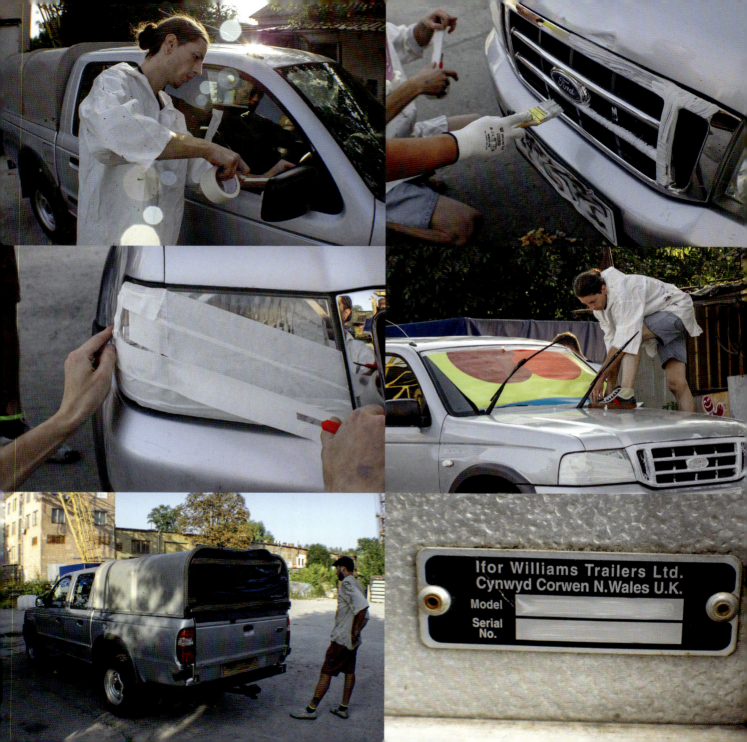

Glass and mirrors are masked and chrome is primed. Lights are also partially masked before being sprayed. This reduces their illumination area, making cars less visible to the enemy when driven at night.

I noticed a Welsh workshop badge riveted onto the trailer canopy [vehicle numbers have been obscured] and discovered that a British female volunteer soldier had imported this 4x4. She would come and collect it in the morning.

Soldiers prefer right-hand-drive British vehicles, I was told, because Russian snipers get confused (and miss) when they try to shoot the driver through the windscreen.

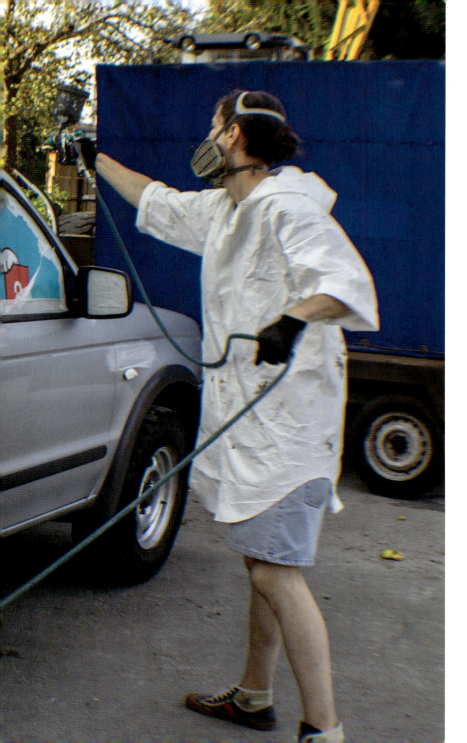

To start with, Grisha quickly sprayed the vehicle's entire body and roof with a continuous zigzag line. The triangular shapes were then filled in with contrasting shades of green and brown. Using pixel stencils (overleaf, bottom row) hard lines between shades were then erased.

Each graffiti artist has their spraying technique, and Anton (overleaf, top row) proudly told me that he had developed this fast, furious and elegant one. Andrii said that most graffiti artists he knows are now camouflaging, and when they see war footage they often spot *"their cars"*. It makes them feel good, he told me, to be helping win the war through art.

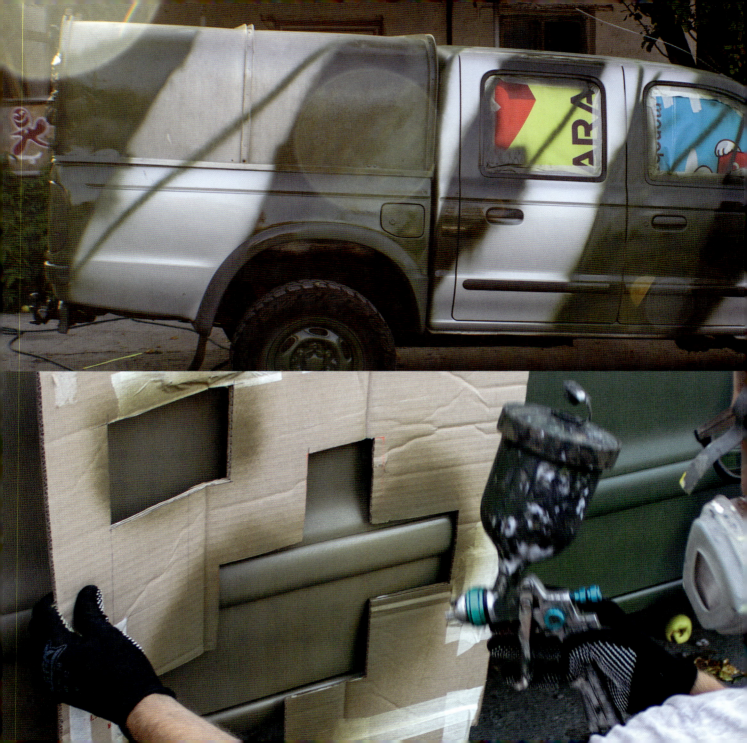

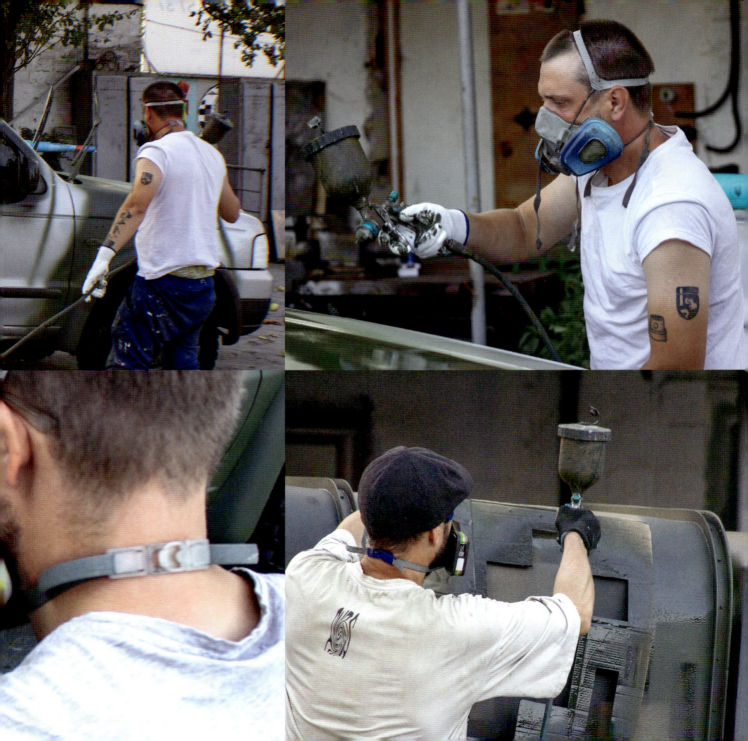

At 9 p.m.—exactly three-and-a-half hours after the British 4x4 was picked up in the centre of Kyiv—it was battle-ready.

The next day, it would be driven east to one of the brutal frontlines by a British female soldier.

Overleaf, left: a rear light after spraying.

Mosaic: some of the many vehicles painted by Andrii Kovtum and his friends over the summer of 2022. These photos were taken by Andrii, and at his request all readable car licence plates have been obscured.

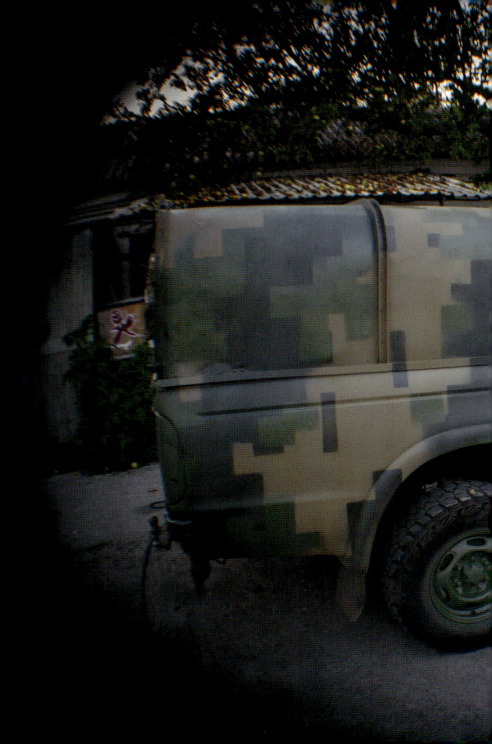

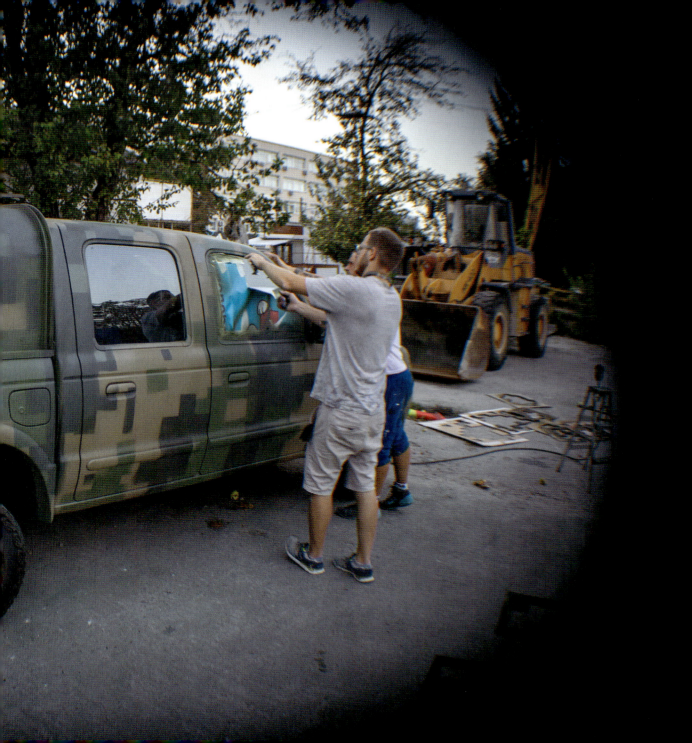

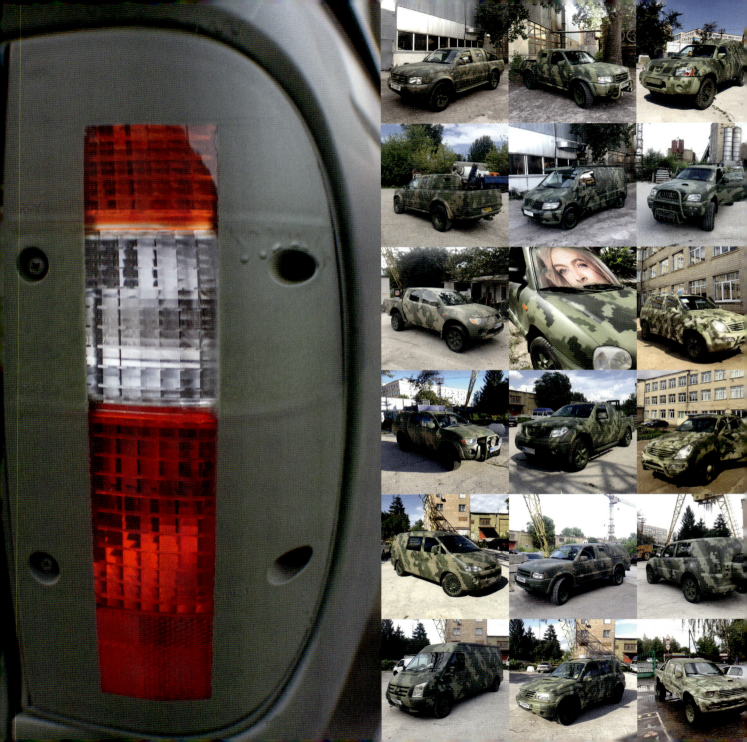

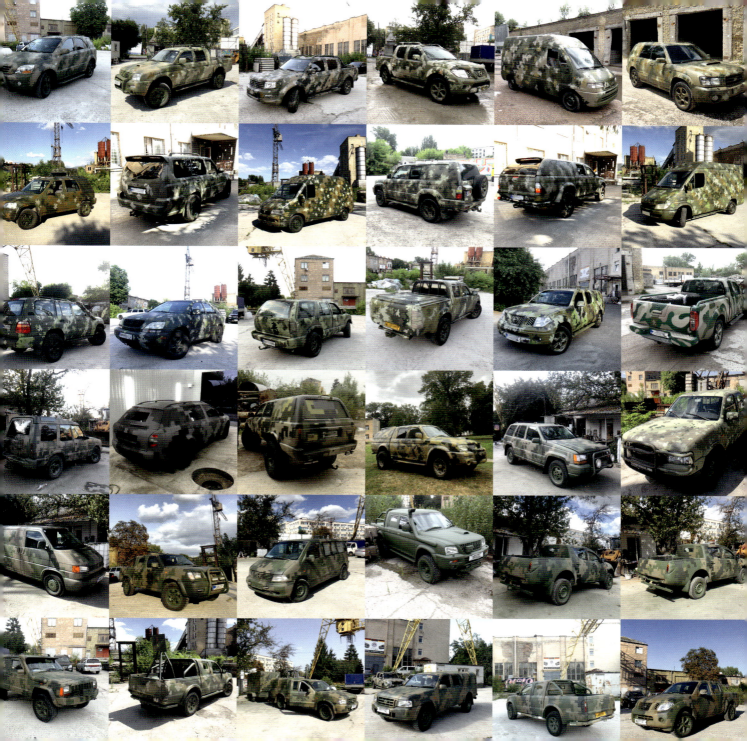

THE KEYS TO HAPPINESS
Nataliia Samruk

"Miss, where are you from?"
I'm from Ukraine.
"Where's your luggage?"
I don't have any
My home is destroyed
And through a mist of tears
I cannot see the world.

"Miss, are you cold?"
Don't worry, I'll be fine
I'm still trembling from having survived
We thought the invasion would be over soon
But Death is still grinning in our faces.

A spring sky, exploding missiles
And barbarians passing verdicts on themselves
You know the only thing we need now
Is to stand side-by-side in this struggle.

Freedom is like breathing
We need it so much
We shall win and make gardens
Instead of ruins all around
The power of victory
Is moving our warriors forward!

Things that seemed so very important
Were totally ruined by this senseless war
Bloody wounds live in my heart, and maybe
That pain will never disappear.

It's quiet here, but I've heard the sirens
And Death breathing, the darkness of night
What's that in my hand? Oh, I almost forgot—
These are the keys to past happiness.

This one is small, it's from the postbox
But no one leaves letters there any more
The wind plays melodies in the branches
And sorrowfully ruffles a cat's tail.

This one is from the station waiting room
Where no more trains will arrive for ages.
And this last one is from my flat—
It's blackness forged from human tragedy.

I wish I could open the door to the future
Where fairy tales come true!

Temples are spun from grey threads
Quiet sadness floats through the heavens.

See page 19 for information about the source of this poem, which is written in rhyming verse in Ukrainian language. This English translation is by Kateryna Papkina.

Right: an image painted in an outdoor graffiti park next to the grounds of the Lavra monastery. Photograph by the author, Kyiv, 2022.

MAKING GRAFFITI
GREAT AGAIN

КЛЮЧІ ВІД ЩАСТЯ
Наталія Самрук

- Пані, ви звідки?
- Я з України…
- Де ваш багаж?
- Я не маю валіз.
Дім мій тепер – то суцільні руїни,
Світу не бачу за маревом сліз…

- Пані, ви змерзли?
- Облиште, минеться…
Від пережитого досі трясе…
Думалось, швидко навала мине ця,
Та раптом Смерть показала лице…

Розчерком градів в весняному небі
Нелюди присуди пишуть собі,
І розумієш: усе, що нам треба, -
Стати плечем до плеча в боротьбі.

Воля – як подих, нам вкрай необхідна.
Ми переможем, насадимо сад
Замість руїни… І сила побідна
Рухає воїв: ні кроку назад!

Все, що здавалось до краю важливим,
Вмить зруйнувала безглузда війна…
Рани криваві на серці й, можливо,
Біль цей ніколи уже не мина:

Тихо у вас, та сирени я чула
Й подих Кістлявої чутно вночі…
Що в мене в жмені? О Боже, забула:
Це ж від минулого щастя ключі!

Цей от, малий, - від поштової скриньки,
Де вже ніхто не напише листа,
Вітер у гіллі мелодії бринька,
Журно куйовдить котові хвоста…

Цей - від вокзалу, від зали чекання,
Де вже не ходять давно поїзди.
Цей – від квартири, а цей от, останній –
Весь почорнів від людської біди.

Як би хотілось мені відчинити
Двері в майбутнє, де казка живе…

Скроні засновані срібними нитками,
Тиха зажура у хмарах пливе…

Even during a war, some artists don't feel comfortable expressing political ideas. Maybe they want to hang on to their innocence, or maybe they are just tired of military hardware and camouflage colours.

Like anywhere in the world, Ukrainian graffiti artists also just want to have fun, or at least approach things from a slightly lighter angle.

In this chapter, there are some examples of anonymous graffiti observed around Kyiv; we meet the Feldman Sisters; Banksy makes a timely appearance; and things get poetic around Independence Square.

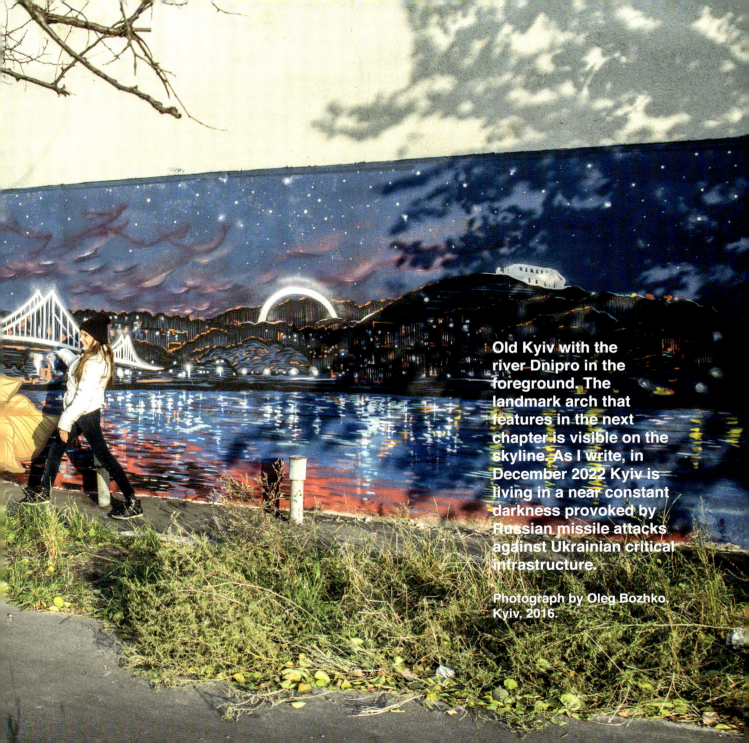

Old Kyiv with the river Dnipro in the foreground. The landmark arch that features in the next chapter is visible on the skyline. As I write, in December 2022 Kyiv is living in a near constant darkness provoked by Russian missile attacks against Ukrainian critical infrastructure.

Photograph by Oleg Bozhko, Kyiv, 2016.

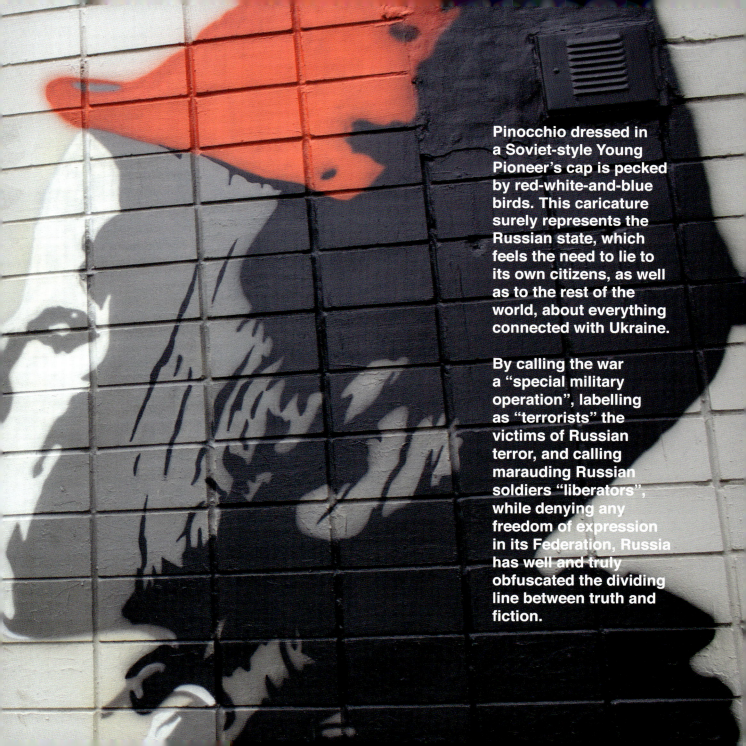

Pinocchio dressed in a Soviet-style Young Pioneer's cap is pecked by red-white-and-blue birds. This caricature surely represents the Russian state, which feels the need to lie to its own citizens, as well as to the rest of the world, about everything connected with Ukraine.

By calling the war a "special military operation", labelling as "terrorists" the victims of Russian terror, and calling marauding Russian soldiers "liberators", while denying any freedom of expression in its Federation, Russia has well and truly obfuscated the dividing line between truth and fiction.

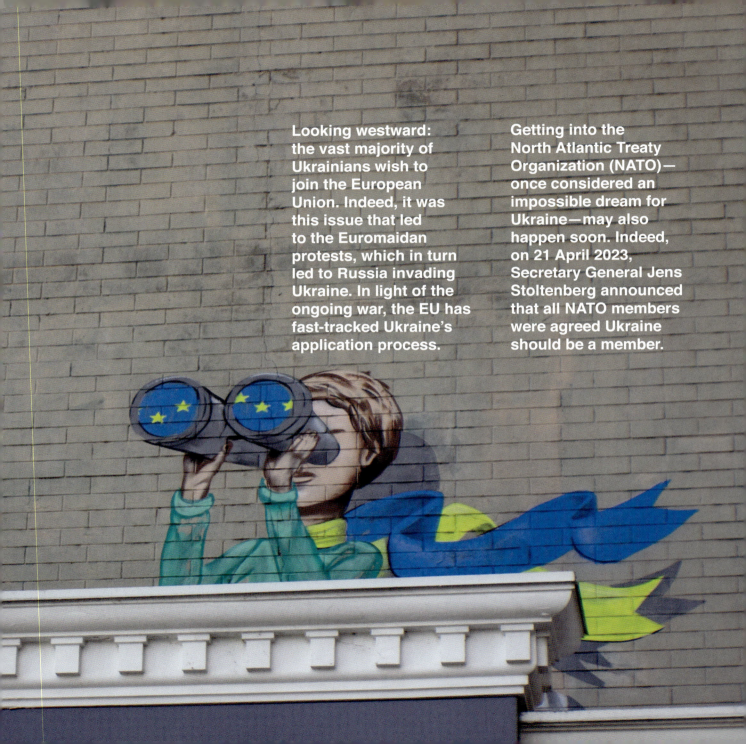

Looking westward: the vast majority of Ukrainians wish to join the European Union. Indeed, it was this issue that led to the Euromaidan protests, which in turn led to Russia invading Ukraine. In light of the ongoing war, the EU has fast-tracked Ukraine's application process.

Getting into the North Atlantic Treaty Organization (NATO)—once considered an impossible dream for Ukraine—may also happen soon. Indeed, on 21 April 2023, Secretary General Jens Stoltenberg announced that all NATO members were agreed Ukraine should be a member.

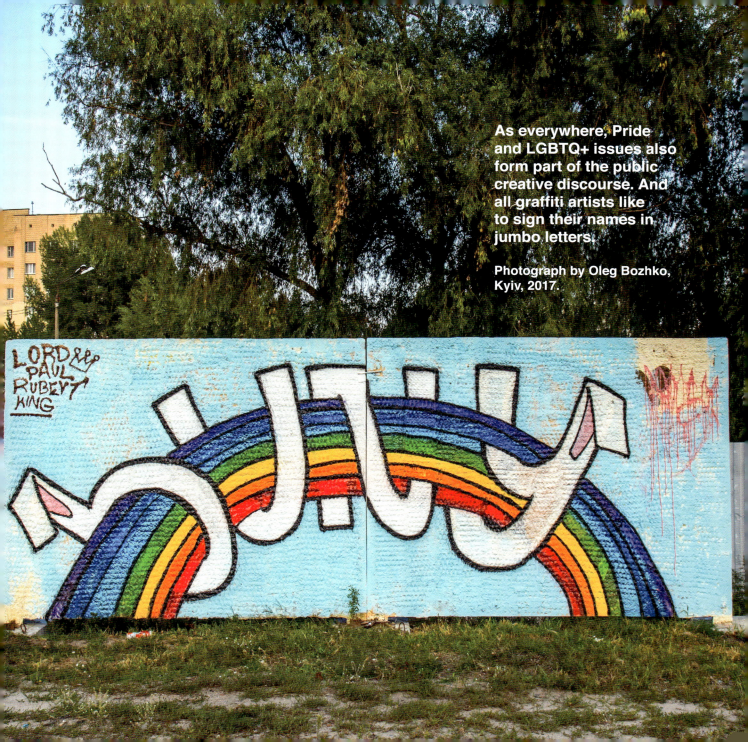

As everywhere, Pride and LGBTQ+ issues also form part of the public creative discourse. And all graffiti artists like to sign their names in jumbo letters.

Photograph by Oleg Bozhko, Kyiv, 2017.

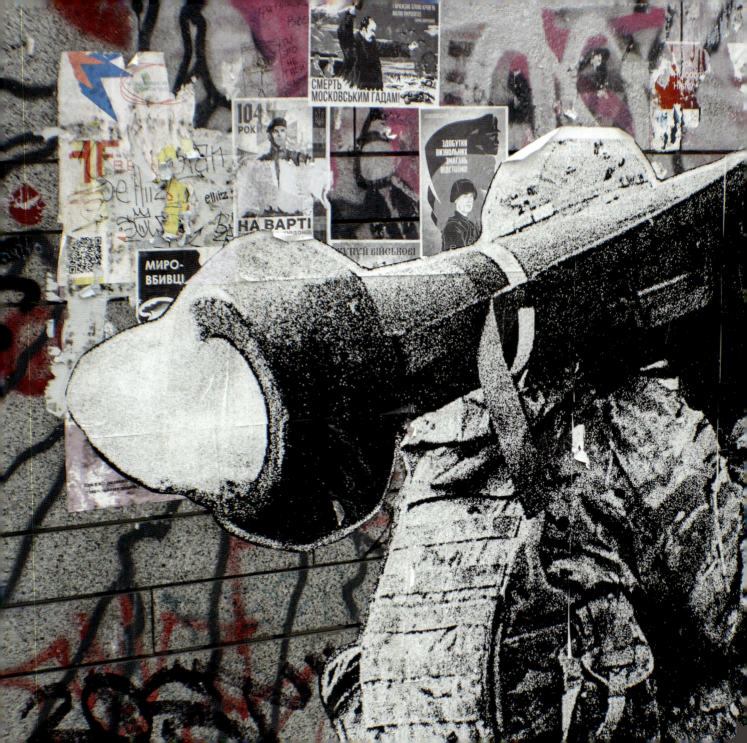

On closer inspection, some graffiti turned out to be photocopied paper stuck to the wall and sealed with a thick coat of wallpaper paste.

This heavily pixelated image of a soldier firing an NLAW anti-tank missile was made up of multiple sheets of letter paper. The NLAW, along with the Javelin, was the star weapon of the war at the beginning of the invasion.

Overleaf: the message on the missile streaking across the wall reads: THE ONLY TARGET— implying Russians, presumably.

Take aim … Fire! Russia's President Vladimir Putin and Foreign Minister Sergey Lavrov, alongside Belarusian President Alexander Lukashenko.

Anonymous stencil art, photographed by Ihor Kucher in May 2023, in the men's washroom at the Podshoffe restaurant on Kyiv's right-bank.

I was told that after a cult British trip hop band called Massive Attack played Kyiv on 26 July 2018, a Banksy graffiti mysteriously appeared in the city. But nobody told me where it was or what it depicted. There is a probably spurious theory that Massive Attack and Banksy share some creative connection, as they are from the same English city: Bristol (where I grew up).

Then one day I came across this image. Was it the elusive Banksy? I doubt it—but it's very nice graffiti in his style. "Never give up in the face of an impossible challenge," it says to me. "Fight!" Which is exactly what Ukraine did and is still doing as this book goes to press.

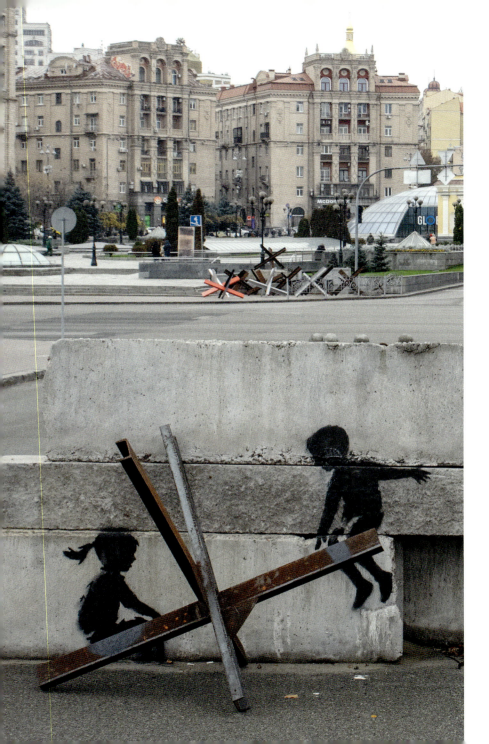

Then, in early November 2022, a series of real Banksys started appearing in Ukraine. People, as well as the press, got excited.

Left: Ihor Kucher took this photo of two children playing see-saw on a barricade. (Varvara Logvyn's red-and-white hedgehog can be seen in the background.)

Right: Banksy soon confirmed that he had been in Ukraine, with this gymnast balancing on rubble in Borodianka (photo by Alina2206, Creative Commons, 2023). After this, another five images by Banksy came to light in Ukraine. The authorities then had to work out how to protect them as cultural heritage.

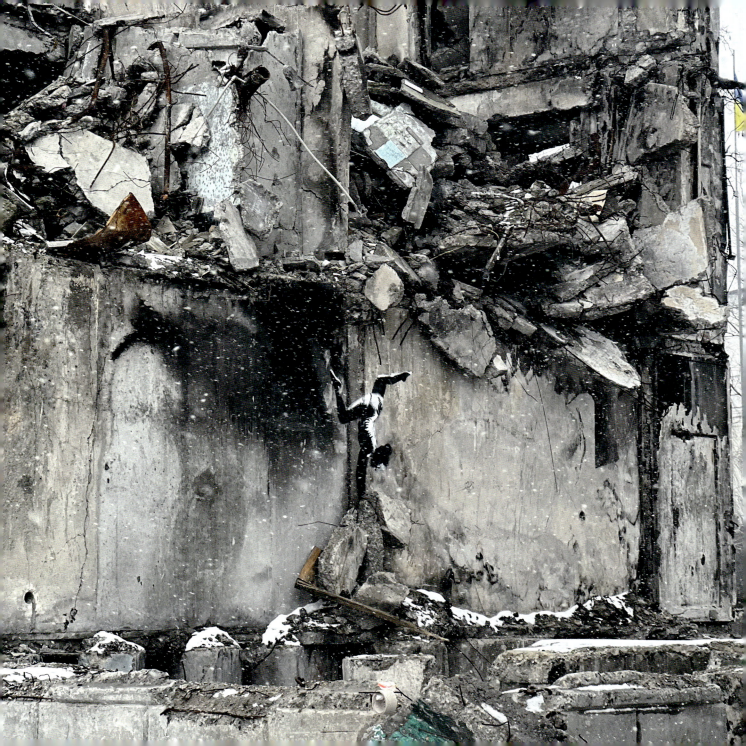

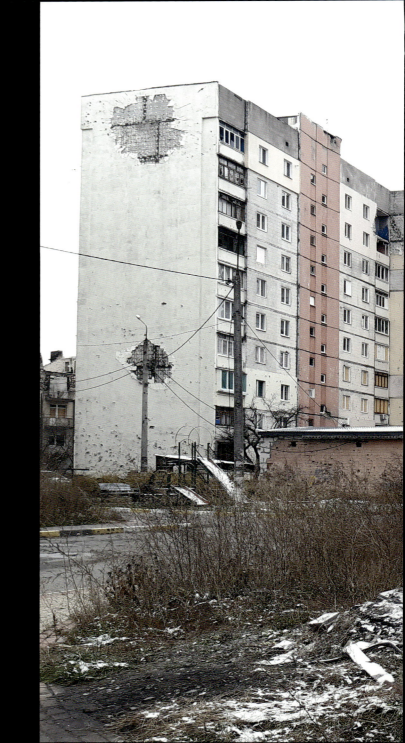

Right: gymnast in neck brace. Banksy, Irpin, 2022. Photograph by Rasal Hague, 2022 (Creative Commons).

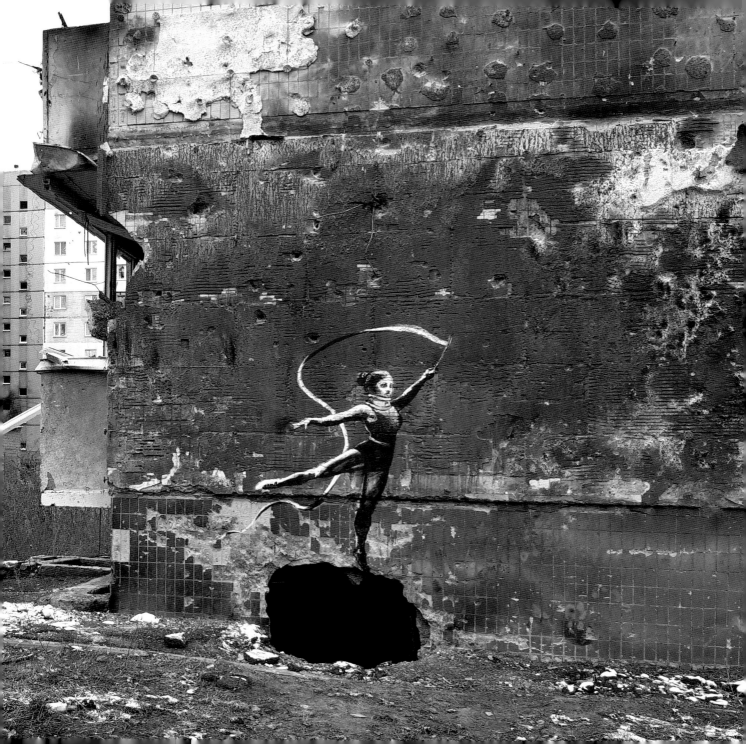

Mishel and Nicol Feldman were two of the most talked-about young graffiti artists in Kyiv when I met them in 2022. They sign their works: SESTRY FELDMAN. *Sestry* means sisters in Ukrainian language.

After the war started in the east of the country in 2014, the Feldman Sisters moved to Kyiv from Dnipro, a large city in central Ukraine, west of the heavily fought-over Donetsk province.

Their graffiti—painted as well as signed collectively—is cheerful and sublime. They told me they don't usually comment overtly on the war in their work, but at the same time they like to celebrate Ukrainian strength and beauty. Walking around Kyiv, I kept seeing the sisters' graffiti. And whenever I did I felt a little lighter for it.

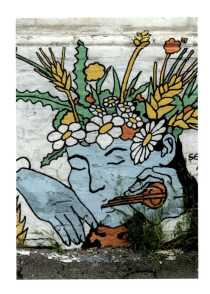

"War is all about fighting. And a lot of guys ... artists too ... think they should go to war. But as girls we don't have this conflict. We don't feel we have to fight. We can ... A lot of women do go to the army ... But it's not an obligation. So we can make our art and not feel like we're doing something less important by expressing our emotions. It's easier for us in that way, maybe."

Mishel Feldman

Above left: a Ukrainian woman wearing a *vinok* headdress (see page 16). Photograph by the Feldman Sisters.

Right: Mishel (left) and Nicol (right) are non-identical twins. They draw and paint independently, but mostly together.

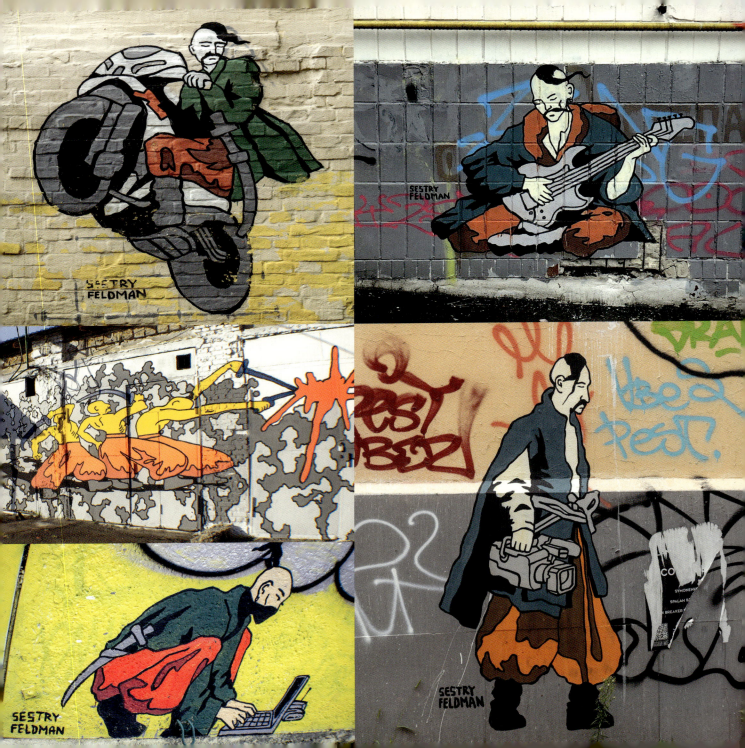

Left: the Cossack in a modern urban setting is one of the Feldman Sisters' recurring graffiti characters. Photographs of the Cossack with a motorcycle, guitar, and camcorder are by the Feldman Sisters.

While researching and writing this page, I contacted a Ukrainian friend in Kyiv; Ihor Kutcher studied at a Russian University a decade ago, and he understands the national psychology of the country well. He told me, *"In Russia they have never really understood the idea of people living by their own rules and electing their own leaders, as the Cossacks did. History classes in Russia were all about dynasties and succession, and any kind of rebellion against the dominant authority was always presented as something stupid and useless. That's why in Russia they see Cossacks only as some kind of destructive outlaws. But they were much more than that. And they were and are highly valued in Ukraine."*

"Cossack" translates as both "armed person" and "free person". Since the 14th century, the semi-nomadic Cossacks were known for their equestrian and military skills, as well their respect of basic democratic values.

In what is now Ukraine, Cossacks could be found in many regions. However, Cossack culture and society flourished especially around the Dnipro river in central Ukraine, where between 1648–1764 the Zaporizhzhia Cossacks formed an independent state, called the Cossack Hetmanate. Founded by Bohdan Khmelnytsky (see page 89), the Hetmanate was destroyed by Catherine II, who ruled Russia between 1762–96.

Zaporizhzhia Cossacks resettled in different regions east of the Dnipro river—around the Sea of Azov, on the Crimean Peninsula, and in the Kuban steppe—becoming a semi-privileged class. After 1917, however, the Russian Bolsheviks almost exterminated them in these places.

After the end of the Soviet Union and the birth of an independent Ukraine, Cossack traditions were revived. Ukrainians today strongly identify with the Cossacks' rebellious spirit, as well as with their battlefield skills: skills that are proving their worth in the current war with Russia. They are also proud if and when they discover Cossack roots in their family tree.

Another of the Feldman Sisters' favourite characters is this yellow flat-man.

Unlike murals, which need the permission of the authorities, graffiti is still illegal in Kyiv. So graffiti artists have to paint at night—and fast. It's mainly for this reason that the sisters started working on each other's graffiti, they told me, since they get fined if caught.

All photographs on this spread are by the Feldman Sisters, seen above sitting in front of their distinctive street art. They are often commissioned to paint cafés, bars, clubs, etc.

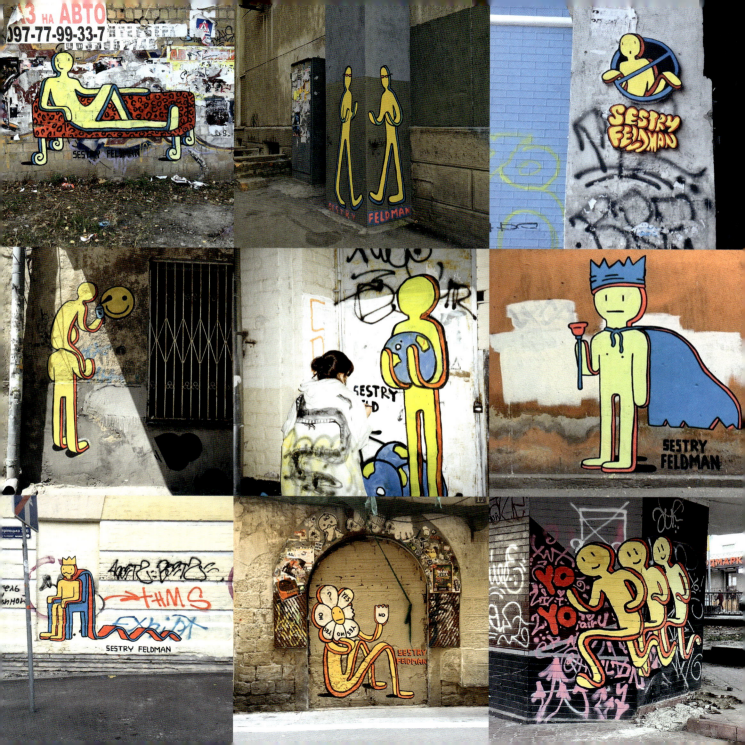

One day, the Feldman Sisters invited me to an avant-garde flat (known as Pink Punk Art Studio) that they had been asked to repaint. It is located in the attic of an old building in downtown Kyiv. A Frenchman named Guillaume Verbecq owns the flat, but he was out of the country.

They had graffitied some slogans on the roof. This was in case any passing Russian fighter pilots or drones were looking down, Mishel ironically explained.

UKRAINE was written on one side of the roof, and FREEDOM on the other.

Inspired by the invasion on 24 February 2022, the Feldman Sisters started working on a Ukrainian-themed pack of Tarot cards. There are 78 cards in total.

They began drawing them while sheltering in the metro when Russia first attacked Kyiv—and it seemed, for a few tense weeks, as if the city might fall.

Each of the sisters designed 39 cards, which were finished on an iPad. Their pack of Tarot cards is now on sale in Ukraine.

The Devil and *The Hanged Man* both represent President Vladimir Putin. The sign around his neck reads: KILLER.

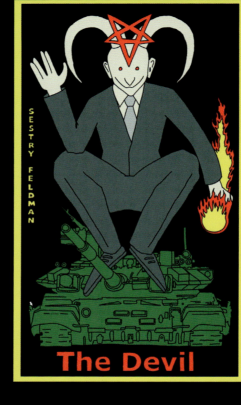

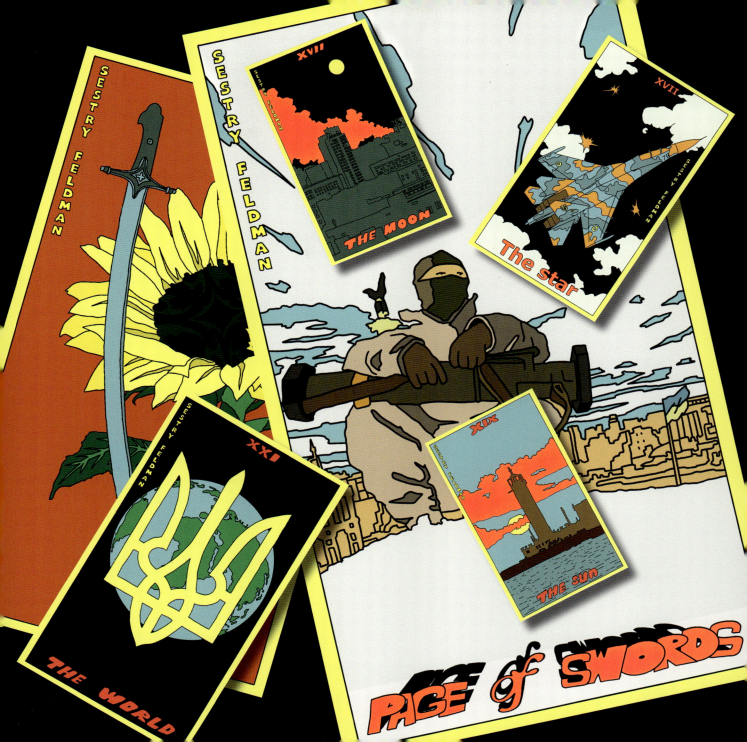

Walking through Kyiv one day, I came across this scene. In 2017, the owner of a furniture store close to Independence Square scrubbed some original street art off his building. It had been painted during the 2013–14 Euromaidan Revolution. Independence Square was the site of riots and death during the revolution—and so young people were angry that the precious graffiti had been wantonly destroyed.

The three images that now mark the spot of the lost graffiti are of three important Ukrainian poets. Collectively known as *Icons of the Revolution,* they were painted by a gaffitist named Sociopath, and are protected by a local by-law.

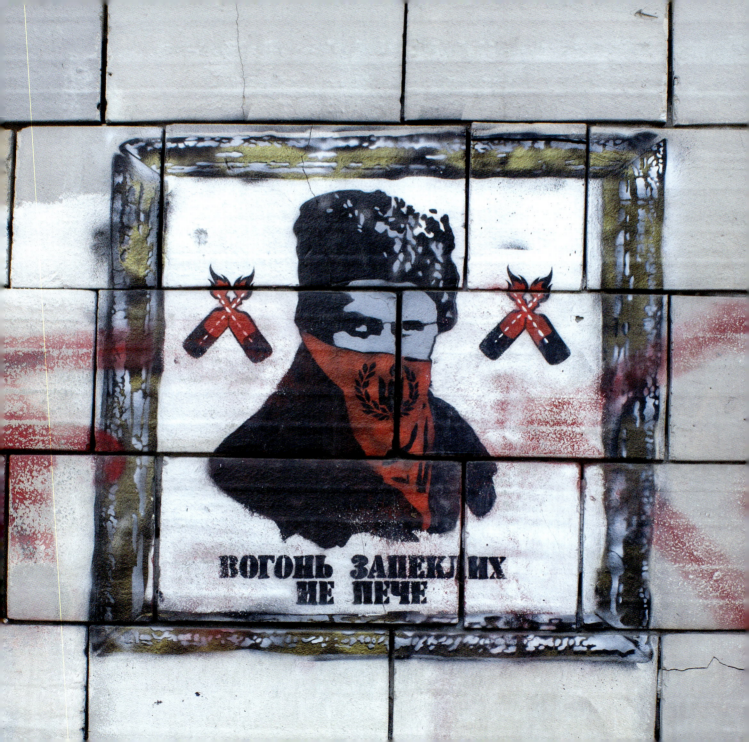

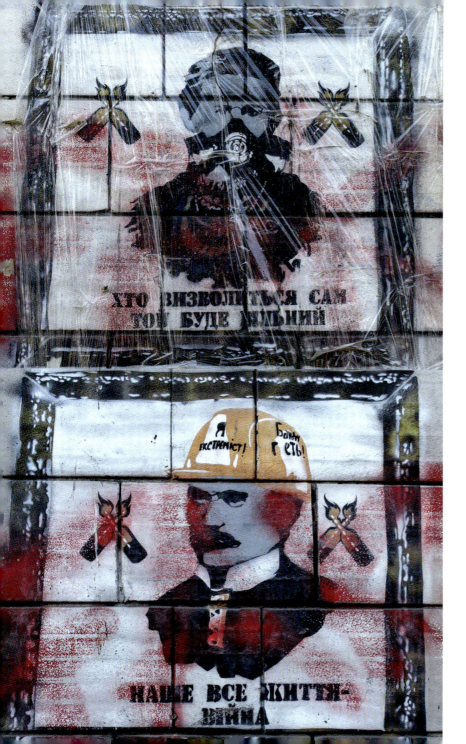

Left: Taras Shevchenko (1814–61): the most famous and politically important Ukrainian poet. The quote from his poem, *Hamaliya*, reads: FIRE DOES NOT BURN THE HARDENED.

Top right: Lesya Ukrainka (1871–1913): a beloved Ukrainian writer, folklorist and feminist. The quote from her poem, *Autumn Fairytale*, reads: HE WHO FREES HIMSELF WILL BE FREE.

Bottom right: Ivan Franko (1856–1916): an outstanding Ukrainian writer, critic and political figure. The quote from his poem, *Mykyta the Fox*, reads: OUR WHOLE LIFE IS A WAR (see overleaf).

MYKYTA THE FOX
Ivan Franko

Our whole life is a war
Everyone fights it as best they can
One with teeth, the other with wings
A third with strong claws
While another jumps fast.
And us, what are we fighting with?

This is just one verse from an epic satirical poem by Ivan Franko (pictured above). The translation is by Katarzyna Szczepańska-Kowalczuk.

All photographs on this spread (except Oleg Bozhko's) are public domain.

Above: there are statues of Taras Shevchenko all over the world. This one, by the Ukrainian-Canadian sculptor Leo Mol (born Leonid Molodozhanyn; 1915–2009) stands in Winnipeg, Canada. It is a copy of a one he created for Bueno Aires.

Shevchenko, however, is still hated by the Kremlin more than 160 years after his death. Before they were forced out of Kherson in November 2022, Russian forces demolished a statue of him.

Right: top, left to right: Taras Shevchenko (his poem *My Thoughts* is on page 319), and Lesya Ukrainka (her poem *Hope Against Hope!* appears on page 203). Shevchenko photograph is by Andrey Denyer (1820–92).
Bottom: a mural of the three Ukrainian poets, by Liryck Bragin. Photograph by Oleg Bozhko, Kyiv, 2022.

WHEN?
Juliana

When will it finally end?
When will our Russian "brothers" go home?
I've been dreaming about it for dozens of nights
Dozens of nights with a fear-torn heart.
When will the guns fall silent?
When will humanity recover its heart and mind?
When will they leave our homes?
When will those people come to their senses?

See page 19 for information about the source of this poem, which is written in rhyming verse in Ukrainian language.

Right: for close to 70 years before Ukraine became an independent nation in 1991, it was the Ukrainian Soviet Socialist Republic. This statue depicts a Ukrainian and Russian worker holding aloft the ribbon of the Order of Friendship of Peoples: a meaningless Soviet award created in 1972 under President Leonid Brezhnev (who ordered the very unfriendly invasion of Afghanistan at the end of that decade).
 The statue was taken down in 2022, a few months after Russia invaded Ukraine and a century after the founding of the Soviet Union. Any shreds of trust in Russia that might have remained after Crimea was annexed in 2014 (and undoubtedly there weren't many) definitively vanished after 24 February 2022. Photograph by Suicasmo, Kyiv, 2019 (Creative Commons).

THE ~~FRIENDSHIP~~
ARCH
OF FREEDOM OF THE UKRAINIAN PEOPLE

КОЛИ?
Juliana

Коли то нарешті уже закінчиться?
Коли наші "браття" поїдуть додому?
Десятки ночей це мені уже сниться,
Десятки ночей вже на серці тривога.
Коли перестануть звучати гармати?
Де людяність, серце і розум почнеться?
Коли полишать вони нам рідні хати?
Коли той народ уже схаменеться?

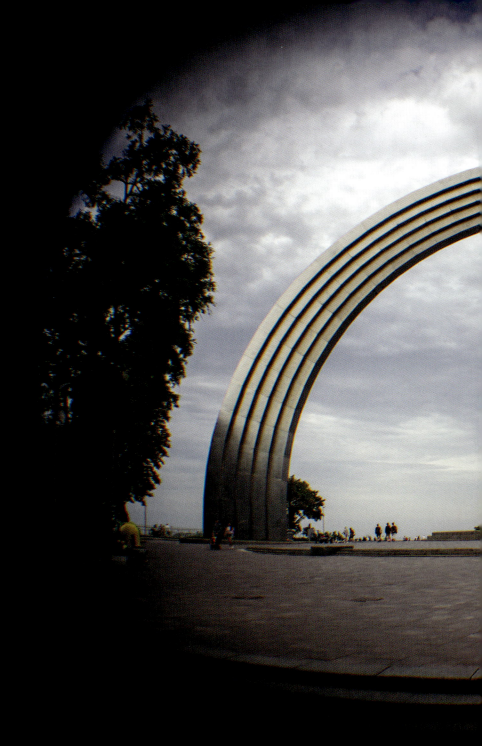

The People's Friendship Arch was gifted to (some say "imposed on") Ukraine by Russia in 1982, a decade before the Soviet Union collapsed. The arch commemorated 60 years of the USSR, and the 1,500th anniversary of Kyiv—making it one of the oldest European cities.

After Russia invaded Crimea in 2014, an artist painted a fissure at the apex of the arch to represent the rupture between the two countries.

Then, in May 2022, the arch was renamed the Arch of Freedom of the Ukrainian People. It was decided not to demolish the monument, but to let it stand with its graffitied crack on permanent show.

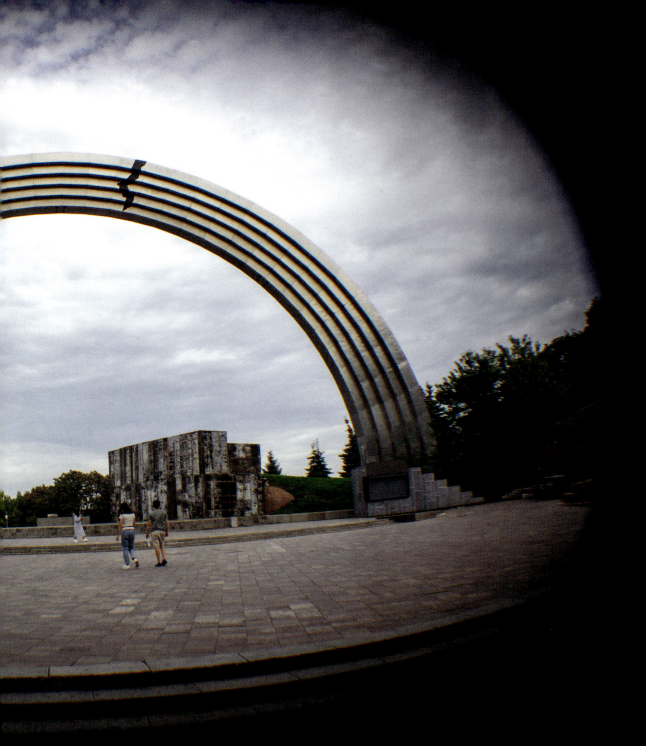

Inset images opposite, top to bottom: Spanish Civil War (Emeterio Melendreras, Madrid, 1937); Bosnian War (FIA, Belgrade, 1992); Aleppo, Syria (The New European, London, 2016). From my book, *Bosnian War Posters* (Interlink Books, 2022).

Granite statues at the base of the arch (opposite, right) represent Cossacks who submitted Ukraine to Russian rule under the Pereyaslav Agreement of 1654. At the time of this book going to press, there is a rumour that these figures may be removed. In Kyiv as a whole, more than 60 Russia-linked monuments are due for demolition.

When I visited, there were some posters visible on the panels boarding up the statues.

My eye was drawn to the top left image: the warplane-filled sky reminded me of the well-known Spanish Civil War poster, *If You Tolerate This Your Children Will Be Next*. The same motif appears on a Bosnian War poster and has been used in the context of other conflicts, too. It made me reflect on how universal an experience war is. All that's needed is a malign leader somewhere with a mania for power, and any of us can be either used as pawns or engulfed in death and destruction.

MADRID
THE "MILITARY" PRACTICE OF THE REBELS
IF YOU TOLERATE THIS
YOUR CHILDREN WILL BE NEXT

? НЕМОГУЋЕ !
ДОСТА!

THE NEW EUROPEAN
ALEPPO
IF WE TOLERATE THIS
OUR CHILDREN WILL BE NEXT

TO END A BOOK: IN CONCLUSION

While I was working on this book in December 2022, President Vladimir Putin suddenly, and in public, called his "special military operation", "war". Three hundred days after Russia invaded Ukraine, this slip of the tongue represented a drop of truth in an ever-expanding sea of mendacity, murder and mayhem.

In 1986, the great American war correspondent Martha Gellhorn (1908–98) wrote in *The Face of War:*

> To get a war started, you need an aggressor, a government so ambitious, so greedy that the vital interests of its state require foreign conquest. But an aggressor government sells its people the project of war as a defensive measure: they are being threatened, encircled, pushed around; enemies are poised to attack them. […] And once a war has started, the government is in total control: the people must obey the orders of their government even if their early induced enthusiasm has waned. They also see that however needlessly the war started, it would be better not to lose it. (From Gellhorn's 1986 Introduction.)

One way for the war against Ukraine to end would be for Russians en masse to awake from their flag-waiving patriotic fever dream; demand, and if need be *force,* political change; and accept defeat. Magical thinking, I am sure: even if they disagree with the war, most Russians probably consider that it would be "better not to lose it".

So, to win on the battlefield—where Russia must be vanquished before any meaningful diplomacy can begin—and lest it end up with a Bosnia-style lethal peace deal (see note on left)—Ukraine fights on with awe-inspiring courage. This quality extends throughout the population: from the very young to the very old; among men and women in all professions and none: from electrical engineers daily repairing the battered grid, to mothers helping their kids study in the absence of schools and teachers; from soldiers of both sexes fighting in the snowy trenches, to graffiti artists on the freezing streets and poets in their lampless homes. Such bravery and resilience—as well as faith in the power of art—still has the ability to surprise us. But as T. P. Cameron Wilson (1888–1918) wrote in the trenches of the first world war:

> […] two things have altered not
> Since first the world began
> The beauty of the wild green earth
> And the bravery of man.

(From *Magpies in Picardy,* published posthumously in 1919.)

MY THOUGHTS

My thorny thoughts, my thorny thoughts,
You bring me only woe!
Why do you on the paper stand
So sadly row on row? …
Why did the winds not scatter you
Like dust across the steppes?
Why did ill-luck not cradle you
To sleep upon its breast? …

My thoughts, my melancholy thoughts,
My children, tender shoots!
I nursed you, brought you up—and now
What shall I do with you? …
Go to Ukraine, my homeless waifs!
Your way make to Ukraine
Along back roads like vagabonds,
But I'm doomed here to stay.

There you will find a heart that's true
And words of welcome kind,
There honesty, unvarnished truth
And, maybe, fame you'll find …
So welcome them, my Motherland,
Ukraine, into your home!
Accept my guileless, simple brood
And take them for your own!

Graffiti on an underpass wall in Kyiv depicts the city skyline, green fields, and three seated Cossacks. Ukraine's most important poet, Taras Shevchenko (1814–61), stands on the right.

In 1840, while living in St Petersburg (the same year he painted the self-portrait on page 170), the passionately anti-Russia, pro-Ukraine Shevchenko (who was essentially a political prisoner in Imperialist Russia because of the power of his words) wrote the magnificent poem on this page. (More about Taras Shevchenko can be found on pages 306–311.)

My Thoughts was translated by John Weir. It was taken from www.taras-shevchenko.storinka.org.

The title of this conclusion is a play on *To End a War* (1998) by US diplomat Richard Holbrooke (1941—2010). His diplomacy in Dayton, Ohio, ended the Bosnian War in 1995, but ultimately failed the Bosnian people; it did not assure real peace or stability. This mistake *must not* be repeated in Ukraine.

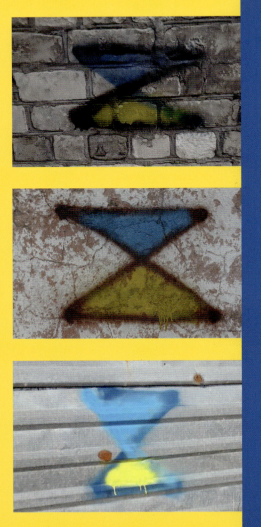

Shortly before going to press, I came across these images on Twitter. They were released by Yellow Ribbon, a grassroots resistance movement active in Ukraine's occupied territories, and were published in the *Life* section of the newspaper *Ukrainska Pravda* on 28 February 2023.

With the addition of one diagonal stroke and Ukraine's colours painted into the two resulting triangles, Russia's Z-symbol is transformed into an hourglass. The Russian Federation's occupation of Ukraine is running out of time, the graffiti says—but just how fast, we shall have to wait and see.

From top to bottom: photographs were taken in Berdyansk on the Sea of Azov, Nova Kakhovka in the Kherson province, and Sevastopol in the Crimea. Anonymous, 2023.